THE FOCAL EASY GUIDE TO

The Focal Easy Guide Series

Focal Easy Guides are the best choice to get you started with new software, whatever your level. Refreshingly simple, they do *not* attempt to cover everything, focusing solely on the essentials needed to get immediate results.

Ideal if you need to learn a new software package quickly, the Focal Easy Guides offer an effective, time-saving introduction to the key tools, not hundreds of pages of confusing reference material. The emphasis is on quickly getting to grips with the software in a practical and accessible way to achieve professional results.

Highly, illustrated in color, explanations are short and to the point. Written by professionals in a user-friendly style, the guides assume some computer knowledge and an understanding of the general concepts in the area covered, ensuring they aren't patronizing!

Series editor: Rick Young (www.digitalproduction.net)

Director and Founding Member of the UK Final Cut User Group, Apple Solutions Expert and freelance television director/editor, Rick has worked for the BBC, Sky, ITN, CNBC, and Reuters. Also a Final Cut Pro Consultant and author of the best-selling *The Easy Guide to Final Cut Pro*.

Titles in the series:

The Easy Guide to Final Cut Pro 3, Rick Young
The Focal Easy Guide to Final Cut Pro 4, Rick Young
The Focal Easy Guide to Final Cut Pro 5, Rick Young
The Focal Easy Guide to Final Cut Express, Rick Young
The Focal Easy Guide to DVD Studio Pro 3, Rick Young
The Focal Easy Guide to Maya 5, Jason Patnode
The Focal Easy Guide to Discreet combustion 3, Gary M. Davis
The Focal Easy Guide to combustion 4, Gary M. Davis
The Focal Easy Guide to Premiere Pro, Tim Kolb
The Focal Easy Guide to Flash MX 2004, Birgitta Hosea
The Focal Easy Guide to Cakewalk Sonar, Trev Wilkins
The Focal Easy Guide to Photoshop CS2, Brad Hinkel
The Focal Easy Guide to After Effects, Curtis Sponsler

COMBUSTION 4

For new users and professionals

GARY M. DAVIS

Focal Press is an imprint of Elsevier Linacre House, Jordan Hill, Oxford OX2 8DP 30 Corporate Drive, Burlington, MA 01803

First published 2005

Copyright © 2005, Gary M. Davis. All rights reserved

The right of Gary M. Davis to be identified as the author of this work has been asserted in accordance with the Copyright, Designs and Patents Act 1988

No part of this publication may be reproduced in any material form (including photocopying or storing in any medium by electronic means and whether or not transiently or incidentally to some other use of this publication) without the written permission of the copyright holder except in accordance with the provisions of the Copyright, Designs and Patents Act 1988 or under the terms of a licence issued by the Copyright Licensing Agency Ltd, 90 Tottenham Court Road, London, England W1T 4LP. Applications for the copyright holder's written permission to reproduce any part of this publication should be addressed to the publisher

Permissions may be sought directly from Elsevier's Science & Technology Rights Department in Oxford, UK; phone: (+44) 1865 843830, fax: (+44) 1865 853333, e-mail: permissions@elsevier.co.uk. You may also complete your request on-line via the Elsevier homepage (http://www.elsevier.com), by selecting 'Customer Support' and then 'Obtaining Permissions'

British Library Cataloguing in Publication Data

A catalogue record for this book is available from the British Library

Library of Congress Cataloguing in Publication Data

A catalogue record for this book is available from the Library of Congress

ISBN-13: 978 0 240 52010 0 ISBN-10: 0 240 52010 6

For information on all Focal Press publications visit our website at www.focalpress.com

Typeset by Charon Tec Pvt. Ltd, Chennai, India www.charontec.com Printed and bound in Italy

Working together to grow libraries in developing countries

www.elsevier.com | www.bookaid.org | www.sabre.org

ELSEVIER

BOOK AID

Sabre Foundation

Contents

About this Book xi
Platforms xii
About the Footage xiii
About the Author xiv
A Few Thanks ... xv

1 Preferences, UI, and Key Terms 1

And So It Begins . . . 2

Quick Visit to the Preferences 3

Major Project Components 8

Main Interface Explained Graphically 11

Data Entry Conventions 18

2 Workflow Basics, Footage, and Viewports 23

RAM Cache and Caching 24
The Cache Meter 25
Display Quality and Caching 26
File Menu Options 28
The Thumbnail Browser 31
Working with Footage 32
Footage Controls (Source and Output Settings) 33
Working with Proxies 37
Missing Footage 38
The Workspace Panel 39
Working with Viewports 42
View Modes 49

3 Paint and Text Operators 55

Paint Preferences 56
Applying a Paint Operator 56

Non-destructive Paint 61
The Paint Operator Toolbar 65
Paint Object Pivot Points 68
Control Points 69
Two Types of Groups within Paint 70
Bezier and B-Splines Tools 73
Categories of the Paint Controls 74
Vector Paint, Raster Output 83
Working with Adobe Illustrator Files 8
Text and Character Generation 86

4 Compositing in 2D and 3D 91

2D Composites 94

Manipulating Layers 97

Transformations 97

Transfer Modes 100

Layer View 101

Effect Operators 103

3D Compositing 107

Additional Notes about 3D Composites 113

... and Finally, Nested Composites 113

5 The Schematic View (Go with the Flow) 117

Accessing the Schematic View 118

Applying Operators 123

Notes on Nodes 124

Further Points on Schematic View 125

Schematic Hotkeys 126

Duplicating (aka Creating Instances) 127

Capsules 131

Schematic Preferences 133

6 Selections and Masks 135

Shared Terminology 136
Selections 143
Selection Operators 143
Mask Operators and Alpha Channels 145
Stencil Layer 151
Preserve Alpha 153
Preferences 154

7 Working with Color 155

Color Spaces 156
Color Channels and Bit Depth 158
Color Correction 161
The Discreet CC 162
Color Matching 167
The Store and Compare Features 170

8 Keying 173

Keyer Types in combustion 175

More than Just Making the Blue or Green Vanish . . . 176

Two Keying Operators 181

Additional Keying Operators 186

One Keying Workflow 189

Additional Tips for Chroma Keying 192

Additional Resources for Chroma Keying 193

9 The Tracker 195

The Enigma Unveiled 196
Two Questions to Consider 197
Applications for the Tracker 198

Let's Make Tracks, Already! 200
Trackers 203
Picking an Element to Track 204
The Tracker Interface in Depth 205
Image Stabilizing 211
Closing Tips 216

10 Animation and the Timeline 219

When and How Much? 220
Methods of Animating in combustion 220
Creating Simple Keyframe Animations 223
The Timeline 225
Animation Channels and Filtering 227
Object-Specific Channel Filters 228
Creating Custom Channel Filter Presets 229
Ease Curves 232
Extrapolation 234
Math Operations 236
Markers 237

11 A/V Editing 241

Audio 242
The Filmstrip 244
The Edit Operator 247
Trimming Heads, Middles, and Tails 249
Simple Editing 251
Duplicating Segments 252
Transitions 253
One- and Two-point Editing 255
Edit Markers 256
Split Layer 256
Additional Notes on Editing within combustion 257

12 Expressions 259

'Quick Pick' Link Options 260
Editing an Expression 263
Expression Browser 265
Converting Expressions to Keyframes 268
Ideas for Further Exploration 270

13 Integrated Particle System 271

OpenGL 272
Components of the Particle Operator 273
The Preview Window 275
Categories of the Particle Operator 276
Closing Tips for Particles 286

14 Rendering and Output 289

Output Format Considerations 290
Render Dialog Window 290
Output Settings 291
Global Settings 294
Statistics 294
Log 294
The Render to RAM Feature 295
Commit to Disk 296
Network Rendering with RenderQueue 299
Network Rendering with Backburner 300

Appendix I: File Sizes and Formats 307

Appendix II: Glossary/Index of combustion Terminology 315

Index 323

About this Book

Since I began using and teaching combustion, I have had the privilege of instructing many artists from varied disciplines in the graphics community. While doing so, I have noticed and kept extensive records of the common learning hurdles that come up again and again to new users. At all times, these learning hurdles and workflow issues have been my primary focus for this book.

No volume or manual could be the entire resource for an application, and I realized this going into this project. Accepting this from the outset, I wrote this Easy Guide with a strong emphasis on the real world, everyday use of combustion and a concentration of getting the beginner over the initial, common stumbling blocks. At its heart, this book is all about workflow . . . the 'art' is entirely up to you.

This book assumes a small level of familiarity with computer graphics from you, the reader. This is, certainly, not to say one needs to be an accomplished animator prior to reading this book. On the contrary, combustion is an excellent tool for users wishing to make the transition from creating static pictures to moving images. It is, however, advantageous if you have at least a basic knowledge of working with an application such as Photoshop, Paint Shop Pro, Illustrator, or CorelDraw. Again, it is not required, but it can help.

In addition to my notes from teaching combustion in a classroom environment, I have pulled from my experience of actually using combustion on many different types of production tasks. This information has been gathered and edited down to become the Easy Guide in your hands. Great effort was put forth to make this the resource I wish I had when learning this phenomenally powerful application. I sincerely hope you enjoy this book and it gets you that much closer to creating spectacular images with combustion.

Gary M. Davis
Visual Effects Artist
Application Training Specialist
http://www.visualZ.com

Platforms

This book was created using combustion 4 for the Windows platform. As combustion uses the 'Discreet Artist' interface, the only visual way the Macintosh and Windows versions differ from one another is the menu bar at the very top of the screen. The screen captures and projects provided should look and function identically on the Macintosh platform.

All keyboard and mouse conventions will be the same except for the three exceptions listed below. On the right is the Macintosh equivalent to the Windows function listed on the left (and used throughout this book).

Windows	Macintosh
ALT key	Options key
Control key	Command key
Right mouse click	Control key + mouse click

About the Footage

While many of the lessons in this book are generic to any combustion project or piece of video or imagery, several clips have been provided for you to use while reading along with the book itself. In addition to my own work, I am providing images from a few great sources. I would like to recognize, thank, and encourage you to visit these fine vendors in stock imagery:

www.MarlinStudios.com www.DigitalJuice.com

Chroma Key sequence used with permission of Haxan Films and Clutch (from the 'Spacegrass' music video) © 2003 Haxan Films.

It should be noted that the footage made available for this book has been extremely compressed to reduce download time. In many cases, the original clips have been resized, shortened in length, and/or cropped to make them smaller. The quality of the files obtained for the lessons in this book is not representative of the fine material that these vendors typically provide end users. It should also be noted that combustion, like any application, runs slower with compressed footage. The more it is compressed, the more the application has to work at first decoding the files to use them. Working in combustion with uncompressed files will be faster than working with highly compressed ones such as these.

To download the files associated with this book, you will need to go to the Focal Press website: www.focalpress.com/companions/UPDATE THIS URL AS NEEDED. The total size of the download is approximately 56 megabytes.

Note: Since the footage is downloaded and is not on a read-only CDROM, I recommend making a second copy of the footage and project files so that if anything accidentally gets overwritten or deleted, you have a backup.

About the Author

Gary M. Davis has an extensive background in broadcast design and motion-based simulator ride content creation. He has studied sculpture, photography, painting, and graphic design and in 1992 received a BFA in computer animation. He then began a three-year partnership that kept him touring and doing video performance work for various recording artists.

The next six years he spent developing motion-based simulator ride films and leading the design team that eventually obtained over a dozen patents for the acquisition and delivery of cylindrical and

hemispherical, stereoscopic digitally projected theaters.

In 1999, Gary went out on his own after becoming one of Discreet's certified Training Specialists for 3ds Max and in 2000 he additionally obtained certification as a combustion training specialist. Past networks that have featured his work include ABC, Fox, MTV, USA and The Sci-Fi Channel. Gary has also performed production work for 20th Century Fox, New Regency Films, Compaq, Lockheed, Disney and Universal Studios, among others.

In addition to traveling for contract production work and private software training, he is also a regular instructor, lecturer and demo artist at many industry tradeshows. Gary continues to write for numerous publications and has been a contributing author to the official Discreet Courseware and *Mastering 3D Studio MAX r3*. He now owns and operates visualZ, LLC, an Orlando, Florida-based consulting and training firm specializing in the integration of 3D animation and compositing techniques.

A Few Thanks . . .

First and foremost, obvious thanks go out to the combustion team . . . especially Eric Brown, Annie Normandin, and Josee Belhumeur. Endless gratitude goes out to you and your group for this wonderful gift you have given me as an artist. Also thanks to Ken LaRue for his last-minute yet helpful suggestions and tech edits on this revision for combustion 4. For that matter, everyone at the Media and Entertainment Division of Autodesk (aka Discreet) deserves a really huge hug. This group has become too numerous for me to mention everyone by name, but you have all become my friends far beyond the scope of mere industry colleagues. Shawn Hendriks also gets the nod for being my constant support helpdesk, demo provider and, most importantly, my very good friend. I'd also like to recognize and bow down to all the application engineers for sharing in the most concentrated source of knowledge I have ever come across during my ongoing stint in the field of computer graphics. You know who you are and I sincerely can't thank each of you enough for the great times we have had and will spend together.

To you, the reader, and all of my past students and production clients . . . I am humbled and grateful that you invest your resources in me. You are a constant reminder that using, demoing, and teaching software are three extremely different things. I continue to strive to be the best I can be at all three of these disciplines largely because of you all. I hope we cross paths again and again.

There are a few people who really helped shape my career along the way extremely various reasons: Ron Coleman; a true renaissance man and the definition of mentor. Ralph Haslacker, Todd Reed, Dennis Warner, and Jason Resener for the insane ups and downs during the start of my professional career. Curtis Sponsler and Chris Murray for allowing me to share and learn so much of creating and running a small business. Thank you all so very much for the life experience.

Lastly, to Miss Luna and Toni; the two ladies in my life. Everything is worthwhile because of you, and I can't express enough what you have done for me over the years. My continued love and thanks are yours eternal.

And So It Begins . . .

... with a blank slate. The combustion user interface (UI) can, admittedly, be a bit intimidating at first. This is because it is so visually different than many graphics applications you may have used in the past.

Because the interface is so barren at times and yet at other moments seemingly convoluted with sliders, it can get confusing at first. Perhaps the most important thing to understand about combustion's entire UI is the fact that the user controls what and how images and tools are seen and edited, and only the controls relevant to the current operation are present at any given time.

At first, you will undoubtedly think tools or controls for something should have been somewhere they are not. This is probably because you have not 'asked' combustion to display the tools relevant to the item you wish to edit. What may at first seem complicated will make life a lot easier as you become comfortable with combustion. We will identify several ways to control this process in a moment, but before we dive into combustion, let's first prepare our computer system.

The default locations are:

Windows: C:\Documents and Settings\UserLoginName\Application Data\combustion4\host.ini

Macintosh: Macintosh HD\Users\admin\Combustion User Data\host.ini

Quick Visit to the Preferences

The default settings for all of the preferences should be fine at first. While only some points regarding the preferences will be mentioned here, others will be addressed elsewhere in this book. As you progress, you will learn how to change your user preferences to accommodate different workflows and project needs.

Note: At any time, if you ever feel you need to completely 'reset combustion', you can find and delete the file named *Host.ini* that pertains to combustion. This is similar to a reinstall of the application and deleting this file will reset all the user preferences. You should only do this action as needed.

Open the user preferences from the File pull-down menu. You can also bring up the user preferences using hotkeys of CTRL + ; (Control and semicolon keys held at same time).

Note: For the purposes of this book, the style of hierarchical menus and commands will be often listed in a manner that is 'vague to specific'. For example, to select Preferences from the File menu, it may be indicated as such: File > Preferences.

Figure 1.1 shows the user preferences panel that can be accessed at any time while working in combustion. The categories of preferences are on the left while the specifics of each are detailed on the right.

General – Many of these settings can help you optimize combustion to perform differently on different hardware setups.

If you are using a multiprocessor computer or one that supports
Hyper-threading, you should make sure you have Enable Multi-processing

(Enable Multi-Processing) checked to utilize all processors.

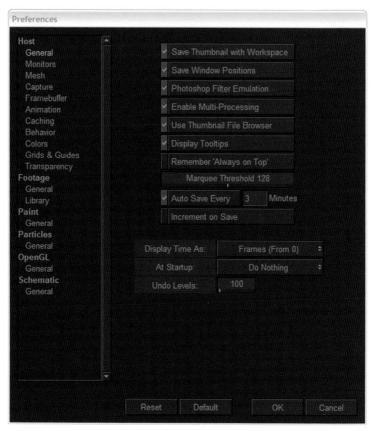

Figure 1.1

The Use Thumbnail File Browser (Use Thumbnail File Browser) option is suggested, and will be explained in greater detail in Chapter 2. You can, however, turn off the Thumbnail Browser here, should you choose to at any time.

Tool tips (Display Toollos) are the pop-ups that will help you to learn the different tools within combustion. When enabled, text will appear if you hover your cursor over many tools. Figure 1.2 shows a tool tip for the paint toolset.

Auto Save (Auto Save Every 3 Minutes) can also be especially helpful when starting out in combustion for the first few times. When enabled, combustion creates a backup file of the current Workspace file for you and saves to this file at a set

interval. A combustion Workspace file named FILENAME.CWS will have a backup name of FILENAME_BAK.CWS. Enabling this option can dramatically lower the worry about frequently saving your work.

Monitors – Figure 1.3 shows where you define how the combustion

Figure 1.2

interface is displayed on multiple (up to four) monitors. Here, you can also enable 'floating' for various menus within the combustion application itself. Many menus in combustion can overlap by default; floating some of them gives you the option of putting them in a different location than the default (docked) location.

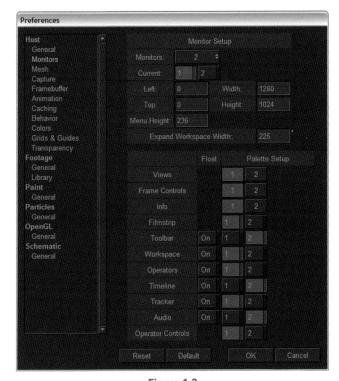

Figure 1.3

Changing the number of monitors at the top of the dialog requires you to exit combustion and relaunch the application, but the other options here take effect immediately after you click OK to exit the preferences.

In Figure 1.4, a custom, two-monitor layout can be seen. Notice how the Workspace panel has been expanded along the far left side of the UI. This can be accomplished at any time while working in combustion by tapping the Shift + F10 hotkeys. This allows the user to see the Workspace panel and the Toolbar simultaneously. This can be especially helpful to new users because the contents of the Toolbar can change depending on what is selected in the Workspace panel. A second Shift + F10 hotkey combination will return it to the bottom of the UI at any time.

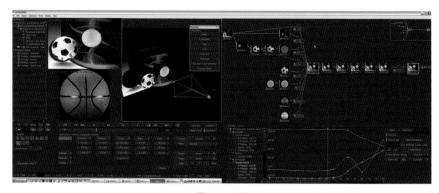

Figure 1.4

The 'Menu Height' setting of the monitor preferences changes height (in pixels) of separation between the viewports and the rest of the lower portion of the UI. You should try changing the Menu Height if you, for example, work primarily on DV footage and on a computer monitor set to 1920×1200 resolution. The 'Expand Workspace Width' setting controls how wide the Workspace panel is when expanded using the Shift + F10 feature. Different settings for these two attributes will accommodate different resolution images and viewport layouts dramatically and will also allow you to make the most of your screen real-estate.

Caching – Sets the maximum computer system memory (RAM) that you allow combustion to recognize. You can set the value as a percentage (%) of system memory or a specific file size in Mbytes (megabytes) of RAM

(). The default allows you to run other applications at the same time as combustion. If you plan on working primarily or exclusively with combustion, you may want to increase this preference slightly. It is not recommended to use 100%. While this will enable combustion to access to all system memory, it will cause any other applications running to take a dramatic performance hit.

Colors – It might seem odd to mention such a cosmetic thing, but people often feel very strongly about the look of their work environment and often like to adjust it to their specific needs.

In Figure 1.5, there are two different UI color versions of the exact same project. The darker image on the left is the 'Charcoal' color scheme and the lighter one on the right is the 'Platinum' color scheme.

Figure 1.5

As a user, you can experiment with these color preferences to determine which is more comfortable for your particular taste. Remember that these are just two presets. You may create your own unique and individual color scheme at any time using the color pods seen in Figure 1.6.

Pen Colors	
Screen Background	Text Edit Button
Window Background	Slider Button
Button Fill	Label
Button Highlight	Dark Text
Button Frame	Medium Text
Shine Border	Light Text
Shadow Border	Highlight Color

Figure 1.6

Tip: Many users like the dark interface because it is easier on the eyes when staring at a monitor for several hours at a time.

Major Project Components

Listed below are several key terms that you may have used or heard previously; however, here they are described as specifically defined by combustion. For example, while you may have worked with layer-based applications in the past, combustion has a very specific meaning for the term 'layer' which may be slightly different than in other software.

Please take a moment to familiarize yourself with these critical definitions and concepts within combustion. These will all be discussed in depth throughout this book, but familiarizing yourself with these definitions as soon as possible will ease the learning curve tremendously. Admittedly, even the simple (?) definitions below are somewhat involved. This cursory overview, if nothing else, is meant to expose you to the major terms of the application. Don't be alarmed if the next page or two have you scratching your head, just let it sink in a bit and, perhaps, come back to them after you have worked in combustion for a short amount of time. Now here we go . . .

Footage is the most basic element in combustion; that is, there is nothing more base level than footage. It all starts here. Individual pieces of footage can be very different in format, resolution, frame rate and bit depth, yet all work together in the same Workspace.

Operators are the numerous effects you can apply to footage such as blurs, paint, keyers, particles and color correctors (to name a very few). Third-party plugins are listed and accessed as operators along with the rest of the built-in effects that are included with combustion. Operators are the functions that change the look of your footage in a series of events occurring to your source footage. No amount of time or writing could cover the vast array of 'looks' you can achieve with all the operators, primarily because their effects are so varied and also because even the order in which they are applied can drastically

change the final look of a project. The results from combining various operators are, quite literally, infinite.

Layers are the primary building blocks of composites. Layers can simply be the output of a single piece of footage brought into a composite, or they can be the end result of a series of several operators applied, in sequence, to a piece of footage. Layers, not footage, define transfer mode and can hold spatial transformations such as position, rotation, and scale. For example, you cannot move footage. Instead, you move the layer that is made out of a piece of footage. You might consider a layer as a container of effects applied to one piece of footage.

Composites are the end result of one or more layers and are where you typically combine the numerous elements of your projects. Composites can be considered a window of a defined size/resolution that allows you to see your layers. A composite can either be flat and two-dimensional, or can literally be a 'porthole' into a true 3D environment complete with a camera and lights. A composite has its own resolution, duration and frame rate that are independent of the layers within. Strangely enough, a composite, itself, is considered an operator because the output of a complex composite can become the single input to another operator, layer, etc. This is called a *nested composite* and is an extremely powerful feature.

An **Edit** operator is similar to a Composite operator, in that it is like a window (with its own resolution) that views several elements together as one. The primary difference is that instead of stacking layers on top of each other as a composite does, the elements in an Edit operator, called 'Segments', are ordered end to end, or 'head to tail'. This process is exactly the same as other non-linear editing applications you may have used such as Avid, Premiere or Final Cut Pro.

Workspace defines the entire project at hand at any given time. A Workspace file saved by combustion has the file extension of CWS, which stands for combustion workspace. Although there can be only one Workspace file open at any given time, this Workspace can contain any number and combination of footage clips, operators, layers, branches, and composites. To combine elements from different CWS files, you can *import* a Workspace into another and then save this with a

new name to reflect the change. You still only have one CWS file open, but have brought the contents of another into the current file. The imported Workspace and all of its branches will become a new branch in the current Workspace, and either remain a separate branch or be available for use in the project that was already present prior to the import. Phew, that sure is a mouthful and a lot to grasp, but for now just remember that there is only ever one Workspace open at a time. The big picture, if you will.

Note: 'Workspace' and 'Workspace panel' are not the same thing. The Workspace panel is detailed in Chapter 2.

Tip: You can launch more than one combustion session from the desktop. This allows you to build and merge elements between CWS project files using concurrently running combustion(s). Be advised, however, that launching multiple sessions of combustion can be extremely taxing on a computer system.

Branches are defined as the individual chains or sequences of data that result when operators are strung together and applied to a single piece of footage. For example, if you have a JPG image that gets color corrected and then blurred, a branch would be created that is the entire series of the three events, starting with the source footage.

In the list below, a few random example branches are listed as might be found in a combustion project:

```
Footage > Operator
Footage > Operator > Operator > Operator > (etc.)
Footage > Operator > Layer > Composite
Footage > Segment > Edit
Footage > Operator > Edit > Composite . . .
Etc.
```

Note: An 'invalid branch' can exist if you have an operator (or series of operators) in the Workspace but it has no incoming or outgoing pixel information.

Remember that when considering the endless possibilities allowed, you must also appreciate that composites and edits are also really just special operators. This allows for branches of the Process Tree to stem in an infinite number of directions. The **Schematic View** is a graphical representation of this Process Tree. The Schematic will be discussed in greater detail in Chapter 5.

Figure 1.7 shows a brief introduction to combustion's Schematic View. Seen here is a simple representation of the example just mentioned. The resulting chain of events (or 'nodes') is a branch in the Workspace.

Figure 1.7

The last several paragraphs were, admittedly, a lot to take in this early on. Do not be alarmed if you are overwhelmed by the onslaught of terminology presented this early in the book.

Main Interface Explained Graphically

- 1 From the File menu, select Open Workspace. The **Thumbnail Browser** will appear.
- Using the navigation portion on the left-hand side, navigate to the location of the project files and open the project file named ch01_ComplexComp.cws. This file was designed to present you with a lot of information at the outset. It is meant to be a rather complex project for a first look at many features.

Figure 1.8 shows a typical project in combustion.

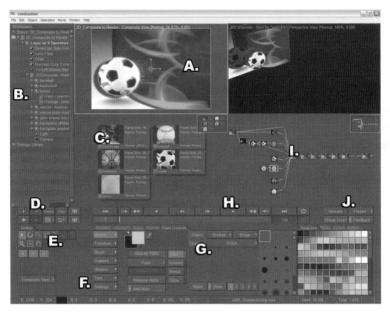

Figure 1.8

Outlined below are brief descriptions and highlights of each area.

- **A** Viewports
- **B** The Workspace panel (currently expanded)
- **C** The Footage Library (seen in a viewport)
- **D** Viewport Controls
- E Toolbar Palette
- **F** Info Bar
- **G** Operator/Footage Controls (depending on current selection)
- H Playback/Transport ("VCR") Controls
- I Schematic View
- J Animate button, Time, Feedback and Display options.

A. Viewports – In the example, there are four equal-sized viewports at the top of the combustion UI. The 'active viewport' is identified by the white outline around it. You can make a viewport the active viewport simply by clicking on it. The text in the upper left of each viewport will always provide valuable information about what that particular viewport is displaying. In Figure 1.9, you can see that the viewport is showing a composite view in Normal View Mode, which is zoomed to 64.17% and is using 8-bit color. Additional clarification and detailed information about viewports will be addressed in Chapter 2.

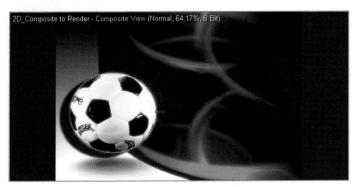

Figure 1.9

Note: At any time, you can toggle the active viewport to the Footage Library by hitting Shift + F12. The same hotkey combination takes you back out.

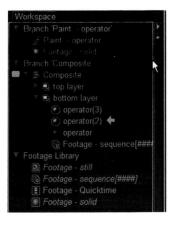

B. The Workspace Panel – Seen in 'Expanded' mode. Your Workspace panel may currently be tucked behind the Toolbar in area E. The Workspace panel is one location where you might organize footage, layers, and composites, rename items, or turn on and off operators or layers, for example. At any time when working in combustion, you can also scroll down to the bottom of the Workspace panel and open a 'text-only' version of the **Footage Library**. The

Footage Library is like a bin of all clips that are available within combustion's current Workspace.

C. The Footage Library – Seen here graphically in a viewport. Here, the Footage Library can be seen in a thumbnail mode rather than the text-based version available at the bottom of the Workspace panel. With few exceptions, anywhere you see a thumbnail representation of an element you can scrub the contents as if it were a VCR by clicking and dragging on the upper portion of the thumbnail. Your cursor will change to a horizontal arrow when ready to scrub the icon.

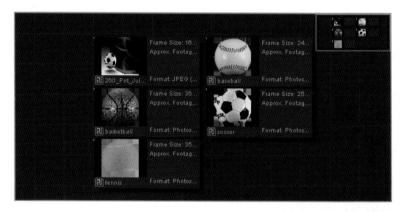

D. Viewport Controls – These controls will always be present when working in combustion. This is where you can zoom () and pan () viewports as well as switch between different viewport layouts using the drop-down menu seen in Figure 1.10. Here, there are also controls for enabling a Schematic View () and icons () controlling what gets displayed in area G.

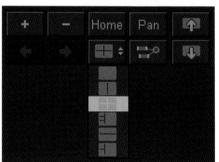

Figure 1.10

Note: The Home and Pan buttons are 'scrub buttons' that allow you to click and drag directly on them.

E. The Toolbar – This will constantly change depending on the contents of the Active Viewport or the currently selected item. For example, selecting the Paint operator or the Discreet Keyer operator will show vastly different toolsets. Figure 1.11 shows the Paint operator's Toolbar.

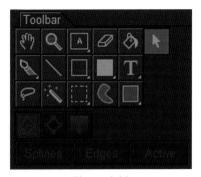

Figure 1.11

coordinate information pertaining to the cursor location, the color of the pixel the cursor is over, an Error Alert indicator, the name of the project, or Workspace (*.CWS file) you have open, and the ever-looming Cache Meter.

You can access the different Info Palette options by right clicking anywhere on this strip at the bottom of the UI.

Tip: Since the Cache Meter is something often accessed while working in any project, you might as well leave the rest of the Info Palette options enabled. They will take up no more interface real estate and may provide valuable information from time to time.

This is provided as position data and is always represented in pixel dimensions and never spatial measurements such as inches or centimeters. The X/Y coordinates onscreen are relative to your image so that the upper left-hand corner of a graphic is always 0,0. There is a color swatch and numerical values in red, green, blue (R,G,B) and percentages of hue, saturation, and value (H,S,V).

The very center of the Info Bar is where combustion lists the name of the Workspace (*.CWS) file that is open. Remember, although you might have 20 branches doing completely different and unrelated tasks, you can only have one Workspace open at a time. When you are using a tool such as Rotate, this file name will change temporarily to indicate Tool Feedback (such as degrees of rotation).

Note: If there is an asterisk to the left of the name of the current Workspace, this indicates that changes have been made since your last save.

G. Operator Controls – Currently showing the controls for a Paint operator. The contents displayed here (area G) will change dramatically depending on what is selected in the project. For example, if a paint operator is selected, you can work and edit with hundreds of different controls. Conversely, if a Box Blur operator is selected, there are only two settings to edit.

You should take notice that when using the default, single monitor UI, the controls for accessing the Timeline, Operators panel, the Tracker and the Operator Controls are all available as small tabs between the Playback Controls (H) in this area. Figure 1.12 shows these five tabs in their default, docked state. With the exception of the Operator Controls, you can optionally float any of these tabs panels from within the user preferences.

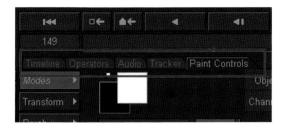

Figure 1.12

H. Playback Controls – For controlling and navigating in time. These are primarily like VCR buttons *for the active viewport*.

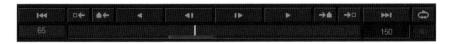

You can also get information here about where you are in time (frame number or SMPTE time code), what has been cached and where your Timeline in and out points are set.

- **I. Schematic View** Seen here in a viewport. This is the icon or node-based representation of the Workspace at hand.
- **J. Animate, Global/Local Time, Feedback and Display Quality** These controls will always be available when working in combustion.

Animate Button – This gem is always a click away and is the easiest way to create keyframes of animation. When enabled (red), changes in almost any value

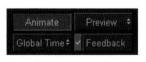

in combustion are being recorded and keyframes are being created on the current frame. You do not need to have the Timeline visible to use this feature.

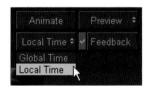

Global and Local Time – This setting changes how the Playback Controls display time. This setting also affects the response of the 'Frame All' button in the Timeline. Global Time always shows the time of the top-level operator or composite in the

current branch and Local Time changes to show the duration of the current selection.

Tip: While initially learning combustion, leave this set to Global Time. This will leave the time controls showing the duration of your project at any given moment.

Display Quality – This provides four preset settings for viewport resolution. This is for working only and does not affect the quality of the final rendering. These settings are very important to understand and are possibly the easiest way to speed up the entire workflow in combustion. The specifics of each setting are detailed in Chapter 2.

Feedback – This is a toggle that can be enabled to let the viewports update while you are making a change in value somewhere in combustion. With Feedback disabled, the screen redraw will happen after you commit the value change (or release the mouse button, for example).

Data Entry Conventions

When you are working in combustion, you are often presented with data entry fields for use in changing various numerical values. There are three distinct ways of using these fields including keyboard entry, sliders and the calculator. To quickly go over these three methods of entering data, please follow this brief exercise:

- 1 Open the Workspace named ch01_DataEntry.cws.
 - 2 Select the layer named 'layer' in the Workspace panel by single clicking on the name (do not click on the icon left of the name). The layer should become highlighted when selected, as seen in Figure 1.13.

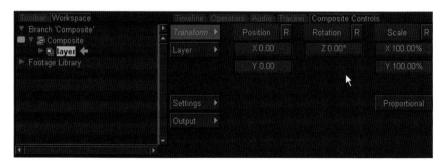

Figure 1.13

- **3** Switch to the Transform category of the Composite Controls.
- To enter data with the keyboard, click ONCE in the Transform > Rotation data entry field. It should change color and you should also notice a blinking cursor, as seen in Figure 1.14.

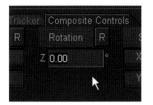

Figure 1.14

You can now enter a value using the keyboard. Often, depending on the value being edited, negative numbers are allowed (as is the case with layer rotation). To exit the field, either hit enter on the keyboard or click anywhere outside of the data entry field to accept the change.

- To use a data entry field as a **slider**, just click and drag your mouse on the data entry field. Positive values will be to the right and negative to the left. When Feedback is enabled (area J), this is the most visually interactive way of manipulating data. If, while using the slider input method, you hold down the Shift key, you will increase the rate of data entry. Conversely, if you hold down the Control key, it slows down the input rate.
- To access the **calculator** input, simply double click on the data entry field. You should see a simple calculator appear as seen in Figure 1.15. Here, you can enter simple values or use simple math functions. For example, if a particular value was set to 36 prior to accessing the calculator, you could quickly double click to access the calculator, enter '/2' (without the quotes) and upon clicking OK to exit, the value will be changed to 18.

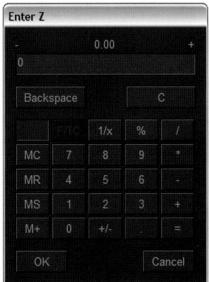

Figure 1.15

The small 'R' button next to any data entry field (Figure 1.16) stands for reset, and is a quick way to reset that particular field to its default value. You will see this throughout combustion. This reset feature is not animatable and will only reset the value to its default value. Additionally, any keyframes

Figure 1.16

will be deleted for that value and you will, in effect, be starting over for that particular data entry value. Use the reset with caution and only when you need a clean slate for that particular item.

Reset buttons such as the one shown in Figure 1.17 also appear throughout combustion. However, unlike the small 'R' buttons next to specific entries a Reset button resets the entire category, not just one value. In this example, all the transformations would be reset.

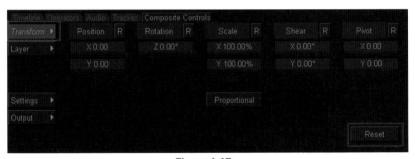

Figure 1.17

You may also come across a **Reset All** button, as seen in Figure 1.18. This example is from the Discreet Color Corrector operator, which has several

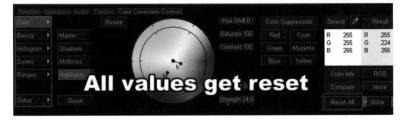

Figure 1.18

categories of functions. Using the Reset All button clears all the settings from all of the operators' categories, not just the one that is visible.

In addition to data entry fields, you may see **drop-down list** menus throughout combustion that indicate choices to be made from several available options. An example of this you have seen is the Display Quality rollout (area J). If you have a scroll wheel on your mouse, you can hover your cursor over the rollout in question and merely roll the mouse scroll wheel to flip through the changes.

Anywhere you see a small icon of a finger pointing (); it is a Pick button for that item. Enabling the Pick icon allows you to make a selection based on an item or area you click in a viewport.

These different ways of entering data provide you convenient access to change values in a manner most appropriate for your specific needs at that moment. Remember, these will all be available throughout combustion, not just for layer transformations and footage controls.

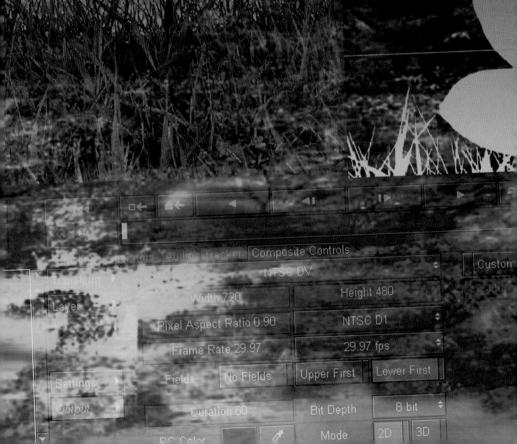

Prior to addressing more specific features, there are a still a few basic concepts to combustion that should be understood at the outset. These are really worth learning early on so that working on explicit features in combustion will be that much easier.

RAM Cache and Caching

At its core, combustion processes nearly all aspects of the application on the CPU(s) of the host computer; however, it stores this information in memory (RAM) as it works. This storing of data to memory is referred to as RAM caching and is how combustion achieves real-time playback at full frame rates, even on modest laptop computers. The frames are processed, then stored in RAM and played back at full speed.

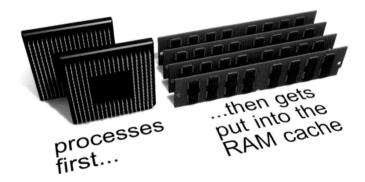

When combustion has used up all available memory, it begins to overwrite data in the RAM cache and adds the new data, remaining 'full' at that point. Out with the old and in with the new, as it were. The more memory you have in your computer, the more you can potentially cache and play back at full frame rate.

People have often commented, 'Gee, combustion needs a lot of memory'. To this, I typically respond, 'it doesn't waste memory, it takes full advantage of it'. These are two very different things and it is important to understand and appreciate the difference between the two.

Even when at rest, combustion has cached the frame where you are currently resting the playback controls. When you start playback of a Workspace,

combustion begins to store even more data into RAM by caching every output in the Workspace (not just a 'flattened' version of what is visible in the current viewport). Due to this, it might be totally feasible to require hundreds of megabytes of memory just to cache a few seconds of video resolution material. A few basic examples of when this might occur are:

- Many layers all being cached in the Workspace.
- You have one layer, but a series of several operators have been applied to it, thus requiring more memory.
- You have a number of completely disjointed branches that are all being cached, but you are only currently looking at one.
- You might have many layers of high-resolution HD material in a lowerresolution D1 composite. Combustion is attempting to cache all the information outside of the visible frame.

OK, so how much is enough memory to adequately run combustion? Ahhh, one of those eternal questions. Quite seriously, too much is never enough, especially when you consider how quickly you can fill it using a RAM cache. It is not uncommon to actively use 2 gigabytes of memory when working in combustion. The good news is that memory gets cheaper every day. At the time of this writing, 2 gigabytes of RAM can be obtained from around US\$150 and up. The minimum recommended is 512 megabytes, but you realistically should have at least a gig of system ram RAM to work productively.

Note: If you exit combustion, anything stored in the cache is lost and must be recached. To save any images you have cached, you must render using the techniques described in Chapter 14.

The Cache Meter

At any time when working in combustion, you will hopefully get used to glancing down to the lower right portion of the UI at the Cache Meter. Seen

in Figure 2.1, the Cache Meter can be thought of in a similar fashion as a fuel gauge on an automobile.

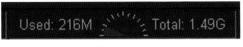

Figure 2.1

Note: If the Cache Meter is not currently visible, you can turn it on by right clicking on the Info Bar at the bottom of the UI and enabling it.

To read the Cache Meter: on the left is how much memory you are currently using and on the right is how much has been made available in the user preferences. The number on the left will change while you are working. Depending on your workflow, you may be surprised at what uses little resources and what demands a lot.

If you want to flush the cache so you can concentrate on a completely different portion of your project, at any time you can right click on the Cache Meter and 'flush the cache'. Flushing the cache purges the system memory of anything previously/temporarily stored in RAM.

Note: Flushing the cache also reloads all the footage. For example, if you edit an image in Photoshop and resave it, you can flush the cache to reload it in combustion.

You can also see what has been cached and what remains to be cached for the current viewport by looking for the ever-growing gray bar under the Playback controls. This bar will dynamically update itself.

Display Quality and Caching

The Display Quality setting changes the way combustion caches all material in the current Workspace. Changing the Display Quality setting is the fastest and also easiest way to

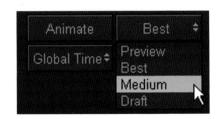

Figure 2.2

reduce the amount of RAM required to cache Workspaces. Figure 2.2 shows the Display Quality drop-down menu.

Note: Switching from one display quality setting to another does not flush the cache.

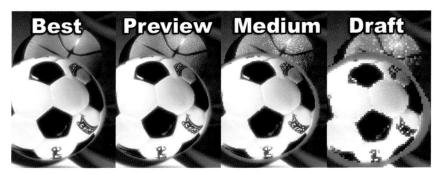

Figure 2.3

Preview – This is an exact representation of how your project looks at full resolution, except that the antialiasing and super-sampling options available in a 3D composite will be ignored. These two features are made available in 'Best' mode, but require extra rendering time that you might not want to waste while building a project. Preview and Best require the same amount of memory to cache, but Best takes longer due to the extra processing required for antialiasing.

Best – The highest quality that elements can be represented. While you may certainly want to render your work with the 'Best' setting, it is often a good idea to build your project using one or all of the other three options; which will increase your productivity. A common workflow is to work/cache at another setting, stop playback, then switch temporarily to Best just to spot check a few frames (perhaps a chroma key edge you have been working on). Then, when complete, you switch back to Medium, for example, to continue working with lower overhead.

Medium – The Medium setting forces clips to be viewed and cached at half resolution or the resolution of any footage with a defined proxy (which will be explained later in this chapter). Medium display quality will cache faster and

require approximately a fourth as much RAM as Preview/Best. Medium is often adequate for most working circumstances and it effectively dramatically speeds up the workflow in combustion.

Draft – The Draft setting processes and displays clips at one-quarter resolution, or half the resolution of any defined proxies. Working in draft will be even faster than Medium and require one-sixteenth the resources to cache the same material as Preview/Best, albeit at a cost in visual quality. For the testing of animation timing only, Draft works great because you are not bothering to cache all the miniscule image information. This allows you to quickly see gross movement, color and timing play back in real time.

Tip: Remember, you can switch between the different display quality settings at any time, even while playing back. The setting in Figure 2.3 is not tied to render quality. For example, you can work for several hours completely in Draft, and then when you are ready to output your work, you render the project with the 'Best' setting.

File Menu Options

As simple as they sound, many of the options in the File menu are one of the

most notorious causes for confusion among new combustion users. Please refer to the File menu dropdown (Figure 2.4) for the following definitions.

New – This presents you with the dialog to create a new branch of some kind in the current Workspace. In Figure 2.5, the left side shows how this dialog may load and the image on the right shows the New > Type rollout expanded. Depending on the type selected, different creation parameters will be available below and a different kind of branch will be created when you click OK to confirm.

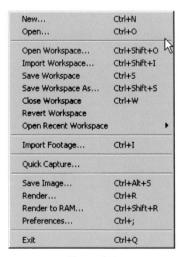

Figure 2.4

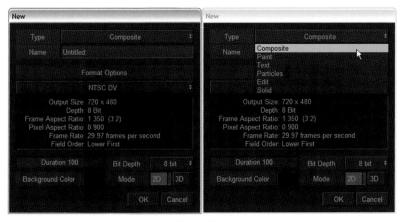

Figure 2.5

This chart briefly outlines the different types available from File > New . . . :

Composite	An empty 2D or 3D composite will be created
Paint	A solid piece of footage with a Paint operator applied
Text	A solid piece of footage with a Text operator applied
Particle	A solid piece of footage with a Particle operator applied
Edit	A blank Edit operator will be created
Solid	A solid piece of footage will be created

Open – This option is for bringing in one or more pieces of footage off the computer system or network drives. You will be presented with the Thumbnail Browser to select the clip(s) and then provided with several different choices of how to bring the footage into the Workspace. This is often confused with Import Footage, which is detailed below. Opening a piece of footage into an operator creates a branch of that type. For example, if you open a still into a 2D composite, the result is a composite branch that contains a single layer. You can open multiple files at the same time, but all the parameters of the resulting branch will use the parameters for the first clip. For example, if I open three images of different sizes into a composite as layers, the first clip chosen will dictate the resolution, frame rate (and so on) of the new composite. This is typically a time-saving feature but you can, however, go and change the parameters of the composite at any time.

Open Workspace – This is only for opening a pre-existing combustion (*.CWS) project file. You will be presented with the Thumbnail Browser; however, you will only be able to browse and open CWS files. New users often get this confused with File > Open. If you open another Workspace, the current Workspace must be closed. There can only be one open at a time.

Import Workspace – This option allows you to merge the contents of one (*.CWS) project into another. The entire contents of the imported Workspace will be brought in as a separate branch, but you will still only have one Workspace open. This Workspace will have the name of the starting project, not the imported Workspace.

Import Footage – This option will only be available if you have a composite, layer or an Edit operator selected in the Workspace. If you have an operator selected (such as a blur, for example), this option to import footage will not appear in the File menu choices. By choosing to import footage, you will then be presented with the Import Footage Thumbnail Browser.

Quick Capture – This is a utility that allows you to digitize footage into combustion directly off miniDV video hardware devices. If you have a DirectShow or QuickTime capture device installed in your computer system through FireWire, Quick Capture allows a basic interface for capturing footage. Figure 2.6 shows the simple interface to the Quick Capture Utility.

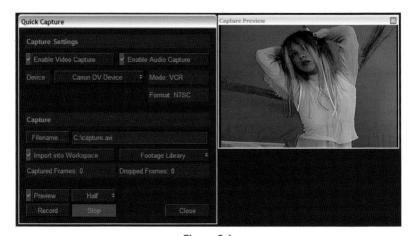

Figure 2.6

The Thumbnail Browser

There are several ways to bring footage into combustion, but the most versatile is via the Thumbnail Browser seen in Figure 2.7.

Collapse – When enabled, this feature recognizes numerically sequential files such as File000.tga, File001.tga (etc.) and treats them much in the same way as a QuickTime or AVI file by opening them as

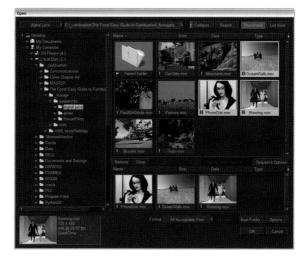

Figure 2.7

one clip. Try browsing to the \... Footage\Sequences\Globe\directory and turning collapse on and off. This will show you how numbered sequences can be treated as individual files or as one long clip.

Sequence Options – This is only pertinent for collapsed image sequences, and can only be accessed if a collapsed image sequence is selected in the lower 'loader' portion of the browser (not the main thumbnail area). This allows you, for example, to load only a portion of a collapsed series of frames.

Thumbnail vs. List View – Thumbnails can be scrubbed by dragging on the upper third of the thumbnail. Sequences are slightly faster to navigate across your network because combustion is doing less work to list text directories. The List view is a text-only account of a directory and the files within. While not as dynamic, this can often be quicker to use because thumbnails are not created.

Options – The thumbnail cache detailed here is on the hard drive and does not encroach on the memory cache of combustion. If you have the space, I recommend making the cache larger to accommodate more thumbnails.

Directories with cached thumbnails will open faster the next time you return to get footage from this location.

Working with Footage

To actually begin working on a project you need some form of image to work on. Any piece of footage in combustion can be broken down into one of three basic categories. Footage can be a solid, a still image, or a series of images that make up a sequence of video or animation.

Solids – It can be thought of as a simple card of color. A solid is a full frame of color that does not exist on the hard drive. Instead, it is created and manipulated internally by combustion. You can create a new solid in a number of ways, but the easiest is from the File > New menu.

Solids are often transparent (0% opacity) and are merely invisible 'placeholder' sources on which you might, for example, apply a paint or particle operator. In this latter case, the renderable particles are created on an invisible plate, which can be moved around independently as its own layer in a composite. All the particles applied to this solid would be visible, but the solid itself would never be seen if it is transparent.

Still Images – They are simply pictures on your hard drive such as a JPG or TGA

file. You can obtain still images from a variety of sources such as stock image libraries, scanners, and digital photography.

Sequences – It can be broken down into two forms: sequentially numbered frames, or single image files that contain multiple frames. Formats vary widely, including QuickTime MOV, Windows AVI, and numerically sequential image series such as File000.TGA, File001.TGA, etc. Combustion caches

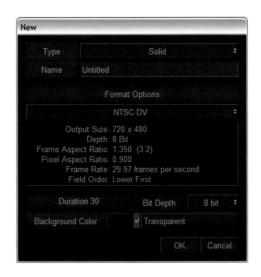

numerical-frame image sequences slightly faster than single files with multiple frames such as MOV or AVI.

Footage Controls (Source and Output Settings)

There are several factors or variables that should be considered when discussing any particular piece of footage. Characteristics such as resolution and frame rate can be found in the Footage Controls and are broken down into two categories, Source and Output.

To access the Footage Controls:

- 1 Open the Workspace named ch02_Footage.cws.
- 2 Expand the Workspace panel to expose the contents of the Footage Library. Here, you will find four clips that represent the different kinds of footage available in combustion: a solid, a still image, and one of each type of sequences (as outlined above).
- 3 Select the footage of the Sequential PNG series. Notice the naming convention of (####) within combustion for numbered frames.

Figure 2.8

Figure 2.8 shows the Footage Controls tab as it appears. Here, the Source and Output categories are now visible for that particular piece of footage.

Figure 2.9 shows the information and thumbnail that can be seen at all times when accessing the Footage Controls (whether or not you are in

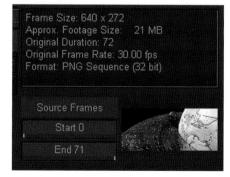

Figure 2.9

the Source or Output category). Here, you can always get basic information about your raw footage.

Footage Controls > Source

Channels & Alpha – This is where you can tell combustion to utilize an embedded alpha channel in a footage clip, if one exists.

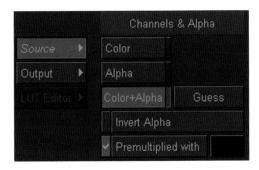

Color – Enables only the red, green, and blue (RGB) channels in the source.

Alpha – Makes the footage act as a grayscale image based on the alpha channel of the source footage.

Color + Alpha – Allows the full RGBA channels to work together to help composite your image(s) over other elements.

The checkbox for **Premultiplied with** (Premultiplied with) should only be enabled if your footage has a premultiplied alpha channel. Animation applications often render images with a premultiplied alpha channel, which can aid compositing over other images. The color switch is provided for you to tell combustion what color the footage was premultiplied with in another application. If you ever see a white or black fringe around CG footage, this is often the culprit.

The **Invert Alpha** checkbox (Invert Alpha) enables you to flip the alpha channel so that areas of transparency are now opaque and vice versa. Quite often, different graphics applications use black as opaque. Combustion allows

you to flip/negate the alpha channel at the footage level to accommodate such inconsistencies.

Field Separation – This is where you can specify field dominance, if any, that your footage contains. For example, NTSC formats are almost always lower field dominant when going to broadcast. If your footage is showing

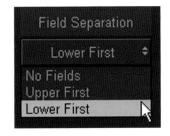

fields in the viewport, you may want to change this setting to match your incoming footage.

3:2 Pulldown – This is for changing the phase of field rendered footage that was created with the Telecine process. This is often the case when, for example, film shot at 24 fps is digitized to 30 fps on video equipment. Using 3:2 Pulldown allows you to work at the native frame rate of 24 fps.

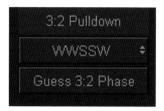

The Guess 3:2 Phase button forces combustion

to briefly analyze the footage and guess the appropriate order of interpretation.

Frame Rate (Frame Rate 29.97 (29.97 fps)) – This sets the frames per second of a particular clip. Typically, the 'From File' setting is fine, but you should check to verify this is correct if you are using sources of several different frame rates.

Pixel Aspect Ratio (Pixel Aspect Ratio 0.90 NTSC DI \sim) – This is a setting used by video equipment to allow images that contain pixels that are not square (1.0 pixel aspect). For example, an NTSC D1 clip that is 720×486 with a 0.9 pixel aspect looks correct on a video monitor that has a 4×3 image aspect ratio.

Note: You should be aware if you are mixing footage of different pixel aspects. For example, a scanned image and miniDV footage do not have a common pixel aspect ratio. You can verify your individual footage settings here.

Footage Controls > Output

Resolution This in combustion refers to the pixel dimension of an image and is always expressed in width and height. Nowhere in combustion will you see spatial measurement such as inches, centimeters, or dots per inch (DPI). Since combustion was primarily designed for film and video, the spatial measurements of this type are irrelevant. Think for a moment if you play the same DVD on a small and large screen TV sets. They are both displaying

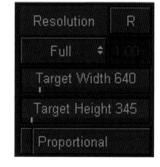

the same source image (which has the same number of pixels), but one is spatially larger as you watch it. Resolution is all about pixels in combustion.

Bit Depth – This controls the range of color available to the source footage. Here, you can also enable *Look Up Tables* (LUTs). You can typically leave this setting alone and let combustion read the bit depth from the source files.

Playback Behavior – Here, you can change how footage will act when it reaches the last frame:

Stop at End	The default. This simply plays a clip through and stops when finished.
Ping-Pong	Plays the footage forwards completely, and then plays backwards completely, and then forwards etc.
Loop	Plays the clip in its entirety and then starts back again on the first frame. This forces continuous playback in one direction.
Hold Last Frame	Plays the clip through, and then holds the last frame as a still image for a user-defined duration in frames.

Cropping – Controls the size in pixels of how each edge is trimmed. This crop can optionally be automated and/or animated. Cropping off unnecessary portions of an image at the footage level is an excellent way to save memory.

Time Stretch – Allows for a constant retiming of your sequences based on either a percentage in speed or an absolute frame count. Frame Blending can be enabled to help transition from frames, should you choose to slow footage below 100%. To pitch the timing of footage playback up and down, you must use a Timewarp operator (not edit this value at the footage level).

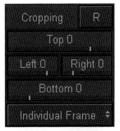

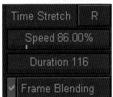

Source Frames – For still images, this is where you can control the duration of the image. For image sequences, it allows you to define

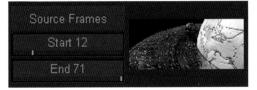

the start and end frame that combustion will use for that footage. The thumbnail updates dynamically as you change the start frame.

Working with Proxies

In addition to the Viewport Quality settings (Draft/Medium/Preview/Best), you can control the interpreted resolution of clips at the footage level using proxies. Unlike display quality, which is global to all elements, proxies are defined *per footage clip*. Proxies are merely lower resolution stand-ins for your source footage that allow better feedback and require less memory to cache. At any time, you can go to the Footage Controls for any clip and make a proxy. One example of when you might want to work with proxies is if you have extremely high-resolution footage and you're running low on system resources.

To create a proxy for a piece of footage:

- 1 Open the Workspace named ch02_SimpleCompsite.cws.
- 2 In the Workspace panel, expand the layer named *globe* with Alpha to reveal the footage node.
- 3 Select the footage that is an image sequence named globe(####).

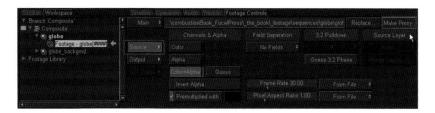

- In the Footage Controls click on the Make Proxy button visible just below the time indicator. The dialog seen in Figure 2.10 will appear.
- Select an output format, location and resolution for your proxy. There are presets available for generating half, third,

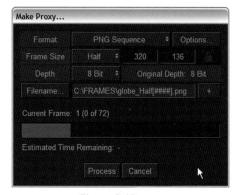

Figure 2.10

quarter, and eighth resolution proxies, or you can define your own resolution

- 6 Click process and the proxy file(s) will be rendered to your hard drive.
- To switch between
 the rendered proxy
 and the original,
 full resolution
 footage, simply
 switch the footage
 toggle from Proxy
 back to Main.

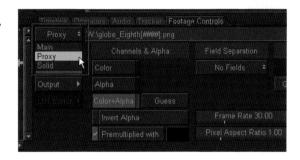

Missing Footage

Often when you move a combustion project from one computer to another, you might get the Replace Footage dialog seen in Figure 2.11. This is because the current project cannot find the source material where it 'thinks' it resides on your computer. The application will initially look for footage using the exact same path as was indicated in the original CWS file. Second, it will look recursively in directories or folders below the folder in which the CWS project file resides. This second method is how the materials for this book are arranged to help ensure no footage files will be missing when a project is opened.

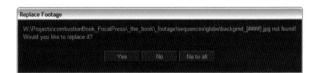

Figure 2.11

Selecting 'Yes' in the Replace Footage dialog will open the Thumbnail Browser and let you navigate to the location of the missing footage.

The Replace (footage) button in Figure 2.12 is also a quick way to swap out source footage so you can, for example, try different versions of a project.

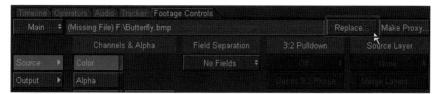

Figure 2.12

The Workspace Panel

The Workspace panel is a text-based, hierarchical listing of the entire project at hand. Figure 2.13 shows a typical Workspace panel that has been expanded. Conversely, the Schematic View, which is detailed in Chapter 5, is a graphical or flowchart representation of the entire Workspace. Changes made to one are reflected in the other and vice versa. While there are many valid arguments why folks prefer one method to the other, the Workspace panel is one place that you can access every single item in any given project, down to the very first/last brush stroke (you can optionally set the Timeline to do this as well).

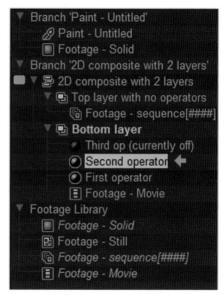

Figure 2.13

Quite often, depending on what is selected in the Workspace panel, different tools will be available in the Toolbar. This is often one of the most confusing elements to new users of combustion, but once understood, it becomes one of the most powerful features of the application. This is because you will never have to hunt down menu elements. To reiterate an important tip . . . expanding (Shift + F10) or floating (in the preferences) the Workspace panel can often be a good idea for new users, because in doing so, you will be able to see both the Workspace panel and the Toolbar simultaneously.

Selecting Items – To select anything in combustion, you click on the text name of the item, not the icon to the left of the name. Clicking on the icon will, instead, toggle the item on or off. When the icon is yellow, the item is on and when grayed, it is turned off.

Turning an item off instead of selecting it is an extremely common mistake made by many new users. Make sure you get used to making Workspace selections by clicking on the *names*. As simple as this rule is, for some strange reason the vast majority of new users want to click on the icon and not the name of the item to select it. Thus, they invariably end up hunting around looking for something that they think is selected, when in fact it is merely turned off. If there is an arrow to the *right* of an element's name, then it is selected. In Figure 2.13, the second operator is selected and the third is turned off.

Note: You cannot animate this on/off of elements in the Workspace panel. This toggle is merely there to turn off elements while you want to concentrate on specific operators, layers, paint objects, and so on.

Creating Multiple Selections – To select multiple items, you can either use a lasso method around multiple items or you can Control + click on names to allow a 'skip' in the sequence. If you hold down the Shift key, you can select the first and last items in a list and the named objects in between will be added to the selection as well. These three methods are common to many applications you may

Remember, a thin white border around a viewport identifies it as the active viewport. This TV icon will always be to the left of an item listed in the Workspace panel and it will move about depending on what you are working on at any given time. Looking for this icon should become second nature.

In Figure 2.14, the icon that looks like a TV monitor identifies what is

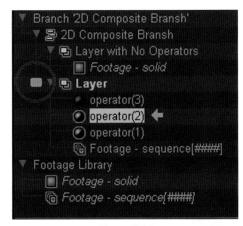

Figure 2.14

have used

being displayed in the *current* viewport at the top of the UI.

In Figure 2.15, the icon of an arrow pointing *left* identifies what is currently selected; therefore, the parameters currently being displayed in the Operator Controls area in the lower/main portion of the UI pertain to this item. When you select something, its controls appear at the bottom of the UI. This icon will also clarify things immensely.

Many items in the Workspace panel may show a small gray triangle to the left of the item's name. If the triangle is pointing right, this indicates that there is more to this element that can be exposed by clicking on this triangle. If the triangle is pointing down, that

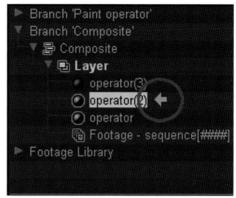

Figure 2.15

Figure 2.16

item has been fully expanded. You can see examples of both of these options in Figure 2.16.

Note: To hotkey through the Workspace panel selection, you can hold down the Control key while using the arrows on the keyboard to navigate the text. Up and down will take you higher or lower, while the right and left keys will expand or contract a group.

Items with their names in *italics* are duplicated or 'instanced' somewhere else in the Workspace. Instances are like copies, except changes made to one also happen to the other. Instancing is a great way to conserve the memory (RAM) of your computer system. When you create a duplicate in the Workspace an instance is created. Duplicates (instances) are not the same as items created by a copy/paste process, since the footage is not accessed a second time. Instancing is visualized and explained further in Chapter 5.

Renaming elements can typically be accomplished at any time by clicking on the name of a selected item and entering the new name. It can often be faster to right click on an item's name and selecting 'rename' from the drop-down menu, as seen in Figure 2.17. This action selects and renames in one process.

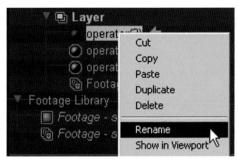

Figure 2.17

Naming and renaming items as you work is critical and can be especially helpful when learning. It will undoubtedly save you time to rename things for organization and clarity as you work. This is, perhaps, one of the biggest tips I can suggest in this entire book.

Deleting items from the Workspace can be easily accomplished by first selecting them and then tapping the delete key on the keyboard.

Warning: If you have a saved *.CWS open and delete everything in it, the project is still open, as indicated by the file name at the center of the Info Bar. The UI will be completely blank, but the project is still open. To save at this point would overwrite your current project name with an empty Workspace. As a precaution, you must either select *File > Close Workspace* or select *File > Open Workspace* to work on another saved CWS file.

Footage Library – This can be thought of as combustion's bin of raw image resources at hand. The Footage Library is always available at the bottom of the Workspace panel. Regardless of the number of branches and various operators you may use, only footage will be listed in the Footage Library.

Working with Viewports

One of the best, unsung, features of combustion is the ability to play back and utilize multiple viewports simultaneously. If you are not used to an application that can do this, it is easy to overlook or not even be aware of this ability. You can assign the output of any part of any branch in the Workspace to any

viewport at any time. Viewports are also where you can enable the Schematic View and the thumbnail-based Footage Library. Controlling the layout of the viewports, being able to identify what is happening in the viewports and knowing how to control this assignment are all vital to working in combustion.

Let's begin by opening the Workspace named ch02_Viewports.cws.

Viewport Layouts – Combustion allows up to six different viewport configurations for your projects. Try switching between them and think for a moment about some advantages that each might present. When you are done, leave the layout as the equal 'four up' () configuration seen in Figure 2.18.

Figure 2.18

Assigning Viewport Contents – If I have a single golden rule for learning combustion, it is this . . . When you are ever in doubt of what you are ever looking at or editing, stop and do these two things:

- Make any viewport the active viewport by clicking on it. The active viewport can be identified at any time by the thin white outline surrounding it.
- 2 In the Workspace panel, *double* click on the name (not the icon) of the item you wish to send to the active viewport. This can be any item including an operator, piece of footage, paint object, composite, etc.

By double clicking on an item in the Workspace panel, you quickly send the output of that node to the active viewport and you also put the controls for that item at the bottom of the combustion UI. This means you are looking at and editing the same thing at the same time. Many times people get confused at first because they are often inadvertently looking at and editing two different things. Referring back to these two steps at any time will hopefully save you hours of frustration. It is, indeed, extremely powerful to be able to look at and edit two different things at the same time, but this is, perhaps, the number one point of confusion for new users. If you get nothing else out of this book, just remember these two steps and what they do.

Tip: To cycle the active viewport, you can use the [hotkey.

Viewport Controls – These controls will always be present when working in combustion. This is where you can zoom (, , , , Home) and pan (Pan) viewports as well as switch between different viewport layouts using the drop-down menu seen in Figure 2.19. Remember, the zoom and pan icons are 'scrub' buttons. This means you can click and drag on them for interactivity of each.

Figure 2.19

The up arrow icon () is for sending the current selected item in the Workspace panel to the active viewport and the down arrow icon () puts the controls of the item in the active viewport at the bottom of the UI.

There are actually quite a few available methods of getting around and navigating within the viewports themselves.

Zooming can be accomplished by switching to the Toolbar and enabling the magnifying glass icon (). By enabling this tool, you

can interactively zoom in and out of your viewports by dragging the mouse up and down. When the magnifying glass icon is selected, you also have the Toolbar Zoom Factor options seen in Figure 2.20. The hotkey for zoom is the Z key.

The + and – icons found here will step the active viewport through the zoom levels listed in Figure 2.20. The hotkeys for these are Control + and Control –.

Figure 2.20

The Home button found here has a three-state cycle. Clicking this once will set the active viewport to 100% zoom. Clicking a second time will zoom the viewport up or down as needed to fit the entire output in the viewport.

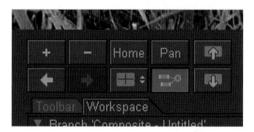

Figure 2.21

A third click will take you back to the original zoom level prior to this three-state cycle. The hotkey for this button is the = key (Figure 2.21).

The Pan button found here (Pan) and the hand icon in the Toolbar () do the same thing. Selecting either of these will allow you to drag the viewport to drag the contents in any direction. The hotkey for panning is enabled by holding down the spacebar while dragging the mouse in the viewport. (Warning – Tapping the spacebar once is a stop/start of playback for the active viewport, it does not activate the pan tool.)

Pixel Aspect Ratio – If your project uses pixels that are not square (the pixel aspect ratio is not 1.0), then you can enable the 'Use Aspect Ratio' option per viewport to display images such as D1 or anamorphic footage correctly. If footage appears squashed vertically or horizontally, you might need to enable this option from the Window menu (Figure 2.22) or by right clicking on any given viewport and selecting Use Aspect Ratio. Enabling this option will let you view non-square footage and composites correctly on your computer monitor, should you so choose.

Playback Controls – These are just like VCR buttons for the active viewport. While you can have up to four viewports showing at any given time, there will only ever be one set of Playback Controls, as seen in Figure 2.23. You can make these controls active for any given viewport by first making a view the active viewport (simply by clicking on it).

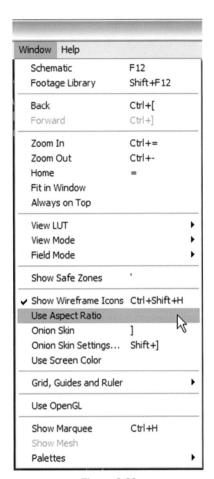

Figure 2.22

Figure 2.23

The following chart will help you navigate the Workspace using the Transport Controls. Learning these particular hotkeys can dramatically speed up your workflow when building projects.

Button	Function	Hotkey
44	Go to Start	Home
≯ I	Go to End	End
□←	Previous Keyframe	Shift + Page Up
→ □	Next Keyframe	Shift + Page Down
4	Previous Marker (selected)	Control + Shift + M
	Next Marker (selected)	Shift + M
4	Play Backwards	Shift + Spacebar or Shift + Enter
	Play Forwards	Spacebar or Enter
41	Previous Frame	Page Up
	Next Frame	Page Down
(none)	Go to Frame (floater)	/

Play Mode – To the right of the Playback Controls is a three-cycle icon that controls settings for play once (, loop play (, or ping-pong (,). For most purposes, you can leave this on loop so that the viewports will

continue playing forward or backward continuously.

Time Indicator – The field on the far *left* in Figure 2.24 reads as the *current frame*. Notice that this is a data entry field, meaning you can

Figure 2.24

use the three different methods of data entry detailed in Chapter 1 to select what frame you wish to park the playback.

There are three ways of expressing time in combustion and they can be cycled or switched on the fly. Time code, frames from zero, and frames from one are the three methods of displaying and inputting temporal values. Io cycle the method, simply click the mouse in the right time indicator. In the example below, all three total exactly 15 seconds of animation at the NTSC frame rate of 30 fps.

00;00;15;00 Time code as hours, minutes/seconds/fr	
0 to 449	Total of 450 frames (frame 0 counts as the 1st frame).
1 to 450	Total of 450 frames.

You can be working in a frame-based method of viewing time and enter an SMPTE time value and vice versa. For example, if you are working in frames, you can hit the '/' key to bring up the Go to Frame dialog and enter 3.00. This will take you to frame 90 in a 30 fps project. The period acts like a semicolon and identifies the value as SMPTE time code. 3.05 is frame 95 in this case (or 3 seconds and five frames).

Tip: To verify which of the frame-based time codes you are using, you might want to jump to the first frame (to be positive). If you know you are on the first frame and it reads zero, then you are using the second method of reading and displaying time.

The **Audio Toggle** () is to enable or disable the playback of an audio file. If you have an audio clip loaded, you can use this as a mute button.

Grids, Guides, and Rulers

Any viewport in combustion can optionally display common grids, guides, and rulers found in most paint and layout applications you may have used in the past. While not reserved exclusively for paint, it is

probably the operator that will make most use of this feature and, in fact, the snaps are only available to work performed within a paint operator. Figure 2.25 shows the flyout menu for all three of these brethren viewport drawing aides. They can be used independently or in conjunction with one another. To create a guide - first show rulers and then click and drag one out from the top or left edge of the viewport into the image. To quickly remove all these drawing aides, select Hide All from this flyout at any time.

Figure 2.25

Tip: There are several user preferences for the appearance, spacing and display of the grids, guides and rulers.

View Modes

Each of the various View modes allows different ways of looking at the image data in any particular viewport. When a viewport is set to display an image, that is, when it is not showing the Schematic or the Footage Library, you can access nine different View modes. Remember that you can make any image in any viewport use any of these View modes at any time. The specifics to each View mode will be detailed after this brief exercise.

Changing the View Modes

Open the Workspace named CH02_Viewports.cws. If this is the last project you opened, you can select Revert Workspace from the File menu.

2 Go to the Window menu and select the View mode flyout.

Tip: The hotkeys for all the View modes are visible here as well. While holding down the Control and Shift keys, you can tap across the numbers on the keyboard (not the numbered pad, but the row of numbers across the top of the keyboard). You can also access these View modes by right clicking on any viewport and selecting View modes from the flyout menu.

3 Select Transparent as the View mode type. You should notice that the composite window now shows the transparent areas as a checkerboard very similar to the way Photoshop displays transparency. Another thing to notice is that the label of the viewport now indicates the View mode

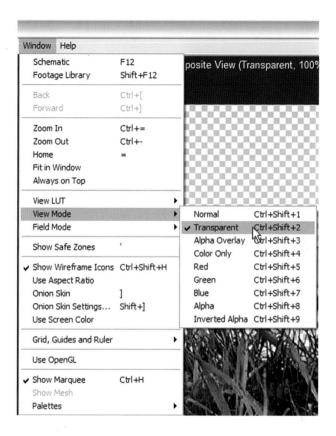

change. At any time, this is how you can easily tell how any viewport's View mode is set.

- 4 Switch to a four-up viewport layout if you have not already done so.
- 5 Using the techniques outlined above, switch the viewport layout to

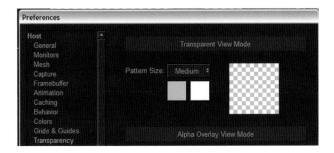

the following examples. When complete, your viewports should exactly match Figure 2.26.

- A Composite view, Normal
- B Composite view, Alpha
- C Composite view, Transparent
- D Layer view, Alpha (zoomed to fit entire image)

Figure 2.26

Below is a brief description of each View mode that you can enable at any time for any viewport.

Normal – Views the image as it will render. Normal mode takes into account and displays any footage settings for premultiplied alpha.

Transparent – Shows a checkerboard in areas that contain any partial or total transparency.

Alpha Overlay – Shows areas that contain transparency information in a color and opacity as defined by the user in the preferences menu.

Color Only – Shows pixel information without any alpha channel considerations. This will also view an image without addressing premultiplication issues at the footage level.

RGB – These three View modes all show a color channel as a grayscale version of just the specified color channel.

Alpha and Inverted Alpha – Alpha is also a grayscale image, but here, values represent transparency information in an image. White is opaque and black is totally transparent. Areas of pure black will completely allow underlying pixels through, while areas of white allow no underlying information to come through. Any gray value in between will result in a proportionate and partial transparency. Inverted Alpha is a way to look at the alpha channel reversed, but it does not actually invert or negate the effects of the alpha channel itself.

Note: These View modes are not an effect and do not change the image in any way. They are just different ways of looking at pixel information in combustion.

CHAPTER 3

PAINT AND TEXT OPERATORS

There are numerous uses for the Paint operator. Examples are hand-drawn and 'tween'-driven cartoon animation, titles and character generation, wire/rig removal, actor blemish touch-ups, laser blasts, and alpha channel touch-ups when creating a chroma key shot. Real Time Roto™ is a term Autodesk uses to describe a process that takes advantage of multiple viewports. You paint on a single frame in one viewport while another viewport is constantly caching and playing back your entire animation in real time as you work. This is an excellent way, for example, to see the progress of a wire removal shot as you work or even to have instant playback of cartoon animations as you draw and keyframe in another viewport. These are just a few uses of the Paint operator, but they collectively show how no single discipline uses paint over another. All users of combustion can find uses for the paint tools within.

Paint Preferences

Before diving into paint, an important user preference within combustion should be addressed and understood. The **Render Cache Size** setting (File > Preferences > Paint > General) assigns a specified amount of your system memory to redrawing objects created on a single frame within any Paint operator. The general suggestion is to set this value to at least double the value of your individual, uncompressed frame size. The default 4 megabytes assigned by combustion should be more than adequate for basic video work. However, if you are working on film or HD projects, the average frame can be upwards of 15 megabytes, and therefore at least 30 megabytes (or more) would be needed just for typical painting operations. If you plan on doing lots of painting, titles and otherwise heavily rely on the Paint operator, you might want to adjust this to suite your specific needs. This memory is taken off the top of your available cache, so don't overdo it by setting this unnecessarily high, either!

Applying a Paint Operator

There are several ways to access the Paint operator. You can apply it as an operator on a solid, as an operator on a piece of footage, or as an operator applied within a branch:

1 To examine the **first** way, select File > New from the menu at the top of the UI. Use the settings seen in Figure 3.1. The name of the new paint

- branch will be especially important for clarity and comparison purposes in a moment.
- After clicking OK to create the Paint branch, you will be faced with a blank, black canvas that is NTSC-DV resolution. It should be mentioned here that a black color in this case does not mean the same as transparent these are separate parameters.

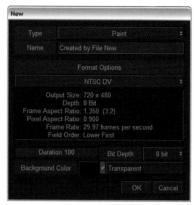

Figure 3.1

- In the Workspace panel, notice that you now have a branch containing a single Paint operator applied to one piece of footage. This footage is a solid that is created internally by combustion and does not reside on your computer's hard disk. Select this footage by clicking on its name in the Workspace panel.
- The Footage Controls tab appears. By switching back and forth between the Source and Output categories, you will notice that all the attributes of the solid footage are the same as the settings from Figure 3.1. Of particular interest is the Source > Opacity setting of 0%, as seen in Figure 3.2.

Figure 3.2

When you created the new Paint branch and enabled the 'Transparent' checkbox, this set the opacity of the footage to 0%. Creating a new Paint branch without this checkbox selected creates a solid piece of footage with the opacity value set to 100%. You can, however, at any time go to the solid footage controls and change this to any value between 0 and 100% (or even animate this value).

When a Paint operator is applied to a completely transparent solid, the color of the footage is irrelevant. You can think of this as if you were painting on a clear piece of acetate, much like a traditional cell animator. If the solid is not 100% transparent, the color of the solid will show as if you were painting on a canvas of that color and opacity. Ultimately, this only has relevance when the Paint operator is located on a layer in a composite and there are other layers behind the paint layer(s).

The **second** way a Paint operator can be created is to open a piece of footage directly into a paint operator. This allows you to open and immediately start painting on a still or moving image off the hard drive:

- 1 Leave the current project as is and select Open from the File menu at the top of the UI. You will be presented with the Thumbnail Browser.
- 2 Navigate to the Footage > Stills > Digital Juice directory on your hard drive and double click on the file named *vegetables.jpg*. The Open Footage dialog will appear as seen in Figure 3.3.

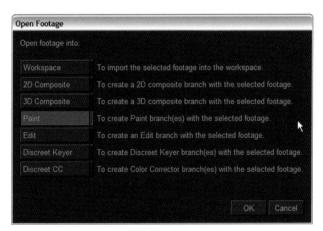

Figure 3.3

You can now open this still JPG directly into combustion with a Paint operator instantly applied. Select 'Paint' from the available choices and click OK to confirm.

You will now have two distinct branches in the Workspace panel, as seen in Figure 3.4. One is named 'Paint' and the other is named 'Paint – Created by File New'. The first branch created is a Paint operator on a transparent solid and the second one created is a Paint operator applied to an image off the hard drive. Notice the order of these branches represents their creation order, and that the new branch did not assume the name of the JPG file we opened.

Select the footage named vegetables in the Workspace panel and you will see the Footage Controls > Source and Output settings reflect the attributes of the still image (including a resolution of 1600 × 1200 pixels).

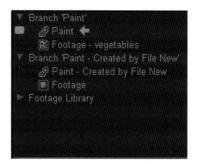

Figure 3.4

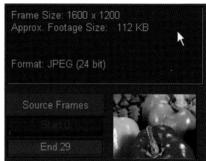

Note: The duration of the still will be that of the *Preferences > Footage > General > Default Still Image Duration*. As this is a single still image, you can edit the length to accommodate a longer or shorter duration in the *Footage Controls > Output > Source Frame > End* setting seen here.

The **third** way to apply a Paint operator is as you would any other operator in the Process Tree. That is, you can place it before or after any other operator. To see this, we will import another project into this current Workspace:

1 Go to the File menu and choose *Import Workspace*. Select the file named *ch03_ToBeImported.cws* by double clicking on it. You will now have three completely separate branches in your Workspace: one is a composite branch and two are Paint branches.

- **2** Double click on the composite in the Workspace panel. This will put the output of the composite branch in the current viewport.
- 3 Click the triangle to the left of the layer named *Train Layer* to expand it and expose the two effect operators, as seen in Figure 3.5. The single layer in this composite is the end result of two operators applied to a piece of moving footage.
- 4 Single click on the Discreet Color Corrector operator in the Workspace panel to select it.
- of the UI, select *Paint*. You should then notice that while the controls for the Color Corrector operator are still active at the bottom of the UI, you have now added a Paint operator in between it and the Ripple operator. The Workspace panel should look like Figure 3.6.

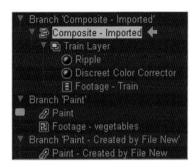

Figure 3.5

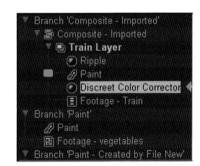

Figure 3.6

If you were to paint in this new operator, the output of the Paint operator will be fed into the Ripple operator, so the ripple will affect the elements created within Paint. To see this:

- 1 Double click on the Paint operator to put the output of this operator in the active viewport. You will notice that the ripple effect is not visible, because we are viewing a point in the Process Tree prior to the ripple effect. This can also be seen in the Workspace panel.
- **2** Go to the Toolbar of the Paint operator and select the Rectangle tool ().

- 3 In the viewport, draw several overlapping rectangles about the center of the image. Make several sizes and shapes, but do not entirely cover the whole train background image.
- 4 Go to the Workspace panel once again and double click on the composite to send the output of the entire comp to the active viewport. You will now see that the Ripple operator is affecting the rectangles you created. This is because the ripple occurs after the Paint operator in the Process Tree.

Non-destructive Paint

Nearly every piece of literature that mentions combustion says something about non-destructive vector painting – but what does that really mean? As you may have noticed, the application keeps track of every Toolbar creation in the Paint operator as an individual object in the Workspace. These objects can be brush strokes, polygon shapes, text and the like. However, unlike many paint applications that get 'flattened' or rasterized as you work, combustion preserves every element created and lets you go back and forth at any time to do things like edit the appearance and attributes of these shapes, reorder their creation order, or even toggle them on/off individually or as groups. These elements are all contained in the Paint operator and while they are non-destructive and unique, they are not actually layers such as you might find in within a composite. They are all objects within a Paint operator. Another significant feature of all paint objects created from the Toolbar is that they are all designed for animation. That is, these objects also have a duration that should be considered.

It can be mentioned briefly that the objects of the Paint and Text operators are not individually displayed in a Schematic viewport (which is detailed further in Chapter 5). You might have one Paint operator with 10,000 brush strokes and a second paint operator that is completely empty. They will look identical in the

Schematic with the exception of the thumbnail representations of their image data. Due to this, it is in the Workspace panel where you do the majority of the reordering, selecting and renaming of the potentially numerous objects created in a Paint operator. The Schematic does not 'do' very much for working in Paint, but it is extremely powerful for other things, as you will see.

The non-destructive, object-oriented workflow is the fundamental thing to remember about combustion's paint and the reason it can be considered serious competition to the likes of Photoshop. The workflow of paint objects is more akin to Adobe Illustrator, but uses paint techniques similar to Photoshop. This allows you to work without worry of error because you can go back at any time and modify or refine every single brush stroke long after it was created. To go back and edit an existing object that is already listed in the Workspace panel, it must first be selected. Take a moment to read that last sentence again, for this is consistently the number one error made by almost every new user to combustion's Paint operator.

To illustrate this briefly:

- 1 Navigate the Workspace panel to the Paint branch named *Created by File > New.*
- 2 Double click the Paint operator in this branch to send its output to the active viewport. The UI and Toolbar for this Paint operator return.
- 3 Switch to the Toolbar and select the Line tool (). Then draw several lines in the viewport. Make sure that a few of them overlap each other as seen in Figure 3.7.

Figure 3.7

4 Go to the Toolbar and switch to the Arrow (Move/Edit) tool (). Then, repeatedly click directly on the different objects in the viewport. As you select different objects, notice the bounding box that surrounds the selected object.

You can also take note that even with just a few overlapping paint objects, it can sometimes be difficult to select objects using the viewports. This is not always the case and depends on the size and shape of the objects in the viewport.

In the Workspace panel, click on the different objects named with the prefix 'Line'. This is a second way of selecting different objects created within a Paint operator. You will notice that as you pick items in the Workspace panel, the bounding box for that object in the viewport indicates that it is, in fact, selected.

Note: The order of these numbered objects is the order in which they were created. The 'oldest' is on the bottom of the list and the highest numbered line was the one most recently drawn.

Selecting objects in the viewport or the Workspace panel are both fine for many occasions, but it is here, in the Workspace panel, that you will be able to select items that might be out of frame, invisible, turned off, or otherwise difficult to select simply by clicking on the item in the viewport. Leave the final selection to the object named *Line(2)* before moving on.

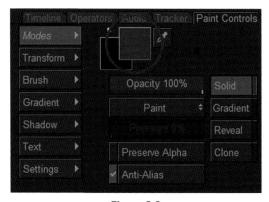

Figure 3.8

- 6 In the Paint Controls > Modes panel, click on the foreground color swatch highlighted in Figure 3.8. When the Pick Color dialog appears, select a bright blue color and click OK to exit. You will notice that the selected object turns blue.
- With this object still selected, select the thickest available round brush preset just under the right end of the Playback Controls. The selected object changes thickness. Again, we have edited an existing object by changing parameters about this object after its creation. You should get used to this ability as soon as possible, for it is the fundamental power of combustion's Paint operator.
- If you click an empty area in the viewport or Workspace panel, you will deselect all objects. At this point, changes made such as the color and brush size (to name a very few) have no effect on existing objects.

When nothing is selected in Paint, all the operator controls are still available, but changes made to attributes like color, font, modes and so on are being made pre-emptively as presets for the next object or brush stroke created. I cannot reiterate this point enough: existing objects typically need to be selected to make changes to them.

Tip: You can modify multiple objects at the same time by first selecting them all in the Workspace panel and then changing attributes like the color and brush size for all selected objects.

9 Reselect the object named *Line(2)*. In the Workspace panel, click and drag (up) on the name of the selected object. You will notice a horizontal bar appear, indicating where you can 'drop' this object in the stack of other objects. The order of these objects defaults to oldest on bottom, but you can use this method of reordering objects to make some appear under (or 'before') others. In the viewport, you will see that *Line(2)* moves closer to the 'top' visually.

Note: Depending on which objects overlap in your viewport, you may have to change the color and/or brush size of several objects to see the effects of this reordering.

10 Right click on the selected object and select Rename from the flyout. Name this object *ThickBlueLine*. You will immediately see the name change reflected in the Workspace panel. You can see that the naming of elements created in a Paint operator can quickly help you navigate through the potentially numerous objects. While I am not suggesting that every single paint stroke be renamed, it can be quite advantageous to identify key objects in your projects.

The Paint Operator Toolbar

The paint toolbar has been optimized to group-like functions into several iconic and text flyouts. When you see an icon with a very small arrow in the lower right, it means that there are several tools that can be accessed by clicking and dragging the cursor

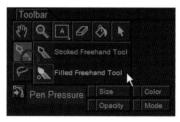

Figure 3.9

off of the icon. Figure 3.9 highlights this small flyout indicator. For example, if you click and drag on the Stroked Freehand tool icon, you can switch to the Filled Freehand Tool as seen here.

The following chart briefly explains each tool:

Grab (Pan). This is the standard viewport Pan tool found in combustion's Toolbar.

Magnify (Zoom). This is the standard Zoom tool found in combustion's Toolbar.

Compare Tool. This powerful tool lets the viewport(s) be used to asses differences between any two points (nodes) in your entire project. This is available within combustion at all times and not merely a Paint option. It is explained in great detail in Chapter 7.

Eraser. This tool is unlike many eraser tools you may have been used to from other paint applications. There are tablet pressure options for size and opacity, as well as options for painting to the background color, reverting to the image beneath the Paint operator, or painting to transparent (which is similar to creating a freehand mask).

Flood Fill. This has a tolerance and crosshair similar to a Magic Wand. Unlike many other paint applications, you are identifying the pixel to fill. If this operation is done on a clip with motion, the tolerance and crosshair may affect a different range of pixels as time progresses.

Arrow (Move/Edit). This is for picking and moving objects. It also activates the bounding box, control point and pivot point options for selected objects. Experiment directly in the viewport with the different bounding box handles and points for position, rotation, scale and pivot point.

Freehand Tools. For freeform drawing tasks. This flyout tool also offers stroked or filled versions; each with similar options for size, opacity, color and mode for graphics tablets. These tools will not have any effect, however, if a tablet is not present. There is also an option () to create shapes that are immediately created as curves that control points accessible. Control points will be detailed in a moment.

Line. This creates a straight line with a click and drag of a start and end point. The resulting objects are actually curves whose end points can be edited. You can also add additional control points by clicking directly on the line after it has been created.

Stroked Shapes. This is for creating polygon and freeform shapes that are outlined. There are options for creating rectangles, ellipses, or freeform shapes using Bezier or B-Splines as controlling guides. To close a shape, simply click back on the first control point.

Filled Shapes. These are exact copies of the Stroked Shapes and their features listed above, with the exception that a closed shape will be filled solid. It should be noted that both of these states are mere starting points and either type can be switched to the other after it has been created. The naming used for the initial type will not, however, be updated

automatically, so care should be taken to rename as needed.

Text. The Text tool has options for creating numbers or time code. Entering the Text tool evokes a plethora of additional tools relevant to creating text. These are replicated in the Text operator. The Text tool will be detailed later in this chapter. **Text Selection** is a tool with the same features as the text tool, but instead of creating ink, it isolates pixels in the shape of a text outline.

Lasso Selection. This allows you to draw a freehand selection onscreen. There is only one option associated with this tool. This is either to convert the drawn shape to a curve object upon completion of the shape, or to leave it as a freehand shape without control points. The same icon () is used to create a control-point-enabled object. Remember that existing objects created without this option can later be converted to curves from the Object menu if the objects are first selected.

Magic Wand Selection. This tool is for isolating pixels much in the same manner as other paint application's Magic Wand tool; you pick a pixel and a predefined tolerance chooses similar, surrounding pixels that are in a range of similar RGB values. The difference is that a crosshair in the viewport identifies the pixel used for the selection. Remember, this is actually an object occurring in the Workspace. This selection may change dramatically if the pixel under the crosshair changes color as the clip plays.

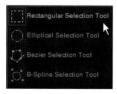

Polygon Selections. Like the Lasso and Magic Wand, these tools are for the selection and isolation of pixels. These are similar to Photoshop's 'marching ants' selections; however, these are also actual objects in the Workspace with duration. All types of selections within the Paint operator act very similarly to the Selection operators detailed in Chapter 6. Instead of isolating pixels for subsequent operators, Paint selections isolate pixels for subsequent objects created within the Paint operator.

Freehand Mask. This allows you to create a freehand vector object that affects the alpha channel of your image. That is, you create 'holes' in the alpha channel of the pixels that the Paint operator is applied to. This tool has the same option () to have the object created as curves with control points.

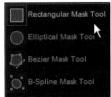

Control Point Masks. This last flyout houses several options for creating masks of various shapes using the standard polygon tools. All mask objects including the Freehand Mask detailed above can also have an opacity value, gradient, and even use the same Edge Gradient technology described in Chapter 6.

Paint Object Pivot Points

The vast majority of all paint objects have an invisible point that they use to base their transformations about. Position, rotation and scale are all performed about an object's pivot point. Open the Workspace named <code>ch03_PivotPoint_MakeCurve.cws</code>. This will be used to explain pivot points through a brief example. This is a simple paint object that has been copied and pasted several times with a rotation about an edited pivot point:

1 In the Workspace panel, select the object named Brush Stroke(10).

You will notice that in the viewport, the Transform box surrounding the selected object also gives you access to its pivot point. Figure 3.10 shows the pivot point visible and ready for editing.

- In the Transform category of the Paint Controls, scrub the rotation value back and forth. You will notice that the selected object rotates about its end point. This invisible axis is actually the location of the object's pivot point.
- 3 Click on the pivot point icon seen in the viewport. Remember, to access and edit an object's pivot points, it must first be selected. You can easily move the pivot point of the selected object by dragging it in the viewport.
- 4 In the viewport, click and drag the cursor directly on the pivot point and move it to the other end of the same flower petal. Notice the shadow effect changing due to the pivot point.

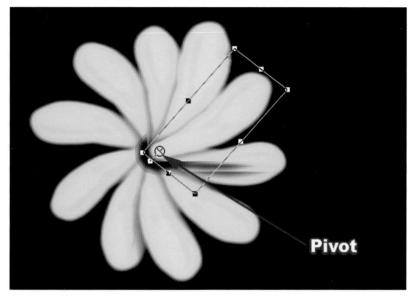

Figure 3.10

Instead of scrubbing the rotation field to rotate the object, this time grab directly on the small handle visible just off of the pivot point in the viewport. These handles offer an alternate way to rotate selected objects.

Control Points

Many tools within the Paint operator utilize control points to define their shape. Tools such as the Line, Ellipses, Rectangles, Bezier/B-Splines and letters created with the text tool all have control points you can access at any time. You might think of control points as 'sub-objects' that can, themselves, be edited, added, deleted, and even animated at will. To access the controls points of a paint object,

you must first select the object and then

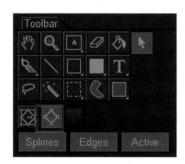

Figure 3.11

enable the icon highlighted in Figure 3.11. In the case of some freehand paint strokes and text, you may have to do one quick step if this icon is grayed out, as

it is for you currently in this example. To convert the selected object to a format that has controls points, it must be 'converted to a curve':

1 To see this workflow, verify you still have *Brush Stroke(10)* selected and go to the Object menu at the top of the UI. Select Make Curve from the pull-down menu.

Note: Objects created using pressure input from a graphics tablet will lose pressure settings when converted to spline curves with control points.

- 2 Switch back to the Toolbar, and the icon for control point access will now be enabled. Click on it. In the viewport, you will see several points appear that make up the object's stroke.
- 3 Click and drag on any of the controls points within the object.

Experiment with editing the Bezier handles and adding control points on the line. To return to editing the transformation of the object and not its control points, simply click on the Edit object icon in the Toolbar (or hit the Tab key).

Figure 3.12 shows an object that has been first made a curve, and then had its control points edited.

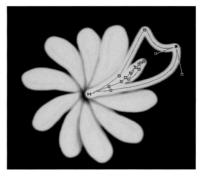

Figure 3.12

Two Types of Groups within Paint

Within the Paint operator there are two types of groups: control point groups and object groups.

Control Point Groups – It can only be created when you are at the control point editing mode of any one object. For example, you could create a rectangle and then group the two control points that make up the top segment of the rectangle. Two great features of control point groups is that they have their own pivot point

and the control points still remain independent and edit-able (by opening the group and selecting the individual control points in the Workspace panel). To see how control point groups are created:

- 1 Create a simple rectangle shape.
- 2 Tap the Tab key to exit creation mode and switch to object selection mode. The bounding box will become visible around the object.
- In the toolbar, enable the Control Point editing mode ().
 You will see the four control points that make up the shape of the rectangle become active.
- 4 Click and drag your cursor around the top two points. This will select both points using a bounding selection method. You can also select multiple points by holding down the Shift key and single clicking on them individually.
- With both top points selected, go to the Object menu and select Group (Hotkey = Control + G). You will then notice a new pivot point between these two points. Figure 3.13 shows that a group has been created in the Workspace panel. As you can see, this group is 'below' the rectangle; indicating that it is a control point group.
- With this group still selected, rotate the group and you will see these two points now share a common pivot point. This pivot point can be moved, animated or otherwise edited to help you control the overall shape of the

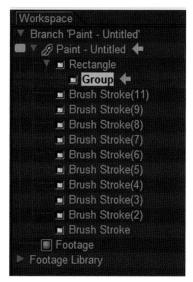

Figure 3.13

original rectangle. By switching back to the control point editing mode, you can still get down to the individual control points within this group.

Paint Object Groups – It can be created at any time while working in a Paint operator. Simply select more than one object in the operator and then select

Object > Group (Hotkey = Control + G). These groups, in turn, can have their own transformations, keyframes, and so on:

- 1 Draw three tall, filled, solid-red, paint rectangles in the viewport.
- 2 Select (just) these three objects in the Workspace panel.
- 3 In the Paint Controls >
 Transform category, scrub
 the rotation slider back and
 forth. You will notice that
 each selected object rotates
 about its pivot point.

- With the three rectangles still selected, go to the
 - Object menu and select Group. You will notice that all three rectangles now have one bounding box around them. Rotate this group and you will see that all three boxes now rotate about the group's common pivot point.
- In the Workspace panel, notice the selected object is named Group. You will also notice there is a small triangle to the left of the name. Click on this triangle to expand the group.
- **6** Select the object named Filled Rectangle(2). You can still rotate and edit the object independently of the group.
- 7 Lastly, select the Group in the Workspace panel and click a green color swatch. All three rectangles become green. This allows you to easily change the modes of many objects at once, while maintaining the ability to go into the group and edit the objects individually.

The Object menu at the top of the UI optionally allows you to ungroup selected groups. You currently cannot drag and drop objects into existing groups but you can ungroup, add the object to a multi-selection, and then regroup. Doing this, however, will cause you to lose any animation applied to the original group (though its contents will still have their own keyframes). You can alternatively

select both the group and the object you wish to add, and group these. When you group groups, they are considered nested groups. Phew . . . say that ten times fast!

Bezier and B-Splines Tools

Several tools available give you the ability to draw shapes with either Bezier or B-Spline curves. Both are ways of creating freeform shapes by defining control points (detailed in a moment). Shapes created with these tools can also be open or closed. Neither of these types of curve is 'better' or 'worse' than the other, they are merely different ways to control a complex shape via control points. Remember, you can create many, many objects that use each type of shape to achieve your ultimate goal. Many of the selections and masks seen in Chapter 6 also utilize this same technology.

Bezier – This tool shapes such as the Stroked Bezier Tool () are created by creating control points in a viewport. If you click to add a point it will be a corner edge and if you click and drag, the initial point will be a Bezier curve. To create an open shape, you draw until you want to end the creation process and then hit the TAB key to exit. To create a closed shape, you return to the first point and close the shape by clicking the last onto the first. You will not be prompted for this closure; it happens automatically. Resulting Bezier shapes always pass through all control points making up the curve. Tangent handles can optionally guide the shape into and out of each control point. The Control key can add tangency, break tangency and remove handles from each control point.

B-Splines – This tool shapes such as the Stroked B-Spline Tool () are similar to Bezier curves in that you create the shape of the curve with control points directly in the viewport, however, default B-Splines do not pass through these control points. Instead of Bezier handles, control points on a B-spline have a single 'weight' attribute that can be edited by a handle in the viewport. As they do not have as many controls as Bezier handles, it is often probable that you will need to use more control points with B-Splines. This is not a hindrance, however, as many users prefer this simplicity over B-Spline objects.

Categories of the Paint Controls

The Paint operator, like many other operators, has several sub-categories of controls. Highlights and major features of each are outlined here, but you should experiment with the Paint operator's controls in tandem with one another. Go slow at first, and then combine features from several categories.

Modes Category

Just under the two active foreground/background color swatches and the opacity setting for paint objects is a rollout menu that defaults to 'Paint' the first time you run combustion. Each vector paint object can have a unique **Transfer Mode**. These modes are Paint, Additive, Negative, Subtractive and so on. Transfer Modes are different ways to have an element blend with other elements 'behind' it. For example, Additive adds the RGB values of selected elements to those pixels below.

Warning: You should really try to get in the habit of setting this back to 'Paint' (with nothing selected) to avoid confusion the next time you return to paint. When you create shapes in certain draw modes, they can sometimes be difficult to see, depending on the image behind the object.

Say, for example, that you are painting on an image with smear and then continue to work elsewhere in your Workspace, you return to paint and forget that you were still drawing with smear. This is extremely easy to forget and often you might ask yourself, 'why aren't these new paint strokes I am making visible?!'. It might very well be because you forgot to return to the Paint draw mode prior to creating them. But wait! It's non-destructive! You do not have to delete them and start over, simply go to the Workspace panel, select the new brush strokes, and change their draw mode to Paint all at once.

Tip: Anywhere in combustion when you see pull-down menus with arrows (such as those seen for transfer modes, fonts or viewport quality), it is possible to use the scroll wheel on a mouse to roll through the choices. Simply float your cursor over the menu and roll the mouse wheel. This allows for extremely fast previews of the effects of different transfer modes on selected items.

Regardless of the Transfer mode, you can also set another important option for a paint object. Just to the right of the Transfer mode settings are options for Solid, Gradient, Reveal and Clone.

Solid	Creates paint objects with one color. This color can be overridden by Transfer mode. For example, painting with a Negative Transfer mode will always result in inverted pixels, regardless of the color of the solid 'ink'.
Gradient	Objects that are set to gradient can be edited in the Gradient category of the Paint Controls. These controls will not be available if the object is not set to Gradient here.
Reveal	This is similar to an eraser, but you have the option of painting from another source or from a different time in the current source. This tool is often used for wire/rig removal.
Clone	This allows you to sample pixels from one place and paint in another. This is similar to the Rubber Stamp tool in Photoshop, except you can additionally clone from a still, moving image, from a different frame within the current source, or even from another source entirely.

Note: The Lock button () found in the Reveal and Clone tool options lets you treat the source as a still or a sequence of frames. When enabled, the input frame number is locked and the source image will be treated as a still image, regardless of which frame you are painting. When unlocked, the source will advance a frame every time you advance a frame in the clip with the Paint operator applied. In the latter case, the frame count can be offset by the amount indicated in the Source frame field.

Selected objects can be changed from stroked to filled, as well as from a shape to mask or selection. These are tools that further make use of the non-destructive workflow in combustion.

Warning: Objects created are named according to their creation parameters. If you create a Filled Polygon and then later change it to a selection, it will still be named Filled Polygon in the Workspace panel (until you optionally rename it).

The **Color Picker** found in the Modes category of the Paint operator is a simple Eyedropper tool similar to most paint applications. This is used to sample color

from the viewport(s). You can optionally take an 'area sample' by holding down the Control key while using this tool. All the pixels sampled will be averaged and one color value will be returned as the foreground color swatch in the Modes category. You will see this icon throughout combustion and its function will remain consistent (HotKey = Y).

The Paint operator is just one place that you may come across the small set of **Store** buttons. Figure 3.14 shows the first two store bins in use, as can be seen by the small dot in the store bins. Other examples of operators with stores are the Color Corrector and the Discreet Keyer. Stores allow you to temporarily save certain groups of settings (in this case the Paint operator > Modes category). To switch between stores, you simply click on the Store buttons.

Figure 3.14

You can, for example, have a thick blue paint preset stored in 1 and a thin smear stored in 2. The hotkeys for switching through the five stores are the number keys (1–5) across the top of the keyboard. This allows you to have several paint mode types literally at your fingertips. You can easily switch back and forth from one to another very quickly, without stopping the overall workflow.

Transform Category

Transformations in Paint are measured from the upper left-hand corner of the image (0,0). You can use this dialog to precisely input data for transformations of selected objects or use the data entry fields as a slider to constrain movement on one axis. It should be mentioned that everything in Paint is limited to 2D space. You can, however, apply Paint operators to layers within 3D composites. These layers can then be translated in 3D space.

Brush Category

This is where you can control the appearance of the brushes in the Paint operator. To edit a brush for an existing object, you must first select that object. I cannot reiterate this enough. In Figure 3.15, a rectangular brush has been selected. The yellow arc is a single curved line but the repetition is due to the spacing setting in the Brush controls category.

Combustion also has the ability to create custom brushes for use within Paint. Figure 3.16 shows a bitmap with alpha loaded into the active brush set. To access custom brush tools, you must switch the highlighted rollout.

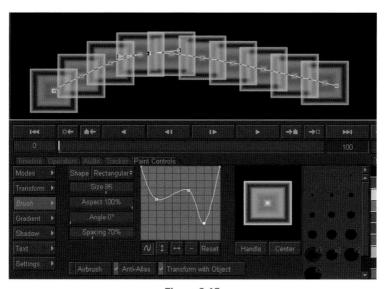

Figure 3.15

Custom brushes can be created from footage on the hard drive, a new paint branch, or a still image generated by a Particle operator. When creating a brush from a new Paint operator, the brush you are creating cannot be used within this new operator – any other brush can be used, however. This is because you are using a Paint branch to create a brush in that initial brush slot. This new brush will be saved in the brush library. It can be useful to use multiple viewports during this operation.

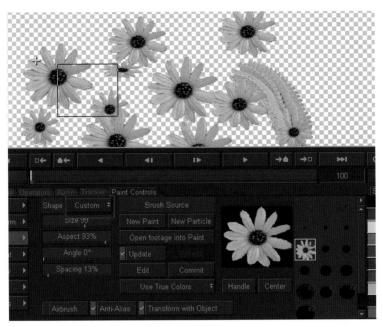

Figure 3.16

Gradient Category

The gradient editor will appear throughout combustion, not just in the Paint operator. To work with the gradient editor here, you must first make an object a gradient object in the Modes category. You can select an object, switch it to a gradient, and then come to the gradient editor to make modifications to the gradient ramp. In the case where an object was a solid color, switching it to gradient and then coming to this gradient editor will result in a solid gradient ramp (with no change across the gradient).

To add more colors to the gradient editor, click in the wide color bar to add a gradient tag. These tags can be selected and given a color using the Swatches, Mixer, Picker or Sliders to the right. There are also controls for gradient opacity. These opacity ramp color tags only use grayscale values for controlling the transparency of the above gradient. Opacity tag values are edited by right clicking on the opacity tags.

Edge Gradients options allow for paint objects to have soft edges using three different methods. To edit Spline Edge Gradients, go to the Toolbar, enable control point editing and Edges.

Figure 3.17 shows the Edit Gradient () icon highlighted in the toolbar. When enabled, you can grab the gradient end points in the viewport or drag the gradient line through an object. Like most values in combustion, this can be animated as well as the colors of the gradient, the position of the tabs, etc.

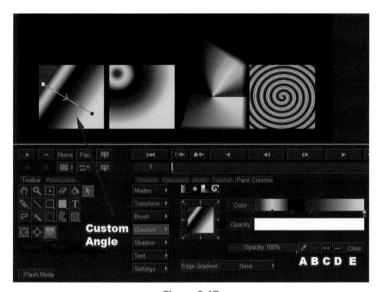

Figure 3.17

The following key identifies the gradient controls to the right in Figure 3.17:

- A Samples color from the viewport for the selected gradient tab
- B Deletes a selected gradient tab
- C Reverses the current gradient
- D Spaces all gradient tabs evenly
- E Resets the gradient editor

Shadow Category

To easily see the effects of a shadow, create several overlapping freehand brush strokes, select them all, and enable shadows from the Shadow category. In the

shadow preview window, you can click and drag to place the shadow of all the objects at once so they appear to be lit the same. These shadows, it should be pointed out, are not true, raytraced shadows like the ones possible in a 3D composite. Paint operator shadows are a 2D rendered effect similar to a Stylize > Drop Shadow operator.

Text Category

This is addressed at the end of this chapter.

Settings Category

Output Selection – This allows a Paint operator to be used exactly like several of the selection operators detailed in Chapter 6. When this is disabled, selections within the Paint operator are only relevant inside the said operator. Enabling this option tells a Paint operator to output any active selections within to the Process Tree.

Flash Output – Combustion allows for the majority of the Paint objects to be exported as an SWF format Flash file. This feature adds the ability for combustion to generate animations geared towards the web. While combustion has previously been able to render streaming (raster) QuickTime files targeted towards the Internet, you can additionally output vector files as well.

To export the SWF file, you stay in the Paint operator and, from the Settings category, select *Flash* > *Export*. This action will not only output an SWF file, but also an HTML placeholder with some statistics about the exported file (such as the file size of the SWF).

The Paint Toolbar has a button that switches the Paint operator into 'Flash Mode', as can be seen in Figure 3.18. This button disables tools within paint that are not compatible with the SWF file format. Using the Paint operator in Flash Mode assures you that the contents of the operator will appear on the web as they do within combustion's viewports.

Figure 3.18

Due to the limitations of the Flash SWF format, you may want to preview an animation within combustion as it will appear when exported to the Flash file format. From the Window menu at the top of the UI, you can select Flash View to switch the active viewport to a player that is compatible with the Macromedia Flash Player. Notice in Figure 3.19 that the viewport label reflects this temporary change. After checking this, make sure to turn this feature off so your viewports will return to normal.

Figure 3.19

Default Object Duration – In addition to painting onscreen in the viewport, every object you create in a paint operator also has a specified duration value. Remember, this is a paint tool designed for the creation and manipulation of moving images. You can, for example, create a polygon selection and paint a brush stroke and have them cover many frames instead of painting individual strokes on several frames as a traditional animator might do.

The Settings category of the Paint operator is where you can set the default object duration of your paint objects. The choices are 1 Frame, All Frames, or Current to End Frame. Remember that a paint object not only has a 'where', but also a 'when'. This is because combustion is a paint tool designed with animation in mind.

1 Frame	Object created in Paint will initially only be created on the current frame in time
All Frames	Objects created are painted on all frames
	Objects will begin on their creation frame, and remain visible until the end of the segment

Figure 3.20 shows the Timeline and the difference between the three types of default object durations. The Timeline will be explained in greater detail in Chapter 10, but it is briefly shown here to illustrate object duration. Notice the names of each object on the left and its corresponding Timeline representation on the right. The white, thin, vertical line represents the current frame.

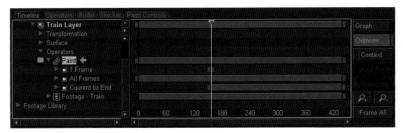

Figure 3.20

Note: The Object Duration setting is also in the Paint category of the user preferences. Here, you can tell combustion how to default each new Paint operator. Changing this setting in a Paint operator simply tells that specific operator how to create new objects. You can always change the duration after the object has been created.

If, after creating an object with a certain duration, you decide to change its in and out points, you can use the following simple solution at any time:

- 1 In the Workspace panel, select the vector objects you wish to extend or reduce in duration.
- 2 Using the Timeline indicator, go to the frame you wish the selected objects to start and hit the comma key on the keyboard. This sets the in point of all the selected objects to the current frame.
- 3 Go to the frame where you want all your selected objects to end and hit the period key on the keyboard. This sets the current selected object's out point to the current frame.

Tip: To quickly extend the duration of vector objects over all frames, first select them all and then individually tap the following four hotkeys in this order:

Home	Comma	End	Period

Figure 3.21 shows the result of selecting all three of the previous example's Paint objects and using this simple four-hotkey combination. You can see that the bar representing each object now covers all frames.

Figure 3.21

This four-key combination also works on setting the duration of a still-image piece of footage, but it does not work on multi-frame footage clips. Also, you do not need to have the Timeline showing for this to work; it is merely used here to illustrate the effects of this quick hotkey combination.

Vector Paint, Raster Output

We have seen that everything created in a Paint operator is a non-destructive, resolution-independent, vector-based object. Right, OK, got it. Yet another important aspect of the vector elements created in the operator is that they can be scaled up and down inside the operator and you will never notice the familiar 'jaggies' associated with a loss in resolution. The output of the operator, however, is raster image data. To explain this through a step-by-step example, make sure you are using Preview or Best display quality:

1 Select File > Open Workspace. If you have a Workspace open, you will be prompted to save this current project.

2 Open the Workspace named ch03_VectorRaster.cws. This will allow us to see the difference between resolution independence and the rasterization of a Paint operator.

In the Workspace panel, expand the layer by clicking on the gray triangle next to its name. Then expand the Paint operator in the same way to access the text group. Select the text by clicking once on the name, as seen in Figure 3.22. When there is an arrow to the right of the name, this indicates it has been selected.

Figure 3.22

- 4 From the Paint Controls tab, select the Transform category.
- Under the Scale transformation fields, enable Proportional (Proportional)

 Then, in either Scale field, click and drag the mouse back and forth
 - to change the size of the text object. When the Feedback button is enabled, you will notice the text get larger and smaller. Notice that no matter how large you scale the text it stays nice and crisp. This is due to the fact that all combustion Paint objects are vector based. Figure 3.23 shows the text scaled to 400%.

Figure 3.23

- 6 Click the R button next to the Scale to reset the transformation.
- 7 In the Workspace panel, select the layer by clicking once on its name.
- **8** From the Composite Controls tab, go to the Transform menu.

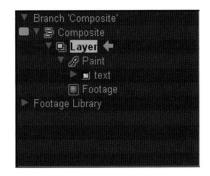

9 Enable proportional scaling and scrub either Scale slider back and forth to scale the entire layer. You should notice that when scaled down below 100%, the layer looks great; however, when scaled up beyond 100%, the dreaded jaggies begin to appear, as seen in Figure 3.24.

Figure 3.24

The previous exercise demonstrates that the contents of a Paint operator stay crisp and resolution-independent within the operator, but pixel information exiting or 'being passed along' by a Paint operator is always rasterized and therefore prone to resolution loss just like any bitmap file on the hard drive. Due to this phenomenon, you should create any Paint branches from scratch with plenty of source resolution so that you can later scale the layer up and down without concern. You should be aware of and clear on this process before you get too involved within a Paint operator.

Working with Adobe Illustrator Files

When you open an Adobe Illustrator file with the *.AI extension, combustion preserves the vector curves by creating a Paint operator on a solid piece of footage. Figure 3.25 shows the source Illustrator file open and as imported into

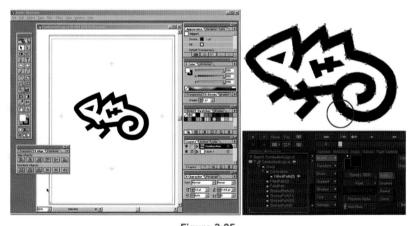

Figure 3.25

combustion. Notice how the vector objects in combustion preserve the tangency of the Bezier handles for the drawn curves. These Bezier handles can be edited and even animated.

Tip: In your vector applications such as CorelDraw, Freehand or Illustrator, you can make a larger page size and combustion interprets this as a larger solid piece of footage. Then the Paint operator contains larger vector objects without the need to scale them up in combustion.

Text and Character Generation

Text in combustion can be accessed via the Paint operator or the Text operator. The Text operator is a subset of the Paint operator; that is, anything that can be created within a Text operator can also be replicated in a Paint operator, but not vice versa

For the purposes of learning the workflow of creating and editing text within combustion, I recommend using the Text operator until you are comfortable with its use. This is to prevent any confusion as to the tools at hand. Using the Text operator instead of Paint will present only the feature set geared towards character generation and not those suited for other purposes like drawing shapes.

If you have a project being built that needs just a bit of simple text, then the Text operator uses slightly less overhead or system resources to cache than a Paint operator. This is, however, negligible, and after you are comfortable with the use and navigation around the Text operator, I might suggest using the Paint operator because of the additional options it presents.

For example, Figure 3.26 shows a simple project that could not be replicated with a Text operator alone. The blue text with black outline could be created in a Text operator, but the yellow box and red brush stroke could not, because they access paint tools that are not available in the Text operator.

Figure 3.26

The most often misunderstood aspect of the Text tool is that it essentially has two modes of use. The first is when you are treating the text as a group of vector objects and the second is when you are treating it as actual text characters. When in Text editing mode (), you will have control over changing the characters and attributes of text much as you would in a word processing application. When the Toolbar is in Text mode, all hotkeys are disabled so that you can enter characters in the text entry field. If you select the Pick tool (), the text group will still be selected, but you will be treating it as a group of vector Paint objects once again.

Figure 3.27 shows the Toolbar and controls for the Text operator. Notice the similarities to the Paint operator. You can also see here that the Text controls > Text category has four sub-categories: Basics, Attributes, Layout, and Advanced.

Figure 3.27

The following chart briefly summarizes the sub-categories of Text:

Basics	Font, Size, Leading, Kerning, Tracking and Alignment
Attributes	Solid/Gradient/Textured Face & Outline, plus Shadows
Layout	Static, Credit Rolls, and Crawls, Write On % and Margins
Advanced	Text on path or loop, plus 4 Variation settings
Number	Only available if you use the number utility in the Toolbar
Timecode	Only available if you use the time code utility in the Toolbar

To explain the Text operator further:

- 1 Open the Workspace file named ch03_TextFX.cws. This is a Text branch consisting of one Text operator applied to a white solid. Within the operator, there are two text groups. Selecting either of these groups allows you to enter text controls.
- 2 Go to the last frame of the animation. You will notice that a second line of text is visible here.
- In the Workspace list, double click on the first group, named *TextFX*. Make sure you are in the Text category of the Text Controls.
- 4 In the Advanced controls, highlighted in Figure 3.28, scrub the Timeline frame indicator back and forth; notice that these values are not animated, yet the first line of text jumps all about. These Advanced > Variation controls are a great way to make complex animation without a single keyframe.

Figure 3.28

5 In the Workspace panel, double click the second line of text named 'are groovy' and then go to the Text > Layout category. Here, the Write On parameter has been animated with only two keyframes, yet the many characters that make up this line of text all get typed on as if by a typewriter. Figure 3.29 shows this value.

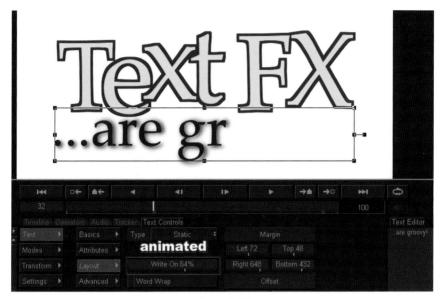

Figure 3.29

Note: To see this value change, you must manually scrub the time slider in the Playback Controls. It will not dynamically update when in normal playback mode.

- **6** Go to the last frame and go to the Text > Advanced category.
- 7 Change the Path Option type from 'None' to 'Path'. This accesses the default path that all combustion text objects have embedded and available.
- 8 Switch to the Text mode () in the Toolbar to make the text's embedded path visible.
- 9 Now, in the viewport, edit the path. You can add/delete control points, edit tangency and edit the Path Offset value now available in the Text Controls UI.
- 10 Experiment with the different text tools. Try changing the second line of text in the Text Editor window. The Write On animation duration will stay the same no matter how many characters the text has.

An important thing to remember about text is that there are two modes. The text seen in Figure 3.29 is being treated as a group of vector objects because the Pick tool () is active. Text mode () lets you edit attributes of the characters themselves.

This chapter was only a brief overview of the Paint operator. Do not be fooled by the initial 'vector-ness' of the objects created within. Transfer Modes, gradients, clone/reveal, selections and masks can work together to provide an incredibly powerful paint set that is completely removed from creating hard-edged, 'polygon' shapes. Learning to be well organized and naming the most important portions of your Workspace will help significantly, especially when dealing with all the vector objects and groups created in a Paint operator. Pretty soon, I promise you will be wondering how you painted in a raster-only environment that flattens as you go.

The word 'composite' is defined as a single structure or entity made up of distinct components. While you can certainly create projects in combustion that require the manipulation and editing of only one image, the real power of the application comes from the various methods of combining several clips and operators as layers. The old adage, 'greater than the sum of its parts' is very much the case when you speak of building composites from more than one layer.

You can think of a composite in combustion as a special operator that, instead of containing footage with effects applied, is a window that 'looks' at layers within an empty void. The size of this window is the resolution of the composite, which

can also have its own bit depth, duration, and so on. A composite with no layers will render blank images of a specified background color. Without at least one layer, a composite alone is like a blank slate.

When you create a new composite from the File menu (File > New) you are faced with the option, among other parameters, to create a 2D or 3D composite. So which do you use and how do you know when to use what?

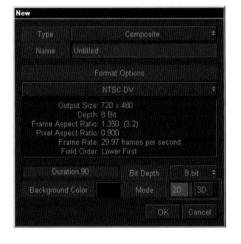

This is not a permanent decision to make or commit to. To later switch one type of composite to the other after it has been created, you access the Output category in the Composite Controls and make the switch seen in Figure 4.1.

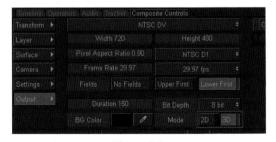

Figure 4.1

Note: A composite node can only be 2D or 3D, but you can have multiple composites of different types nested inside each other and in an unlimited number of ways.

It should also be mentioned here that instead of creating an empty (File > New) composite, you can, alternatively, select File > Open and combustion will allow you to use the Thumbnail Browser to open one or more clips all at once as layers in a new composite. The difference here is that the *first* piece of footage selected will determine the size, frame rate, bit depth, and duration of the composite created. This can be a nice little time saver if you have a 'master' clip on which you plan to build.

Null object(s) – These are an unsung hero within any composite. Null objects are invisible points in space that hold transformation information such as position, rotation, and scale. Any number of these can be created from the Object menu seen in Figure 4.2. These non-rendering helper objects can be used for a variety of things including targets for lights and cameras in a 3D composite or as parent(s) to layers in a composite.

Figure 4.2

Parenting – This is a means to make an object control the transformations of another object. These objects can be layers, lights, camera, and null objects. If an object has a parent, it will inherit the animation transformations of

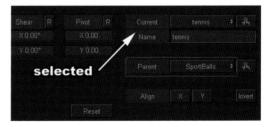

Figure 4.3

the parent without actually getting keyframed itself. Figure 4.3 shows the UI for creating parent relationships.

Tip: An old animation trick is to use invisible nulls as parents to objects. This lets you animate the nulls while leaving the child object's animation channels empty and, therefore, available for secondary animation such as random jitter created with expressions.

2D Composites

So what's the difference between 2D and 3D composites? Simply put, a 2D composite is very much like working in Photoshop; you apply effects to layers and the order in which the layers are stacked determines how they are viewed in the viewports. Like Photoshop's layers, the layers in combustion's Workspace panel are listed bottom to top; the layers at the bottom of the list can be considered at the bottom of the pile and those higher up

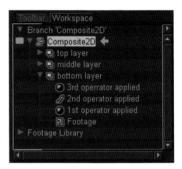

Figure 4.4

are on top of the composite. Figure 4.4 outlines the hierarchy of a simple 2D composite.

While on the topic of Photoshop, combustion even lets you bring *.PSD files into composites and keep their layers intact. In addition, Photoshop PSD layers can take advantage of transfer modes (aka 'blending modes') that are, likewise, preserved in combustion.

To see how combustion handles PSD layers, follow this simple exercise:

- Open the Workspace file named ch04_PSD_layers_BEGIN.cws. This is a simple, one-layer composite that we will use as a starting point to add PSD layers.
- **2** From the File menu, select Import Footage.

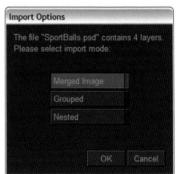

Figure 4.5

- **3** Browse to the . . . _footage\stills\DigitalJuice\directory and select the file named *SportBalls.psd*.
- 4 Upon clicking OK in the Thumbnail Browser, you will be presented with the dialog seen in Figure 4.5. These are the three options that will only be presented when importing images with layers such as PSD and RPF.

Note: Each option is explained below and it may be worth the time to try all three individually. You may either undo each operation or merely select File > Revert Workspace to start again.

Merged Image – This is exactly like a flattened image in Photoshop with one exception. A single, new layer with the PSD document name is created in the current composite. However, if you go to the Footage Controls > Source tab, you will notice a Source Layer setting currently set to Merged Layers. Disable this and you can optionally dial in which individual PSD layer you want to use. Figure 4.6 shows the difference between the two settings.

Figure 4.6

Note: The difference in frame size is due to the merged image using the resolution of the Photoshop PSD file, but any 'non-merged' layers extracted from the PSD file use the resolution of the individual PSD layers. These can, in turn, be dramatically larger or smaller than the PSD file they are contained in. Notice how the tennis ball is not cut off on the right; its entire image layer is preserved and intact.

Grouped – The layers and transfer modes are preserved in their entirety and come in as footage sources for layers in the current composite. This method makes each Photoshop layer in the PSD a layer in the current composite. Additionally, a null object with the name of the original PSD file is created. Figure 4.7 shows the resulting Workspace panel. All the new layers have a null object as their parent so that if you perform any transformations to the null, it will affect

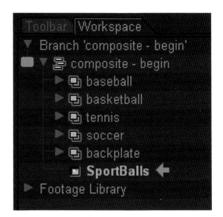

Figure 4.7

all these layers. This is a fast way, for example, to scale all the layers to fit into the viewport or animate all the layers as one, without nesting them.

Note: Nesting layers will be explained later in this chapter.

- 5 Reimport SportBalls.psd, but this time, import the PSD files as Grouped.
- 6 In the Workspace panel, select the null object and move, rotate and/or scale it. You will notice all the transformations are carried through the layers because each has this null object set as its respective parent.

Nested – This option for importing PSD layers creates a single layer that has the resolution of the original PSD document, but this layer is actually a nested composite containing all the individual layers. You can choose this option if you know you want to apply operators to all the PSD layers and treat them as one, yet preserve the layer information all within a single 'wrapper'.

Tip: When in doubt as to which of the three import options to select for PSD files, I suggest you use Grouped. This option preserves the layers and creates a null object for easy transformations. If you later want to nest them, you can select and nest the layers.

Manipulating Layers

To create a composite with layers, you can simply open up one or more footage clips into a 2D or 3D composite. When you become more comfortable with combustion, you may begin creating empty composites and then importing footage as needed, but initially, it may be easier to just open a piece of footage directly into a composite, especially if the footage is the resolution of the target composite. Remember, opening footage into a composite branch results in a composite that starts out as the same size and frame rate as the first clip opened. If, for example, you open a still, mega-pixel image from a digital camera into a composite, the resulting composite will be set to a high resolution, and for video-resolution work you would then need to change the composite to the target video resolution. Your footage and layer would remain higher resolution than the composite 'window'. They do not get scaled to fit.

Once you have footage in a composite as layers, the three primary ways to alter and manipulate these layers are Transformations, Transfer Modes, and Effect operators. You will also make use of Layer view, which is a means to set a viewport to view any one layer in its entirety.

Transformations

Transformations are possibly the most basic way to manipulate any component within combustion. Fundamentally, they are the familiar move (), rotate (), and scale () which most graphics applications use in some form or another. There are two additional transformation controls in combustion called shear () and pivot () that will be explained in a moment. Figure 4.8 shows the transformations available in a 2D composite.

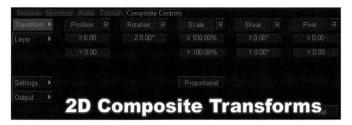

Figure 4.8

Note: Composites, unlike Paint/Text and Particle operators, use the center of the image as the origin of position (0,0). For example, in a D1 (720 \times 486) video clip, the origin is at 320 \times 243. Paint/Text and Particle operators use the upper left corner as the source of origin (0,0).

Figure 4.9 shows the transforms available in a 3D composite.

		ators Audio Tracki	Composite Contr	ols		
	, ,				Shear R	
Layer		X -358.41			X 0.00°	X 0.00
Surface		Y -36,37		Y 100.00%	Y 0.00°	
			Z.81.45°	Z 100.00%	Z 0.00°	
Settings				Proportional		
Output		3D C	ompos	ite Tr	ansfo	rms

Figure 4.9

An extremely basic, yet often overlooked, concept is the simple fact that an object or element in your project usually needs to be selected prior to making a

change in transformation. For example, to typically move something, you have to select it first. When using the Toolbar or the Composite Controls to perform simple transformations, items must be selected first and then transformations can be applied.

If you find yourself entering data in a transformation field but nothing is changing in the viewport, just remember that an item must be selected prior to applying a transformation.

Position – Controls the location of the selected objects or layer. Position is associated with the Toolbar arrow tool. Technically, there is no 'Move' tool in combustion.

Rotation – Translates the object around its pivot point (defined below). In a 2D composite or another 2D environment such as the Paint, Text or Particle

operator, you can only rotate on the Z axis. By definition, the other axes do not exist in 2D space. The Z axis used in 2D rotation could be thought of as an invisible line from you, the viewer, into the computer screen. Objects rotate around this line like spokes on a wheel. In a 3D composite, you are free to rotate objects and layers on all three (X, Y, Z) axes.

Scale – Changes the size of the selected object or layer. When the Proportional button in enabled (), all the scale values are linked.

Shear – Shear might best be thought of as a way to make your selected objects in an 'italics version' of themselves. That is, the layer object is skewed.

Pivot – The pivot point of a layer or object controls where that element will base the center of its transformations.

The following exercise has several purposes. First, you will perform a simple transformation using three different methods and second, you will use the three ways of entering values in a data field. Remember, this second procedure can be performed anywhere you see a data entry field in the UI:

- 1 Open the Workspace file named *CH04_SimpleTransformation.cws*. This is a simple, 2D composite with two layers. The background is a brick wall and the foreground layer is a metal grate that has a drop shadow operator added for effect.
- In the Workspace panel, select the layer named Grate. You will notice a yellow outline with a small crosshair in the viewport now surrounds this layer. If you select the layer named wall, you will deselect the grate and now see the yellow outline slightly beyond the frame of the composite itself (this is because the wall footage is larger than DV resolution). Make sure you return to having the grate layer selected before moving on.
- 3 In the viewport, click and drag on the grate layer. You will notice it moving wherever you drag your mouse.
- 4 In the Composite Controls, verify that you are in the Transform category.
- Here, you can use the data entry fields to control precise transformations.

 Try using these as sliders by dragging directly on them, typing in values, or by double clicking to access the calculator. You can also try out the

'R' reset buttons to reset individual transformations. The button at the bottom that is labeled 'Reset' will reset all the transformations for the selected object or layer.

Transfer Modes

Simply put, Transfer Modes are different and numerous ways of having a layer blend with the imagery behind it. A layer does not need to have an alpha channel to take advantage of Transfer Modes, and therefore these are an excellent way to get variable transparency without alpha channel creation methods such as masks, keyers, or Paint operators.

Figure 4.10 shows the Adobe Photoshop settings for Blending Modes (Photoshop calls them Blending Modes and Combustion calls them Transfer Modes).

Figure 4.10

Figure 4.11

In Figure 4.11, the layer named 'Paint – title' is selected and its Transfer Mode is set to Multiply:

- 1 Open the file named *ch04_TransferModes.cws*. This is a two-layer composite. The top layer is a still image of color bars.
- Select this layer and go to the Composite Controls > Layer category.
 This is where you can edit a layer's Transfer Mode in a 2D composite.

3 Change the top layer's Transfer Mode from Normal to Screen. The screen transfer mode makes light pixels show while making dark pixels transparent. If you have a scroll wheel on your mouse, you can float the cursor over the Transfer Mode setting and roll the wheel to cycle through the various choices. Notice that several transfer modes do not affect pure black or pure white.

Layer View

Recall that any viewport can be assigned to view the output of any operator in your composite. If you set a viewport to Layer view, you might initially get confused because a Layer view does not show transformations or transfer modes. The layer is shown flat and in its entirety. The advantage of a Layer view is that you might, for example, have various layers scaled and/or placed about in space where they are difficult to see. Layer view allows you to quickly look at a layer prior to any transformations or Transfer Mode settings.

To help explain what a Layer view is, let's examine a Workspace file:

1 Start with the file named *ch04_LayerView.cws*. This is a Workspace that contains the sport balls PSD layers imported as Grouped, but the layer named 'tennis' has been slightly scaled and rotated. In addition, its Transfer Mode has been changed to Multiply.

In Figure 4.12, the right viewport that the tennis ball is set to is Transparent View Mode, yet because the viewport is a Layer view, you do not see the scale transformation or the effects of the Multiply Transfer Mode.

Figure 4.12

- Move, rotate, and scale the tennis ball layer around in the left viewport. You will see it transforming about and the layers will show through below, but the Layer view on the right remains unchanged.
- **4** Make the right viewport the active viewport.

Effect operators are always listed in categories such as 'Keying', 'Channel', or 'Blur/Sharpen', for example. Figure 4.13 shows the Operator tab accessed. Here, you can see that the category selected is a third-party resource named

Figure 4.13

Trapcode. To the right, you can see that there are three Trapcode plugins loaded and available in combustion.

5 Double click on other layers in the Workspace panel. This will allow you to look at a Layer view for each layer, but leave the left viewport at the composite level.

Effect Operators

In addition to the spatial transformations and Transfer Modes, Effect operators are another powerful way to manipulate footage within combustion. No amount of time could possibly cover all the combinations of effects that the different operators can accomplish. The workflow of using Effect operators will be explained here, and key operators such as the Color Corrector and Keyer are detailed elsewhere in this book, but you should experiment with different operators on a familiar piece of footage to see how they alter your image.

The order of operators is especially critical in combustion, because the image data 'going out' of one operator is the input to the next in the series. The Schematic View is often the easiest way to visualize this, but it is in the Workspace panel that you can easily reorder operators by merely dragging one above or below the other with a single click and drag.

With few exceptions, third-party plugins will act and appear as part of the native combustion interface. Any third-party plugin that uses the Adobe After Effects programming guidelines typically works in combustion as an operator. Several

demo plugins are included on the combustion installation CD. In addition, most plugin manufacturers offer a demo download of their products. This allows you to test the compatibility prior to purchase.

Applying Effect Operators

Combustion allows you to import and export the settings of any operator as a (*.CBS) file. Figure 4.14 shows the buttons for importing and exporting

Figure 4.14

operator settings. These can even be animated values, but only identical operators can be imported into each other. For example, you cannot load a Box Blur setting into a Gaussian Blur operator because they are not the same function.

To apply an operator, select the item to which you want to apply the effect and then pick the operator itself. This simple rule seems to be one of the most fundamental things, yet it is very easy to mistakenly apply an operator to 'nothing'. This is especially true when you use the Operators tab panel to apply Effect operators. Remember, you should first try to get used to selecting something and then applying an operator to it.

There are four primary ways to get to the same operators in combustion. Regardless of the method you use, the operators will always be listed in categories or by vendor name in the case of most third-party plugins.

To apply any Effect operator, you first select the layer or object and then you can do one of the following:

- Access the Operator menu at the top of the UI (Figure 4.15) and select the Effect operator from the lists.
- Right click on an element in the Workspace panel and apply the Effect operator from the Operators list.
- 3 Right click on an element in the Schematic View and apply the Effect operator from the Operators list.
- 4 Access the Operators tab (F5) found next to the Timeline and Audio tabs.

Using any of these four methods will allow you to work in a manner that is efficient and best suits your particular workflow. Sometimes it literally comes down to which is the most convenient at that moment, depending on where your cursor is located onscreen.

Figure 4.15

The Merge Operator

There is a simple operator that can be useful for simple, two-layer compositing tasks. The Channel > Merge operator allows a foreground with transfer mode to be composited over a background (and that's all it does!). These two layers have no opacity setting or transformations available. The primary reason for using the Merge operator instead of a simple 2D composite is that they use less system resources and process slightly faster. While it is true that two layers might seem limiting, you can easily cascade several Merge operators to replicate the effects of a 2D composite with many layers.

Ideally, the two layers will be the same size. The Merge operator does provide several **Merge Mode** options to crop or scale one layer to the other, however. The resolution of the output of this operator largely depends on this setting as well as the pixel information going into the operator, itself. The alpha channel of both layers is, however, considered upon output of a Merge operator.

The Merge operator can be especially useful when you know you will not have to transform the layers. One common example of this is with CGI footage that is rendered as elements (specular, diffuse, lighting, etc.) or in passes (foreground, hero, midground, background, etc.). These typically all use the same camera animation and are images that simply need overlaid with a transfer mode and/or alpha channel.

Note: When you initially apply a Merge operator to an item in the Workspace, that item initially becomes the foreground layer in the Merge node; which also defaults to Normal transfer mode. These can, however, both be changed after its application by accessing the Merge Controls tab.

To briefly examine the use of the Merge operator on CG footage, perform the following brief exercise:

- 1 Open the Workspace named ch04_MergeStart.cws.
- 2 In the Workspace panel, open the Footage Library and right click on the background footage.

From the flyout, select Add operator > Channel > Merge. This will apply a Merge operator to this footage.

- 4 Double click this Merge operator in the Workspace panel. The merge controls will appear and you will see that this footage is currently set to be the foreground.
- 5 Click on the Background slot that says NONE. This will open the Pick Input dialog seen here.
- **6** Select Open Footage, navigate to the . . ._

footage\sequences\globe\directory and then select the footage

- named globe_[####].png. At the dialog for loading the image sequence, use the Load Image Sequence options and click OK to confirm. This is a 3ds max rendered globe with embedded alpha channel.
- In the Merge Controls, click the Switch input button (Switch input). When you playback the clip, you will see the simple composite of the globe over the background layer. At this point, try expanding Workspace panel and apply a (slight) blur and/or color corrector operator to the background layer.

Note: You can also apply operators downstream of this Merge operator by selecting it and then applying any operator. These will, effectively, be applied to both layers within the Merge operator. This effect is very similar to a 'nested composite', which will be detailed at the end of this chapter.

3D Compositing

Any of the aforementioned tools in a 2D composite can be used in a 3D composite, so technically speaking, you could always just work a 3D composite if you wanted to and simply not use the features unique to a 3D composite (such as Z space, lights, etc.).

You can think of 3D compositing as working in a true 3D environment similar to working in 3ds max, XSI, Maya, or Lightwave, except instead of working with 3D models, you use 2D layers in a 3D world. This is actually a great way for artists to introduce themselves with 3D space without the worry of modeling and texturing.

As well as adding a few more transformation channels, making the switch to a 3D composite changes the Composite Controls > Layer category dramatically and also adds three new Composite Controls categories: Camera, Light, and Surface. These add several additional features for compositing.

Figure 4.16 features the additional options to the Layer category in a 3D composite mode. The attributes of a 2D composite found in the Layer

category are found in the Surface category when you are in a 3D composite mode.

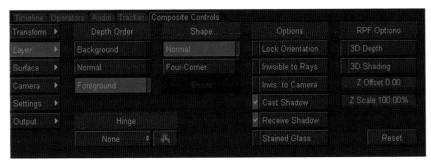

Figure 4.16

Layer > **Depth Order** – It is a layer setting in a 3D composite. This is the ultimate override to (a) stacking order in the Workspace panel and (b) positioning in Z space.

For example, if you have a two-layer composite and the first layer is on top on the Workspace panel listing, then you move the layer in Z space further from the camera and, therefore, it goes behind the second layer. If you set the depth order of this layer to Foreground, the Z depth is overridden and the layer becomes visible again, even though it is physically behind the other layer. No layer in a composite will appear in front of a layer set to Foreground. This is particularly useful in the case of complex composites where you wish to override 3D space and/or stacking order and want to ensure the layer is 'on top' no matter what.

Layer > Shape – In a 3D composite, switching the Shape from Normal to Four-Corner allows for the popular 'Four-Corner pinning' effects to be utilized. While the layer is in a Four-Corner state, you will see that each of the layer's corner points will be visible as small dots. You can select the individual corner points and distort the shape of the layer in abstract ways by dragging (or tracking) each of the corners.

Tip: Selected corners of a Four-Corner layer appear as yellow dots. To select more than one corner, you hold down the Shift key while making the additional selections.

Layer > **Options** – These allow you to set attributes of layers as follows:

Lock Orientation	This forces a layer to ignore 3D space and always face the camera and be in front of the other layers. This is useful for burning in logos on a clip.
Invisible to Rays	This makes a layer unaffected by lights.
Invisible to Camera	This makes a layer invisible, but it will still cast shadows and reflections.
Cast Shadow	Turns off the shadow casting attribute of a layer.
Receive Shadow	Turns off the reception of other shadows on a layer.
Stained Glass	This is an option to make a layer that casts colored shadows based on the colors in the layer. This can be used to create gobo effects.

Tip: The lights in combustion are additive just like in the real world. For example, if you shine a pure red, a pure green, and a pure blue spot light in the same location, the resulting/overlapping area is lit white.

Light – A light must be selected for this Composite Control category to appear. There is one white point light by default and a 20% ambient white light value. You can add any number of lights from the Object menu at the top of the screen. This Light category allows you to edit selected lights, change their type, color, set targets, etc.

Distant	These lights are considered infinitely far from the objects.
Point	Casts light in all directions from a single point in 3D space.
Spot	Casts light in a defined cone and direction. This cone can have a user-defined angle and soft edge that gradates from full intensity to no illumination (outside the cone).

Note: The effects of lights will not be seen without enabling Composite Controls > Settings > Shading and/or Shadows.

Camera – A 3D composite can only have one camera. This category allows you to choose from stock lenses, edit the field of view/focal length and can

optionally get its transformation information from an RPF rendered sequence (generated in an application such as 3ds max).

Tip: To animate a camera cut effect, you must animate the camera with a jump in position from one frame to the next (possibly in conjunction with an interpolation type of Constant in the Timeline to assist this hard jump). Also, remember that cameras can be parented or targeted to any other object or null in the composite.

Surface – This is where you can set layer opacity, reflectivity (how much it will behave like a mirror when composite reflections are enabled) and the front/back visibility of a layer. Remember, in a 3D composite, layer Transfer Mode, Opacity, and Stencil options get 'moved' here.

To examine some of the attributes of a 3D composite:

- 1 Start by opening the Workspace file named *ch04_CameraPan.cws*. This is a 3D composite made up of 2D stills in 3D space.
- 2 Cache the left viewport in medium or draft display quality. The only thing animated in this Workspace is the Camera, yet notice how the layers seem to move at different speeds. This is actually caused by an effect known as parallax. The camera is moving and because of the separation of the layers in the Z position, they appear to move by the camera at different rates.
- 3 Stop the playback and manually scrub the time slider. Notice that now in the right viewport you can see the camera moving. To see the yellow field of view as in Figure 4.17, the camera must be selected. Elements that do not render such as wireframes do not play back in caching views and often it is advantageous to scrub the Play back Controls manually. This is especially true if you have multiple viewports open.
- 4 Set the current time to frame 100 by hitting the/key and entering 100 in the Go to Time dialog.
- 5 Pick the different layers in the left (Camera) view. Notice that they are slightly more difficult to pick in a 3D space. The more layers you have,

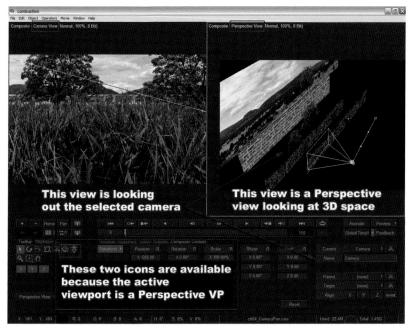

Figure 4.17

the easier it is to pick layers by name in the Workspace panel or the dialog seen in Figure 4.18.

6 Select the layer named BrickWall and rotate it using the Transform controls. Notice that if you rotate it on its Y axis, it passes through other layers in true 3D space. Also notice that Feedback is only active

Figure 4.18

within the selected viewport. Only when you release the mouse do the other viewports update. This is yet another example of why you should know which viewport is the active viewport.

7 Switch to the Composite Controls > Setting category and enable the Render Effects named Shading and Shadows.

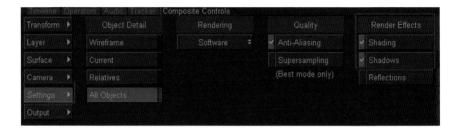

- 8 In the Workspace panel, select the light named 'Light'.
- 9 In the Composite Controls, go to the Transform category and scrub the Position X, Y, and Z sliders to see the effects of moving the light in 3D space. Those are true, raytraced shadows you are manipulating, unlike the Drop Shadow operator or shadows effects in Paint and Text operators, which are a nice and simple 2D cheat for shadow effects.
- 10 Activate the right viewport and switch to the Toolbar.
- Rotate tool () icon. By clicking and dragging directly on this icon, you do not even need to move into the viewport to make changes. You will orbit the viewport and 'look around' your 3D space. Clicking and dragging directly on the Perspective Zoom tool () takes you into and out of a perspective viewport in a

similar manner.

Tip: When dealing with 3D space, it can be an extremely good idea to keep track of things in multiple views, and not concentrate too hard on how just one view looks. Manipulating elements in 3D space, especially if you make transformations directly in a Perspective viewport, often confuses new users. One common solution is to do a transformation in one viewport while watching the other viewports to see the results.

Practice with multiple viewport layouts. Try setting some viewports to look at footage, others to operators, yet others to different views of your 3D composite windows (that is, top, front, left, right, and perspective).

Additional Notes about 3D Composites

3D space can get confusing at first, especially if you are used to a 2D system like Photoshop. You have been living in 3D space your entire life, however, so all of us are 3D artists at heart! Keep simple spatial rules of perspective such as parallax in mind. For example, things farther away seem smaller in scale than identical items close up.

Try using null objects and layers as targets of spotlights and cameras. This allows you to easily aim them. The lights or camera can stay in one place, but automatically rotate to aim at (the pivot point of) a moving target.

Several composites have been provided for you to examine, and I encourage you to really abuse them. Experiment in 3D space with layers, lights, shadows, reflections, cameras, layer transformations, and targeting . . . and animation! The Workspace named *ch04_Nulls.cws* has been set up for your examination and experimentation.

. . . and Finally, Nested Composites

The idea is both simple in concept and complex because of the endless possibilities it opens up. Basically nested composites are a way to treat several layers as one. You can think of it like grouping layers. For example, if you have two layers that you want to apply a ripple to, you could apply two ripples, or nest them and apply one ripple operator to the nest.

Note: In After Effects, nested composites are called 'pre-comps'. You may already be familiar with this workflow.

Simply put, a nested composite is a way to treat a composite as a layer inside another composite. Put yet another way, let's say you have a composite made up of layers A and B, and you nest them. These nested layers are now a composite

that we will call AB. You might also have a second composite in your Workspace that has two layers; the first is called C and the second is the AB nested composite you created earlier. Figure 4.19 shows this scenario and you can also open the file named ch04_NestedABC.cws to examine this simple setup.

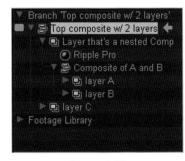

Figure 4.19

There are two composites in the Workspace, but one of them is actually a layer in the

second. Due to the non-destructive way combustion works, you can go back anywhere along the way and make changes that are reflected downstream within the image data Process Tree. Notice in Figure 4.20 that the effects of the Ripple

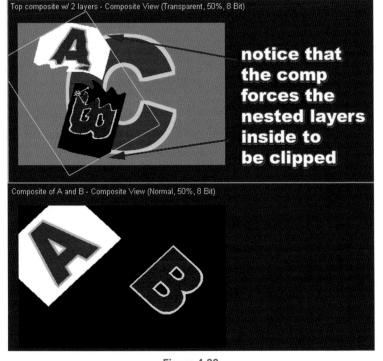

Figure 4.20

Pro operator get applied to both the A and B layers, because it is actually applied to a nested composite. Also take note of both viewport labels, which identify each as a separate composite.

Tip: The option to 'Resize Image' found here will be seen throughout combustion. This typically gives you the option to extend an operators effect beyond the resolution of the image it is applied to. For example, a Gaussian Blur that goes beyond the edges of the frame.

To create a nested composite, we will perform the same simple action:

- 1 Open the file named *ch04_Ready2Nest.cws*. This is an unnested version of the above example. There are two branches that are completely disjointed in the Workspace.
- **2** Expand and examine the Workspace panel. You should see that there are two branches and the familiar footage library.

Notice that *Composite AB* has two layers and *Composite C* has only one layer. The next few steps will introduce a new way to use the Workspace panel to add a layer in a composite (C). In this particular case, this new layer will be another composite, but you can use this technique to add layers from other operators in your Workspace.

Note: This function can also be performed in the Schematic View with great ease and visual aid.

- 3 Select the composite named Composite C.
- 4 Right click on it and select *New Layer From Operator* . . . from the flyout menu seen here.
- From the Operator Picker dialog that appears, double click on the composite operator named Composite AB. This double click makes the selection and also confirms the choice. When the dialog disappears, notice that you now only have one branch in the Workspace. This has two layers, one of which is the composite you picked. You may have to double click the top level to see the viewport seen in Figure 4.21.

You can also create a nest of layers at any time by simply selecting the layers you wish to nest and selecting Nesting from the Object menu.

You can additionally right click on the selected layers and choose Nesting, or simply hit Control + E to evoke the Nesting Options dialog.

Starting with 2D composites and then migrating to the additional features of 3D composites allows you to learn features 'as they come'. This is, however, not to say that 3D composites are for more 'advanced' users; they merely add features that may

Figure 4.21

prove useful for a particular task. Learning in 2D and moving to 3D may help in the initial phases of getting up to speed in combustion. Keep in mind that you can use both 2D and 3D composites throughout combustion at any time, and change them on the fly. The Merge operator is also available for simple 'A over B' comps.

The Schematic View is similar to the Workspace panel in that it is basically a look at the entire Workspace (project) at hand. The most obvious difference is that instead of being a text-only listing and organizational layout, the Schematic is an iconic or 'node-based' system that shows the flow of image data.

The Schematic shows the sequence of events of footage and operators as nodes connected by arrows which indicate flow direction. Once again, this flow of data is known as the Process Tree. The Schematic is one place where this name begins to visually make some sense (branches, trees, etc.). It should be mentioned that this Process Tree is not 'object oriented'. For example, you do not see lights and cameras of a 3D composite in the Schematic View. This all really starts to make sense when you visualize the representation of the branches in your entire project in a Schematic View. Here, you can not only visualize your Workspace, you can also manually 'wire' nodes together to organize (rewire) the order of this pixel information.

Outlined below are various methods of working in the Schematic, as well as a few of the not-so-obvious points about it. I actually think the best way to learn the Schematic is by opening projects you are familiar with and looking at how they were put together. Likewise, when I am asked to examine any *.CWS file, this is the first place I look because it is an immediate roadmap to the bulk of the project.

Accessing the Schematic View

- 1 Let's begin by opening the Workspace project ch04_Ready2Nest.cws.
- 2 This next step is a four-hotkey process. You will switch the active viewport to the Schematic, clean up the layout of the Schematic and fit the contents to the window. Carefully hit the following keyboard shortcuts individually and in this order:

The first hotkey switches you to a Schematic View. To toggle the active viewport to/from a Schematic View, you can interchangeably use any of the

three methods listed here:

The remaining three hotkeys represent a hotkey combination that should be learned as soon as possible:

This cleans up the layout of the Schematic so that nodes are not overlapping one another, and immediately fits the entire contents of the viewport to the view. This is not just for when you start the Schematic; you can do this at any time. During the next few paragraphs, you may find it useful to experiment and then clean up the Schematic contents before moving on using this quick, three-hotkey series. You can optionally turn on Auto Layout in the user preferences.

3 Try the Zoom and Pan tools in the Schematic View. All the icons and hotkeys for zooming and panning work for navigation within the Schematic as well. Always remember that a Schematic View is (also) just another viewport. It can be cached like any other viewport, but this can greatly affect the overall performance of combustion.

Please refer to Figure 5.1 or your current UI for the following brief descriptions of this simple Schematic.

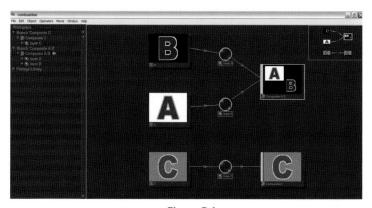

Figure 5.1

The branch with 'C' has been moved to the bottom during this 'clean-up' procedure. This has no relevance in the Schematic, as these two branches are currently completely disjointed. The position of the layer nodes in the Schematic has no relevance to the layer order or depth in Z space.

In the upper right corner of the Schematic is the Display Overview. This is a small representation of the entire Workspace and is similar to the navigator found in other applications you may have used. A small rectangle representing the Schematic will be visible in the navigator; you can drag this around to control the panning of the Schematic. This can help you pilot around the Schematic if you happen to be zoomed in on one portion. Remember, the Schematic is just like any other viewport, and the icons and hotkeys for zooming and panning work just like any other view.

In this example, there are two disjointed branches in the Workspace that are both composites. One branch (C) is a composite with one layer; this layer is the end result of one piece of footage and it has no operators applied. There is another branch made up of a two-layer composite (AB). Likewise, these layers are made up of footage without any operators applied. In the composite named AB, you can see that the layers have both been scaled down and they are both slightly offset so both are visible and not overlapping.

The round nodes without any thumbnails are the layers themselves. The round nodes represent what get transformations and have transfer modes, among other things. To see how this functions:

- 4 In the Workspace panel, select the item named Layer A by single clicking on it. In the Schematic View, notice that the round node to the right of the footage A gets highlighted, indicating it is selected.
- With Layer A selected, access the Composite Controls > Transform category and change the rotation value for this layer to 45 degrees. Remember, what you are rotating is the layer, since it is selected. This layer is represented by the round node, but there is no visible translation occurring to the node. That is, in the Schematic the node looks the same, yet the thumbnail of the resulting composite shows that the Layer A has been rotated.

All the nodes with thumbnails represent the end result of the output of each node. The thin arrows going from one node to another indicate the flow of pixel information. Some nodes have a red stripe down one side and white stripe down the other side. The red stripe represents the output of a node

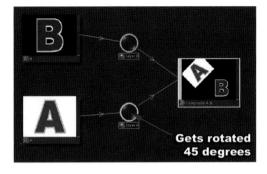

and the white represents the input. Round nodes always represent composite layers while square nodes represent the segment input(s) to an Edit operator, which is detailed further in Chapter 11.

To change the input of a layer, carefully click and drag on the red bar to the right of the footage named B. Continue to drag the output of the Footage B and connect it to the round node that is named Layer A. You should end up with a Schematic that resembles Figure 5.2.

Figure 5.2

A few observations: notice that the output of A has been removed and

now the footage named B is going out to two layers. One of the layers has previously been rotated 45 degrees, and whatever comes into this layer node, therefore, is seen rotated. Again, this is because what was rotated was not the footage, but the *layer*, which is represented by the round node. Layer nodes can only *ever* have one input, but this can come from the output of just about any kind of other node except another round layer node.

7 Before moving on, put this back to the starting point by either reverting the Workspace from the File menu, performing undo(s), or simply by

putting the output of footage A back into the node named Layer A with a second click and drag wiring.

Using the Schematic, we will now recreate a step from the last chapter. We will create a single, new layer in composite C, which is a nested composite that contains both A and B

8 In the Schematic, wire the output of the composite named AB to the input of the composite named composite C. Do this by taking the red output of the composite AB into the white stripe input of composite C. Figure 5.3 shows this procedure in mid-stage.

Figure 5.3

Just before you complete this task, you will be presented with a small pop-up window that indicates you need to make a new layer with this method. Depending on the layout of the current Schematic, this dialog can be difficult to see, as shown in Figure 5.3. When you complete this connection, you will have created a nested composite exactly the same way you did at the end of the previous chapter. Leave this project open at this point before moving on. A cleaned-up, resulting Schematic can be seen here (Figure 5.4).

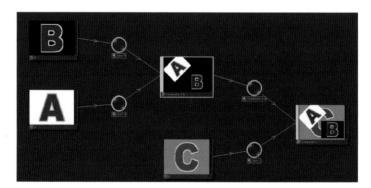

Figure 5.4

Note: Using this procedure, it is a common occurrence to end up with a layer named 'layer'. Like elsewhere in combustion, you can right click on an item and select rename elements at any time. If this occurs, it is a *really* good idea to immediately rename this layer to something more appropriate. You will rarely, if ever, want a layer simply named 'layer'. This is much too vague if you have a complex Workspace.

Tip: When you are still learning, it is also a good idea to name the round nodes something like 'layer person' or 'layer background'. This will help identify elements over in the Workspace panel. It is often ideal to enter the Schematic just to rename lots of things, because it can often be clearer as to what is a footage, operator, (composite) layer, (edit) segment or composite.

Applying Operators

To apply operators, you can simply select a node in the Process Tree and then apply the new operator to it. New operators typically get applied downstream of the selected node. However, if you apply an operator to a round node, the node will end up (remain) at the end of that chain and the new operator gets applied the same as if you applied it to the last/previous operator in the chain.

- 1 Select the round, layer node named composite AB by clicking directly on the node in the Schematic view.
- Right click on the node and, from the flyout, select Operators > Blur/ Sharpen > Box Blur. This will apply a single operator to the nested composite.
- In the Box Blur Controls dialog now visible at the bottom of the UI, increase the value to 30. This will blur the nested composite as seen in the thumbnail of the composite C.
- 4 Clean up the Schematic by tapping L== . You can see that the operator was added to the composite AB yet remains prior to the round layer node in composite C.

Switching the order of two operators can be accomplished by one click/drag in the Workspace panel, but in the Schematic you must either rewire several in and out links or you can use a cut/paste procedure on operators. However, it depends on which works best for any given moment in a project; they all have advantages.

Try using a simple Workspace such as this to apply, reorder, rewire and rename operators using the various means available in the Workspace panel and Schematic View.

Notes on Nodes

Any node or icon in the Schematic View represents a point in the flow of pixel/image information. At each of these stops, something typically happens to the image information and then gets passed along.

Again, most operator nodes have a white and red stripe down their sides. Red represents the output of data and the white stripe represents the primary input to a node.

Footage – It can only have output and never has an input. Footage, however, can have several outputs off the same node. This creates duplicates, which will be detailed in a moment.

Operators – This such as Paint, Gaussian Blur (and the like) have both inputs and outputs. Effects operators are applied in a series, where one is applied, does its effect and then passes the outgoing pixel information to the next operator for it to do its effect. The order of operators can easily be seen here

and in the Workspace panel. The outputs of an operator can also be duplicated; or have multiple outputs. Many operators may also have what is called a **secondary input**, which is signified by a **light blue input**. A secondary input is used for special case operators when they need additional information for some effect. Figure 5.5 shows a Paint

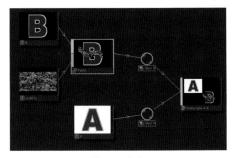

Figure 5.5

operator applied to *Layer B*. You can also see that the plant footage is coming in as a secondary input to this operator.

Notice that the Paint operator actually has two input bars, one white and one blue. The white input is always the primary input and the blue the secondary input. Most operators do not have a secondary input, but depending on their function, others may. The secondary inputs in the Schematic are (secondary) images being used by that operator in some fashion. In this example, it happens to be a Clone source for a paintbrush in the Paint operator. You would not be able to find this information in the Schematic View, however. A Paint operator, for example, often has several secondary inputs because of the numerous things that can be done in a single paint operator.

Layers – It will be represented as round nodes, not as thumbnails. This is helpful to differentiate them from other nodes in the Workspace. Layer nodes can only ever have one input. In a composite, these nodes hold information pertaining to the layer such as transformations and Transfer Mode information (i.e. Normal, Additive, Hard Light, etc.), among others.

Composites and Edit Operators – These can only ever have round nodes coming into them, nothing else. Layers in composites and segments in an Edit operator are both represented by a round node, but the icon next to the element's name in each case differs accordingly. These round nodes are vastly different to thumbnails of all other elements in a Schematic View, even if zoomed extremely far out. This makes them easy to identify and locate. Both Composite and Edit operators can have an output and do not always have to be the 'end of the line'. When a composite's output is the input to anything else, this is considered a nested composite.

Further Points on Schematic View

To wire and break connections, you merely drag from the output (red line) of one node to the input (white line) of another. The flow can be broken by clicking on a wire and dragging it outside of any node, thus breaking the connection with a quick flick of the wrist.

When you select a node with one click you are selecting it to either move it in the schematic view or apply an operator. The control panel at the bottom of the UI does not change to the control panel relevant to the selected node. If you want to access any given node's controls, you need to double click that node and then it will not only be selected, but also the control panel changes to the relevant node.

Working on the first frame of a project while in the Schematic can often be a really good habit to get into. This is primarily true if you are creating or rewiring layers; if you are not on the first frame, you will be creating layers at the new location in time. This is a powerful feature, but it often confuses new users who are not aware they are working in time on a different frame. Always be aware of what frame you are working on. I cannot emphasize this point enough.

With the exception of an edit or composite, a Schematic View does not show the contents of operators, only the flow of data coming into or out of them. Therefore, operators with lots of objects are seen as a thumbnail representation of their end results. Examples of operators that can potentially have many objects within them include Paint, Text, Particles, Masks and Selections. These are the operators that might need examination using the Workspace panel.

A Schematic does not show any information about keyframes or animation. It is a Process Tree. Only the updating thumbnails can indicate any change of pixel information.

Scrubbing icons can be useful in the Schematic if you wish to see what images look like at various stages of the Process Tree. You can hold your cursor on the upper third of the thumbnail and it will change to a left/right arrow indicating a jog/shuttle wheel format.

Schematic Hotkeys

A few more hotkeys that are extremely usefully for speedy workflow in the Schematic are listed below. The majority of these tools can be accessed from the right click menu in the Schematic, if you do not want to use hotkeys:

L	Cleans up the ${\bf L}$ ayout of the Schematic. Overlapping nodes will be made clearly visible.
=	The same as the Home icon. This is a three-cycle hotkey for zooming viewports.
Control + A	Selects A II the nodes in the Workspace.
Control + D	Deselects everything.
Control + click node	Adds to the current selection.
Shift + click node	Selects node and all those UPstream.
Alt + Shift + click node	Selects node and all those DOWNstream.
G/U	G roup and U ngroup selected nodes. This is useful to clean up an area that you may be done working on and want to hide from the rest of the Schematic. You can select several nodes and tap the G key to make them all be represented by one node. This does nothing for hierarchies in the Workspace; it is purely cosmetic for Schematic purposes only.
Т	Toggles all the <i>selected</i> node's T humbnail icons on and off. While learning, it is a good idea to leave thumbnails on to help analyze things in the Schematic.
Shift + keyboard arrow keys	Cycles between the four available flow directions. By default, the arrows keys the Schematic reads left to right – you can, however, change this to suit your needs. Some Schematics fit differently (read: better) using different flow directions. Some 'want' to be wide and others are easier to read tall.

Duplicating (aka Creating Instances)

The concept of instancing is not something that is specific to the Schematic, or even to combustion. Like several other functions in combustion, it is often easier to visualize this process because of the diagrammatic nature of the Schematic View. When you duplicate something in combustion, it creates a special copy that has a connection to the original and vice versa. Changes made to one also occur to the other. This is because there is only one source used in several places. This can be a considerable time saver and also a great way to save precious cache resources. Let's look at an example of this workflow.

- 1 Start by opening the workspace named ch05_DuplicateSTART.cws.
- In the Workspace panel, select the layer named businessMan and copy it (Control + C). For this step, do not use the Schematic.

Note: Doing this in the Workspace panel copies the entire branch below this point, which is what we want. Copying in the Schematic only copies the selected nodes.

3 Now paste it (Control + V) two times and then offset the two new layers in the X position by using the Transform category of the Composite Controls. You should end up with something like Figure 5.6.

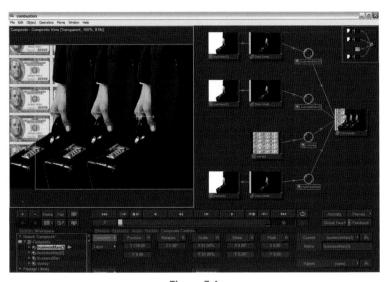

Figure 5.6

Notice that there are now four layers in the current composite and three of them are derived from copies of the same two operators. There are a total of seven operators needed to complete the composite, and caching one frame of these at Preview display quality takes about 15 megabytes.

of the bottom Draw mask operator's thumbnail and link it to one of the other copies layer nodes. This will bypass the two nodes that currently make up that layer. If you do this twice, you can end up with something similar to Figure 5.7.

Notice in this figure that the four nodes in the upper left are no longer needed in our composite.

Select and delete these four unnecessary nodes by clicking on them all and tapping the delete key on the keyboard.

After tapping the L key to clean up the layout, Figure 5.8 shows the resulting Schematic layout for the current

Workspace. The resulting

Schematic has the same visual end result as before but it only takes around 8 megabytes to cache one frame. This is because there are only three

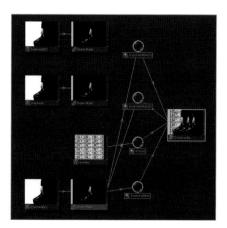

Figure 5.7

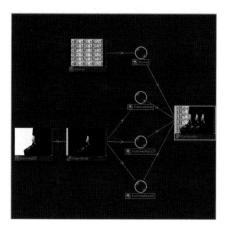

Figure 5.8

nodes and one footage operator to cache. You can see how instances can be a fantastic way to optimize the use of system resources, especially precious RAM.

Note: If, in step 2, you used 'duplicate' (Control + Alt + D) instead of copy/paste, you would have initially created duplicate instances resulting Workspace like the one seen here.

6 If you apply operators to the layers at this point, the new operators will be applied after the instance point but be placed before the layer node. This allows you to have instances at one point and then break off individual branch elements to perform unique operations from that point on.

Figure 5.9 shows an example where three separate color correction operators have been applied to the layers. As you can see, their unique settings result in each layer being colored differently, yet as the Schematic shows, changes made to the raw footage or the Mask operator will affect all of the branches downstream from the point it was instanced.

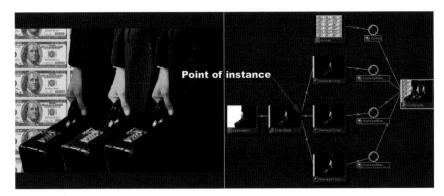

Figure 5.9

Remember, items in the Workspace panel and Timeline that are labeled in italics are duplicates (instanced) in combustion. The Schematic is often the best place to find out where these duplicates occur. Anywhere a node has multiple outputs, it has been instanced somewhere in the Workspace. You could, for example, have one branch being used in many different composites.

Go back and edit the Mask operator applied at the beginning to the single source footage clip. You will notice that the changes are reflected downstream to all three of the colored layers. This shows how an instanced operator can save you valuable time while building a project.

Capsules

Users of any software often develop their favorite techniques to achieve a certain effect. To create an old-time sepia look, for example, you might always use a Glow, Color Corrector and Film Grain operator (each with its own settings) applied in a specific order to a piece of footage. It would seem useful, then, to be able to save these setups for the "looks" you like to reuse at a later time. In a nutshell, Capsules are a way to bundle several operators and their settings into one super-operator. These custom capsules can be saved to the hard drive and re-used at a later time . . . or even traded with your online buddies like baseball cards or action figures!

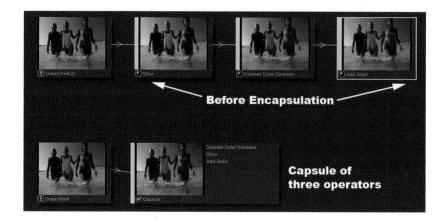

To create, save, and re-use a custom capsule:

- In the Schematic view, select (preferably) more than one operator applied to a single piece of footage. Technically, you can encapsulate a single operator if you like, but there is no particular reason to do this when initially learning combustion.
- 2 Right click on any of the selected operators and select Encapsulate from the flyout. At this point the capsule has been created, as can be seen in both the Workspace panel and the Schematic view.

Note: the limitation of creating a capsule is that the selected operators need to have at least one input and no more than one output. It should also be mentioned that a node with a secondary input is considered an output. Operator nodes that are not directly in a series, as well as group nodes, cannot be encapsulated.

Note: Capsules retain and embed all the controls for the parameters of the operators within the capsule. Likewise, they retain the original schematic of the operators as a pseudo-secondary schematic that you can enter. To go into a capsule's own schematic, right click on the capsule and select Edit Capsule. To exit this new, secondary schematic, double click on either the input or output nodes available at the extremes.

3 To save a custom user capsule, right click on an existing capsule and select Save Capsule from the flyout. These files created here are saved to your hard drive or network as *.CCW files.

Applying an already-saved capsule to items in your workspace is very much like applying a regular operator. To apply a capsule:

4 Select the item where you would like to apply the capsule and go to the Capsule category of operators. The single choice here allows you to Browse Capsules on the network. This selection will invoke a thumbnail browser that only allows you to select combustion *.CWW files.

A capsule has three categories within the Capsule Controls: Basic, Inputs and Controllers:

Basic – Considered the 'top-level' of the capsule and is where any exposed controls and text information can be accessed and edited.

Inputs – Here, you can add up to fourteen additional inputs to the capsule. These can be used for functions within the capsule's processing tree. Any new inputs will be accessed back in the Basic category of operator controls. You can also create and edit the notes seen in the Basic category. Many users leave themselves reminders or directions to other users of this capsule.

Controllers – This area allows the user to define what channels of the capsule are exposed in the Basic category. You can add (Add III) empty

channels for later, customized use with expressions; which are detailed in Chapter 12.

The ChannelPick window on the right portion of the Controllers section acts very much like the Workspace panel and is where you can access all the parameters of the operators making up the capsule. If you have any channels selected in the ChannelPick window and then select Clone & Link (Clone & Link), you will add this selection to the exposed controllers available in the Basic category.

Note: after an additional input or channel is exposed to the user in the Basic category, it can be optionally renamed for clarity using the Input and Controllers sections of the capsule.

The Link button () is essentially the same as the Link expression feature detailed in Chapter 12 and is used to have one animation channel drive another through the use of an automatically created JavaScript expression. An exposed capsule control is first selected and then linked to a channel in the ChannelPick window.

Schematic Preferences

In the user preferences for combustion, there is a category specifically for the Schematic. Here, you can set several options for Schematic grid size, layout, emphasis and overview position/size. Experiment with different preferences but I suggest the defaults at first.

In the Schematic preferences seen in Figure 5.10, I highly recommend leaving the option for Auto Layout off (the default). Auto Layout redraws the Schematic with every single operation and this can get confusing when trying to organize your nodes. Likewise, the option for Display Layers as Round Nodes should be left on. Round nodes easily identify a layer because their appearance is different to the other operators. Again, these are just suggestions for a starting point. The rest of the preferences here are primarily cosmetic.

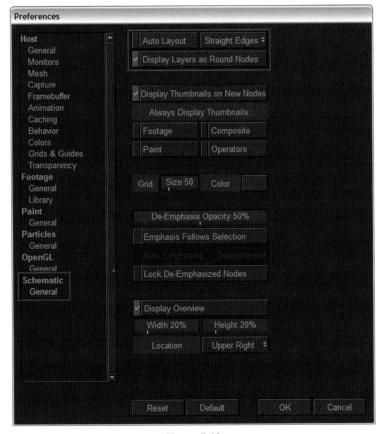

Figure 5.10

Try opening different CWS project files and initially examining them in the Schematic. Here you can quickly find out how many layers there are in the entire project, how many composites there are, if there are instances, etc. I have heard people say, 'I never use the Schematic' or 'I only work in the Schematic'. In my opinion, either of these decisions is a bad move. The Schematic and the Workspace panel both have their strong points and advantages over one another. The Schematic allows you to easily visualize the overall flow of pixel information starting at the source footage, while the Workspace panel allows you access to every single brush stroke, particle emitter and text object within different operators, for example.

CHAPTER 6 SELECTIONS AND MASKS

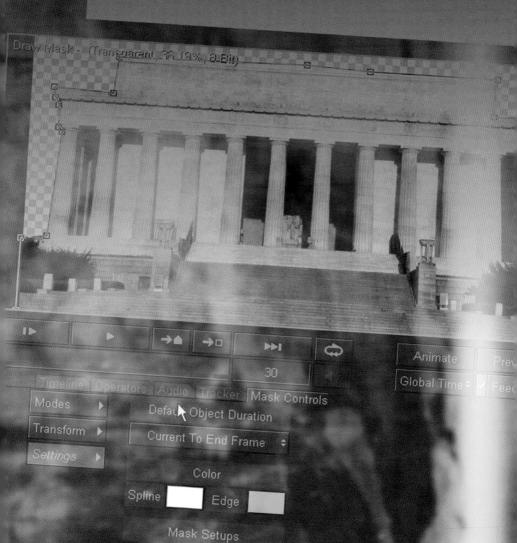

Import...

Selection and masking operators are used for quite different purposes, but the toolsets used in each are derivatives of the Selection and Mask tools previously discussed in Chapter 3. Selections are used when you want other operators and effects only to occur on part of an image. Masks are used when you only want part of an image to be visible, while other portions are made partially or completely transparent to allow the images or pixels below/behind to be visible.

Shared Terminology

As selection and masking tools share so many of the same terms and common tool workflows, the common verbiage is listed here only once. For example, feathers, edge gradients, and Boolean functions apply to selections and Mask operators alike.

Control Points on Bezier and B-Spline Curves – As was mentioned in Chapter 3, several tools available give you the ability to draw shapes with either Bezier or B-Spline curves. As a reminder, neither of these types of curve is 'better' or 'worse' than the other, they are merely different ways to control a complex shape via control points. Remember, you can create many interacting objects that use each type of shape to achieve your ultimate goal.

- Bezier shapes are created by creating control points in a viewport. If you click to add a point it will be a corner edge and if you click and drag, the initial point will be a Bezier curve. To create a closed shape, you return to the first point and close the shape by clicking the last onto the first. You will not be prompted for this closure; it happens automatically. Resulting Bezier shapes always pass through all control points making up the curve. Tangent handles can optionally guide the shape into and out of each control point. The Control key can add tangency, break tangency and remove handles from each control point.
- B-Splines are similar to Bezier curves in that you create the shape of the
 curve with control points directly in the viewport, however, default B-Splines
 do not pass through these control points. Instead of Bezier handles, control
 points on a B-spline have a single 'weight' attribute that can be edited by a
 handle in the viewport.

Remember: Regardless of if you use Bezier or B-spline shapes, you can optionally create control point groups as was detailed in Chapter 3.

Feather – A feather is a gradual change in the amount of opacity of a mask or selection. As in other graphics applications, this means a gradual change from full effect to no effect whatsoever. The amount of feathering is typically measured in pixel values starting at 1. Within combustion, feathering a mask or selection often helps blend the area that is being modified with the rest of your image. In both selection and mask objects, a feather alone is a uniform amount around the entire perimeter of the object's boundary.

Edge Gradients – These are derived from the Discreet Systems products and are a very powerful tool in the combustion arsenal. There are four types of Edge Gradients detailed here:

This disables Edge Gradients, You can however still use the standard feether

Nono

None	setting for the object to provide softness to the boarder.
Offset	Provides an offset amount (in pixels) that can be $\pm/-$ the border of the selected object in question. For example, you can have an inner offset of 5 pixels that will create a feather of 5 pixels inside the vector shape. You could, in turn, change this to 5 pixels outside the drawn shape. There is also an Opacity setting that controls the visibility of the feather.
In/Out	This allows you to independently control the inner and outer offset amounts as detailed above. This setting, however, does not have opacity for the Edge Gradient, as does the Offset type.
Splines	This is the real powerhouse. With spline-based Edge Gradients, you get the ability to have a non-uniform, variable feather around a vector-based selection or mask object. To see the splines and edges, you must be in control point editing mode.

Combine Modes (aka Booleans) – In many computer graphics applications, Booleans can be thought of as a way to resolve intersecting shapes. In 3D modeling and animation software, for example, you can Boolean an overlapping sphere and a cube to get a resulting 3D object that may be one added to the other, one carved out of the other, and so on. In many other applications the result of a Boolean is one shape. In combustion, however, these shapes are not permanently joined; instead, Combine Mode (Boolean) functions of each vector shape dictate how they interact with one another for a resulting, single function.

The shapes are left independent of each other for a non-destructive workflow. combustion uses four Combine Mode functions within several operators, especially Draw Selection and Draw Mask.

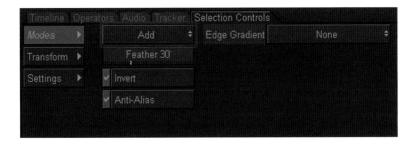

There are four types of Combine Mode (Boolean) operations vector objects can be set to use. These are listed and detailed below:

Replace	This overrides any object drawn prior to the current object. For example, if you have a number of objects drawn using the Replace mode, then only the last object drawn will remain active, because each subsequent object replaces the preceding object.	
Add	This takes into account selections or masks below and adds to the area. For example, if a vector object set to Replace is followed by an object drawn using the Add mode, the result is the union of the two objects.	
Subtract	A vector object that has a subtraction setting will 'carve out' from preceding selections or mask objects.	
Intersect	This option is used when you only want to leave behind the area where two vector objects overlap.	

The first object you create in an operator should typically be set to Replace or Add. Subsequent objects and their Boolean values will result in an infinite number of combinations, because of the infinite shapes and overlapping potential.

In Figure 6.1, the red square can be thought of as the first object drawn and the blue circle is the second; thus, the 'start' point. Each of the four resulting examples indicates the result if you were to change the circle to the 2D Boolean setting described below each sample.

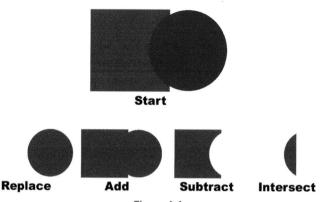

Figure 6.1

Selections and masks will be detailed after a brief, introductory lesson. Keep in mind that the majority of the tools and settings used in this lesson apply to both selections and masks:

1 Open the file named *ch06_FeatherExamples.cws*. This is a composite with one layer. This layer is made up of a still image with two operators applied to it. The first is a Draw Selection operator that contains three vector objects, the second is a Color Corrector operator set to tint incoming pixels purple.

Figure 6.2 shows three vector selection objects in one Draw Selection operator. These three selection objects are all the same shape, but one is hard edged,

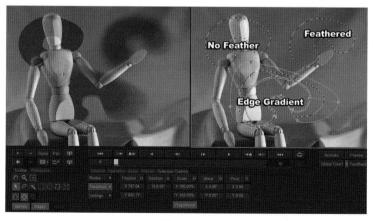

Figure 6.2

one is feathered and one uses a spline-based (variable) Edge Gradient. The output of this operator is passed along to another operator which tints selected pixels purple. The left viewport is set to view the output of the Color Corrector node and the right viewport is set to view the Draw Selection operator that occurs prior to the Color Corrector operator.

- 2 Make the right viewport the active view by clicking on it.
- 3 Expand the WoodDoll layer and then expand the Draw Selection operator all the way. Then double click on the name of the vector object named 'feather'. It will become selected in the right viewport.
- 4 Go to the Modes category of the Selection Controls now available at the bottom of the UI.
- 5 Change the feather amount from 30 to 5. Notice that in the left viewport, you see the effects of the feather, but in the right viewport where you are working, you cannot actually see the result of the feathering. This is because, by itself, selections don't alter an image; they only pass pixel information along to the following operators applied in the series. These selections indicate which areas should and should not be affected by operators further down the Process Tree. Scrub the feather amount input field as a slider and notice the 'marching ant' marquee change shape in the right viewport. When you are finished, put this feather value back to 30.
- With the right viewport still active, double click on the vector selection named Edge Gradient.
- 7 Go to the Toolbar and click on the control point editing (button. Then, enable the Splines and Edges options as seen in Figure 6.3.

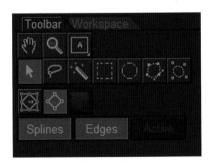

Figure 6.3

Tip: The Tab hotkey cycles between object and control point editing when a vector shape is selected.

In the active viewport, you should see the green and white splines representing the Edge Gradients set for this object. If you go to the Modes category of the Selection Controls, you will notice that there is no feather amount set (amount = 0) but, instead, the Edge Gradient type has been set to Splines for this object. This gives you a powerful, variable edge gradient that can change across the perimeter of this selection object.

8 You can edit the control points directly in the right viewport. Notice that the white spline is the master shape and the green splines represent an inner/outer variable feathering effect. The table below outlines the various ways combustion edits control points and tangency handles:

Move control points Add control points	Click and drag on the control point More over an empty portion of the white line until the cursor becomes a plus sign. Click where you wish to add a new control point
Remove control points	Select the control point and tap the delete key
Extend the tangent handles for a point	Hold Control key down while dragging on a control point
Retract tangent handles	Hold Control key down and click once on a control point
Break tangent handles	Hold Control key down while dragging tangent handle

Note: Tangent handles are only available on Bezier shapes. B-Splines only have a single weight parameter to affect the shape of the curve around a control point.

Important: The procedures in this chart work for all spline curves in combustion, not just mask and selection objects. For example, you can break the tangency in an animation Timeline curve using the last technique listed above. Another point to mention is that all of these functions listed here are animatable!

To examine 2D vector object Booleans in a Selection operator:

1 Select File > Revert Workspace to start again, or simply reload the workspace named *ch06_FeatherExample.cws*.

- 2 In the Workspace panel, select the vector object named 'none'. This is the first selection object applied. It has no feathering, as can be noticed in the upper left-hand corner of the left viewport.
- 3 In the right viewport, move the object over to the right and down slightly until it overlaps the other two vector selection objects. You should end up with something that resembles Figure 6.4.

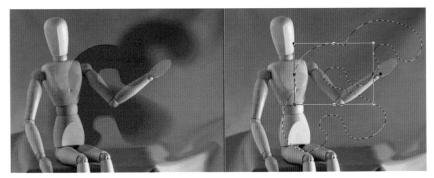

Figure 6.4

Notice that one marquee seems to encompass all three objects and the image on the left has one ameba-shaped area of purple. While this certainly is the case, each vector selection object still has its own marquee working with the other two. This purple area is made up of several different selections and feather types working in tandem due to Boolean operations. Remember, this process also works for masking operations in almost the exact same manner. You do not need to do all the work with one vector selection or mask object.

- 4 Select the vector object named 'feather'. This is the second vector object applied within this operator.
- 5 In the Selection Controls > Modes category for this object, toggle the Invert button repeatedly. Notice while you do this that the inversion of this selection object means that the pixels outside the area drawn are selected instead of the pixels inside the marquee boundary.

Tip: Quite often when drawing a mask or selection, you will invariably create the object inverted when you did not want to and vice versa. Just select the object and then switch this parameter. There is no need to recreate the shape from scratch. You are in non-destructive land now!

- 6 Before moving on, return the Invert state to disabled.
- 7 With the object still selected, switch the mode from Add to Subtract. The selected object is used as a 'cutter' and the resulting selection has been carved out of the other selections. Notice that the feather of the cutting (subtractive) object is still utilized.

Selections

If you only want to have an effect take place on part of the image, you typically use a Selection operator first to isolate the portion of the image you want to affect. For example, to turn an actor's eyes a different color; you select them with a Selection operator and then apply a color corrector. Only the selected region of pixels will be affected.

Selection Operators

Channel Selection – If you want to make a selection based on a particular color channel in an image, you can use the Channel Selection operator to derive the selection information from red, green, blue or the alpha channel. For example, suppose you are forced to chroma key a subject against a rough-textured key wall. You can select and then slightly blur the green or blue channel (only).

This will then help with the keying process, which occurs later down the flow of operators by eliminating the extra detail in the rough surface of the key wall.

Compound Channel Selection – This is exactly like the Channel Selection operator, except that the secondary input of the operator can come from another node elsewhere in the Workspace.

Draw Selection, Elliptical/Rectangular Selection – These three operators provide the basic toolset for manual creation of a selection. The Draw Selection operator adds an empty operator but does not initially create any vector objects within the operator. You are provided with five different tools to create a selection object in the viewport. The second two operators are identical to the Draw Selection operator in every way, except they initially add one default selection object of the named type at their creation time. In this case, the default vector object can then be edited to become the shape needed. In all three cases, you can add and manipulate multiple selection objects in the same operator. These can overlap using the aforementioned Boolean functions.

Feather Selection – Most selection objects and/or operators you create have a built-in feather control. The Feather Selection operator can add a feathering amount to an existing selection, perhaps if the selection was the result of several vector objects, for example. Another case when this might be useful is if you use the output of a Discreet Keyer as a selection and you want to add feathering.

GBuffer Material/Objects Selection – These two operators only work on files with extra metadata information such as RLA/RPF files from 3ds max. Frames rendered must have Material and/or Object ID values set in the 3D application prior to bringing them into combustion for these operators to be able to get the extra data needed to perform the selection.

Invert Selection – All the pixels in the current existing selection get flipped once this operator has been applied. The exact opposite selection is the result of applying this operator. This includes an inversion of any feather information.

Paint – The Paint operator can be used to create selections by using the Lasso, Magic Wand, Text Selection tool, or any of the polygon selection flyout tools. To finish the procedure of using the Paint operator as a selection, you

need to drop down to the Settings category of the Paint operator and enable the option for Output Selection (Figure 6.5). This is useful if, for example, you want to output a Magic Wand or text-shaped selection out of the Paint operator.

Figure 6.5

Remove Selection – This operator has no controls, yet performs an *extremely* important task within combustion. You use the Remove Selection operator when you want to end the selection chain or branch in order to be able to affect your *entire* image once again. Adding this operator is a good idea when you want to finish off the inclusion or exclusion of prior selection operators. To many new users, this is an extremely different workflow to many other image editing programs.

Mask Operators and Alpha Channels

When you want to see only part of an image, it may be a good time to ask yourself if masks and masking techniques are the right solution(s) for the task at hand. There is an entire category of effects operators simply called 'Mask' to handle the majority of these cases. There are additional means to add alpha channels to an image that will be outlined in a moment.

Unlike footage obtained via a real-world camera, computer-generated animation frames can optionally contain an alpha channel rendered directly into the image

for compositing purposes. Footage obtained from real-world cameras has no alpha channel. If an image has no alpha channel but you need one, masks are one common way to create it. Masks remove or leave parts of an image and show other layers below the area 'masked out'. These alpha channels are typically an embedded image file that is represented by grayscale values, but in combustion you can create and view an alpha channel as part of the Process Tree

Animated, frame-by-frame masking or selections is often referred to as rotoscoping. Ideally, a subject would be isolated on a blue screen, but often this is not the case. To remove the subject from the background in these cases you can isolate the subject with a mask.

Draw Mask Operator

This operator is applied and within it you create and manipulate vector shape objects. Instead of 'laying down ink', these vector shapes obscure or leave behind pixels depending on whether they are inside or outside of the shape. Pixels left behind will be visible and those obscured are made invisible. In these areas, images behind the current layer show through. The **Elliptical Mask** and the **Rectangular Mask** operators add a single, default vector mask within the operator at the time of creation. These simply save you one step if you know you need an oval- or rectangular-shaped mask as a starting point. These shapes can, however, be changed to any shape using the same vector drawing tools that you have seen elsewhere throughout combustion.

To quickly create and see the effects of a mask:

Open the project named *ch06_ForMasking.cws*. This is a two-layer composite of two still images. You will remove the sky from the memorial using a Draw Mask operator. This will allow the sky in the second layer to become visible around the building in the resulting composite. Take a moment to notice that the foreground layer has been scaled down to 30%. The footage for this layer is 1600 × 1200 resolution.

- 2 Apply a Draw Mask operator to the layer named Memorial and then double click this new operator. This will fill the viewport with a layer view of the memorial.
- Zoom out until you can easily see the edges of the image.

- 4 Switch to the Toolbar and select the Bezier Mask tool ().
- 5 Start drawing an extremely rough, basic shape around the edge of the memorial. To close/complete the mask object, click the first point again for closure. Notice in Figure 6.6 that there are several mask points outside the visible frame.

Figure 6.6

Tip: Keep in mind the non-destructive nature of these vector masks. You can initially rough in the shape and then go back and refine it later. Often, new users initially and painstakingly draw the exact shape of the mask, forgetting that they can adjust the shape of the mask later. Just draw a starting mask to see the effect and refine it once you know it is what you need.

Note: If upon closing/completing the mask, the memorial disappears and the sky is left behind instead, you need to select the mask object in the Workspace panel and invert the mask in the Modes category of the Mask Controls. You might also verify the mask's mode is set to either Add or Replace. Either will work fine in this case.

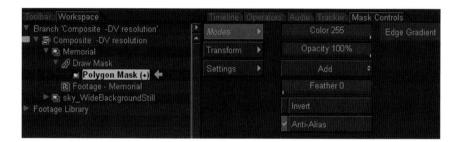

6 Double click the Composite node in the Workspace panel. This will send the output of this composite to the current viewport. You may need to zoom back to 100% to work full screen once again.

- 7 Scale the Memorial layer and notice that the mask scales with it. Scale and position the layer until you end up with a simple composition that suits you.
 - 8 For a slight challenge, set a dual viewport layout. In the left, have the composite in full view. In the right, put the output of the Draw Mask operator by double clicking on it, etc. These two views can be at two different zoom levels if, for example, you wanted to see the entire result in one viewport, but work at 100% zoom scale in the other. While you work on refining the mask in the right viewport, you will see the changes appear in real time in the left viewport. Figure 6.7 shows this workflow. You can see that points have been added and edited.

Figure 6.7

Note: Keep in mind that all of these points can be animated to accommodate movement in the footage.

G-Masks – The Edge Gradient feature seen in selections works identically in masking operators. You may, however, hear of the term 'G-Masks' when dealing with the Autodesk/Discreet product line. G-Masks are the nomenclature for masking with a spline-based variable feathered edge. G-Mask is an abbreviation for garbage mask, an industry term for masks that are used to remove unwanted elements, or 'garbage' in a shot.

Paint Operator

This operator keeps popping up all over the place! The two lower/ right-most icons in the Paint operator toolbar are identical to the Draw Mask operator's Toolbar and can be used freely at any time within a Paint operator. Figure 6.8 shows these five similar tools in the Paint Toolbar.

Figure 6.8

In addition, painting only on the alpha channel has the same effect as painting with a mask. In this case, remember that pure black is transparent and white is opaque. For paint objects to draw only on an alpha channel, access the Modes category of the Paint operator. Then, with the objects selected, you change the channels to draw on to 'Alpha':

Using any of the methods outlined in this chapter allows you to isolate parts of an image. Selections isolate some pixels while ignoring others. Masks completely block or leave behind pixels. Feathering and Edge Gradients are ways to add a falloff to an effect and nearly all of this is animatable.

Set Matte Operator

This operator is not in the Mask category of operators, but it has several resulting characteristics common to a mask. The Set Matte operator can be found in the Channels category of operators, and allows you to pick any node in the current Workspace as the source for another branch's alpha channel. This is one way to quickly generate an alpha channel when there may not be one present:

- 1 Open the file named ch06_SetMatte.cws.
- 2 If you look in the Workspace panel list you will notice that the composite only has two layers, named DollHeads and Autumn, yet the flower image is loaded in the Workspace and being used as a secondary input to the Set Matte operator.

- 3 Move, rotate and/or scale the layer named *DollHeads*. You will see that the alpha channel of the flower also scales with this layer. This *DollHeads* layer has the Set Matte operator applied, and this operator has identified the flower footage's alpha channel as the input source. The alpha channel that results can be considered embedded in the layer. They cannot be moved independently of one another.
- For a challenge, try applying a Paint operator to the flower footage in the Schematic. Then paint on the alpha channel in this Paint operator. The output of the Paint operator will automatically be rewired to become the secondary input of the Set Matte operator, and the effects will be seen downstream on the DollHeads layer.

Stencil Layer

This is a special case and is actually not an operator. Any layer can have what is known as a Stencil Layer. This can be set in the Layer category of a 2D composite or in the Surface category of a 3D composite. This function is similar to a Set Matte operator in that you are pulling pixel information from one place to create an alpha channel in another place, but the difference is twofold.

First, the Stencil Layer must reside in the same composite as the layer using this feature. The Stencil Layer does not need to be visible and, in fact, gets turned off upon use. The second difference is that any transformations to the Stencil Layer source are seen in the alpha channel of the layer using this information as a stencil:

- 1 Open the file named ch06_StencilLayer.cws.
- **2** Go to frame 30 using the frame indicator bar in the Playback controls. Notice that the text is hidden behind the globe and in front of the background image.

While this might seem simple to do with three layers (background, text, and globe), the text is actually a layer in a composite with only one other layer, a nest of the globe and background. In this example, the nest was created so that the globe and background could both get a single color corrector and a glow applied, but the text would not be affected. The alpha channel of the original

globe sequence provides a stencil for the text. The entire resulting composite is then Color Corrected and Grain is added to all elements (including the text).

3 In the Workspace panel, navigate to the layer named 'text with Stencil' and select it. Then go to the Composite Controls > Layer category as seen in Figure 6.9.

Figure 6.9

- 4 Toggle the Stencil Layer setting for Invert on and off. You will notice that the pixels in the viewport that make up the text are inverted in visibility. Return this value to Invert when finished with this examination.
- 5 Select the layer named *globe stencil* and then go to the Transform category of the Composite Controls.
- 6 Move the layer, even though it is turned off, its position is irrelevant as you can see when you move the globe stencil.
- 7 To see this layer, double click on the *globe stencil* layer name. This will make the current viewport a Layer view. Try switching the different view modes to Alpha and Transparent. This will allow you to see where the alpha channel exists for that image sequence.

Preserve Alpha

Like the Stencil Layer detailed above, this is not an operator, but another means to affect the alpha channel of an image. Therefore, it is listed in this chapter. Just under the setting for a layer's Transfer Mode is a checkbox for Preserve Alpha. This means that objects or layers below this point will be considered cumulatively, and their resulting alpha channel will be used as a mask for the objects with the Preserve Alpha option set:

- 1 Open the file named ch06_PreserveAlpha.cws.
- 2 Select the layer named 'flower'.
- **3** Go to the Composite Controls > Layer category and enable Preserve Alpha.

You will notice that even though the flower layer has an embedded alpha channel, enabling this option causes it to take into account the layers below as well when calculating transparency.

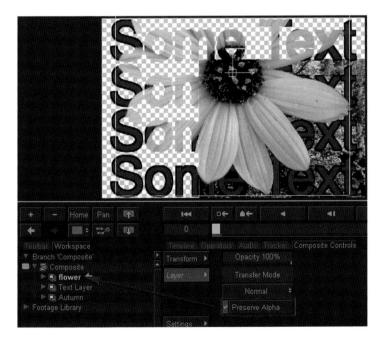

Move the flower layer around in the viewport to examine it further. If you move any of the other layers beneath the flower, the flower layer will only be visible where there are pixels below.

Note: Within a Paint operator, individual objects can use a Preserve Alpha option that is identical in function to this layer-level option.

Preferences

As you saw in the previous example, a marquee of dotted lines, often referred to as 'marching ants', indicates the area of a selection object. The location of this line of marching ants can be adjusted in the User Preferences > Host > General category, where there is a setting for Marquee Threshold. The default value of 128 means that if there is a feathered selection, the 'marching ants' line will be right in the middle of the boundary between full selection and no selection. If you change the Marquee Threshold to 1, for example, the very outer limits of a feathered edge will be where the marching ants occur on a selection. You can adjust this to suit.

Tip: You can temporarily disable the marching ant marquee from the Window menu by turning off 'Show Marquee' (or tapping Control + H). I strongly recommend, however, turning this back on immediately after you have seen what you need to do. This is because a hidden marquee is one of the most sure-fire ways to ruin your day. You may end up troubleshooting a project looking for objects that are turned on, yet have completely invisible marquees.

CHAPTER 7 **WORKING WITH** COLOR Cerrection Controls Shadows Highlights ges Hue Tint 56 Strength 14.7 Reset

Combustion has the ability to work with color information in many different ways, as can be seen in Figure 7.1. It may seem easy to pick a pixel that represents the color that you are after, but understanding the basics of the different color spaces, color channels, and bit depths will help you create and alter images with more control.

Figure 7.1

Color Spaces

Figure 7.2 shows four different ranges that all represent the same thing: a transition from dark to light. The first example represents the familiar 8-bit color range 0–255 that you may be used to when dealing with paint applications such as Photoshop. Many video software and hardware systems use the second and third

0	128	255
0.0	0.5	1.0
0%	50%	100%
shadows	midtones Figure 7.2	highlights

means of describing color values. Regardless of the method, the absence of any color information is black and complete values represent pure white.

Combustion can use any of the above methods to describe color depending on what tools you access. For example, the sliders in the Paint operator use the first and third samples in Figure 7.2, as well as a third named hue/saturation/value (HSV).

Red/Green/Blue (RGB) – This is probably the most familiar color model in which other graphics applications you may have used operate. RGB is actually three

separate color components that add up to one color. Mixing low values results in darker colors and higher numbers are proportionately lighter. For example, (0,0,0) represents zero amounts of RGB, respectively. Pure white is represented as (255,255,255) in an 8-bit color space. Pure green would be represented as (0,255,0). Mixing 256 RGB values results in the familiar 16.7 million colors in an 8-bit color model (QuickTime's 'millions of colors').

HSV – This color space is often represented graphically as a color wheel or spectrum of color.

Hue is measured in degrees and can be considered a true 360-degree color wheel, as seen in Figure 7.3. Notice that it begins and ends with pure red. The hue represents color.

Saturation is typically a percentage. The more saturated a hue is, the more it resembles that pure color. The less saturated it is, the closer that color approaches white. In Figure 7.3, colors closer to the center of the wheel are considered less saturated

Figure 7.3

Value is also typically a percentage. This can be thought of as a grayscale multiplier of the hue and saturation. Value represents the brightness of a color. A value of 0% means pure black, regardless of the hue and saturation quantities.

Cyan/Magenta/Yellow/Black (CMYK) – This is a color space designed with the process of prepress printing in mind. While these colors can naturally be used, they are typically expressed in terms of RGB. For example:

- Cyan is the combination of green and blue.
- Magenta is the combination of red and blue.
- Yellow is the combination of red and green.
- Black is the absence of any RGB. In combustion, the amount of black is measured in luminance. Therefore, CMYK is referred to as CMYL in combustion.

Combustion does not typically express color in CMYK except in the rare occasion of the Discreet Keyer. There you have the option to use RGBCMYL as a color space for keying.

Color Channels and Bit Depth

Within combustion, pixel information is treated as RGBA, which stands for red, green, blue and alpha, respectively. The combination of the first three represents the color of the pixel and the alpha channel represents how transparent that pixel is.

Tip: Remember, you can look at these individual color channels at any time by enabling the View modes from the Window pull-down menu. This workflow is detailed in Chapter 2.

Depending on how many values are available to each of the RGBA channels determines the bit depth of an image. As you may have read, combustion can work at mixed bit depths within the application. This means that you can use footage with different bit depths all within the same Workspace. It is important to understand the terminology of color when working within combustion, especially if you are coming from a background that 'only' uses 8-bit color depth.

Most of the applications and file formats that are commonly used in computer graphics use the 'millions of colors' that QuickTime vaguely distinguishes, or the 16.7 million colors that more accurately describe the number of colors available. In most paint applications, color represented in R, G, B and optionally an alpha channel.

Quite often, people will identify an image that only has a grand total of 256 colors as '8 bit'. An example of this is a GIF file. In the world of the Internet, an '8-bit' image refers to the total number of colors available.

In the realm of video, film, and animation, '8-bit color' typically refers to 8 bits of color information *per channel*: RGB. This is the bit depth that most digital video equipment uses to capture and manipulate color. When you go to the cinema, chances are that the image you are looking at was shot on film and then converted

to 10-bit color, which has a higher range of values than video equipment. The chart below outlines the different bit depths that you can utilize in combustion.

Bit depth	Color range per channel of RGBA	Total available colors
8 bit 10 bit 12 bit 16 bit Float*	0-255 0-1023 0-4095 0-65535 0.0-1.0*	16,777,216 (or 256^3) 1,073,741,824 (or 1024^3) 68,719,476,736 (or 4096^3) 281,474,976,710,656 (or 65,536^3)

^{*}Float bit depth uses a floating-point value between zero and one, and is often represented by a decimal number. The range is technically 32 bit per pixel (0–4,294,967,296 per RGB channel) and is one of the only color models to typically use decimal values.

Tip: When you are working in combustion, you should make sure that your operating system desktop is using a full range of 8 bits of color per pixel. This is often referred to as True Color. High Color is only 4 bits of color per pixel, and does not represent color well when you are dealing with applications such as combustion.

The following is a simple exercise demonstrating the different ranges:

- 1 Create a new Paint branch from the File > New with the settings seen in Figure 7.4.
- **2** Go to the Paint Controls by double clicking on the Paint operator in the Workspace panel.
- 3 In the Modes category, click once on the main/foreground color swatch.
- 4 In the Pick Color dialog that appears, notice how the RGB sliders have a range from 0 to 255. Thi

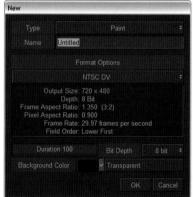

Figure 7.4

sliders have a range from 0 to 255. This is because 8 bits of color are made available to the RGB channels, since we initially

created an 8-bit Paint branch by setting the bit depth in the new dialog window.

Note: The Pick Color dialog might first appear in a color percentage (%) format and need changed to see RGB sliders from 0 to 255.

- 5 Click the cancel button to leave the color the same as you found it when you evoked this dialog.
- 6 In the Workspace panel, select the solid footage beneath the Paint operator.
- 7 Switch to the Footage Controls > Output category and change the bit depth from 8 to 16.

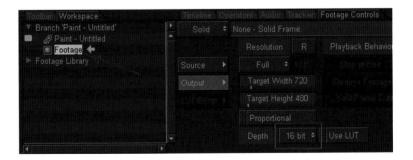

- 8 Once again, select the Paint operator in the Workspace panel.
- 9 Bring up the Pick Color dialog again by clicking on the foreground color. You will notice that now the color sliders go from 0 to 65,535. This is because 16 bits of color are available to each of the RGB channels; thus allowing an exponentially larger range of color to be available to an image of this bit depth.

Color Correction

Arguably the best thing about the general process of color correction is the truth in the old saying, 'If it looks right, it's right'. While this may certainly be the case, it requires a bit of understanding about how most color correctors (CC) work before we can talk about the specific buttons in combustion's CC operator(s). Any color correction system of merit will be able to deal with color using three sets of three values. These all interact and can affect each other at any time to achieve the look you desire.

RGB – These are the color channels for RGB, as outlined above.

Shadows/Midtones/Highlights (SMH) – These could be thought of as the dark, middle, and bright colors in your image. For example, any pixel that is (0,0,0) is pure black and therefore a Shadow, whether or not it resides in an element of the image that is in shade.

Gamma/Gain/Offset – There is obviously a lot of math going on under the hood here, but when dealing with the three primary ways of manipulating color, I will refer to the simple diagram in Figure 7.5. As you can see in this example, the values across the bottom of these three charts represent shadows, through midtones on up to highlights from left to right.

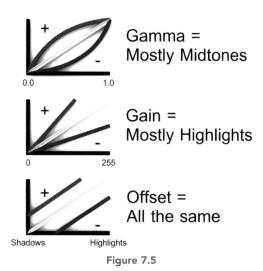

These simple charts represent

color 'response curves'. Each of the three charts shows color ranges of equal value, but they are represented in (0.0–1.0), (0–255), and (Shadows to Highlights) scales to remind you that all of these are interchangeable. The white lines represent unaffected color prior to color correction. The red lines represent a positive adjustment of a particular type and the blue lines are a negative change.

For example, the red and blue Gamma curves in the Shadows and Highlights have changed little from the original white value, but the midtones are greatly affected.

Gain value changes have little effect in the Shadow range, but the brighter a color is, the more it is altered from the original value.

Since the red and blue lines representing change for Offset are parallel to the original color, this means that Offset affects color the same across shadows, midtones, and highlights values. As you can see, none of the three affects shadows more than the others. This is an important aspect of Color Correction.

Tip: Often in video and film, it is desirable to keep blacks as dark as possible so the footage does not look washed out. Avoiding changes in Offset and only using Gamma and/or Gain will allow you to preserve your darks much easier. In the case that your shadows are already washed out and far from black, you will have to use tools to 'bring them down' to this level, should you so desire.

The Discreet CC

The Academy Award-winning Discreet Color Corrector (often hereafter referred to simply as 'CC') is an extremely powerful yet surprisingly simple system for manipulating an image's data. With little effort, you can master dramatic looks and change the mood of an image very quickly.

If you look in the Operator tab at the Color Correction category of available

operators, you will see several choices listed. The first choice, the Discreet CC, is the operator in its full form. The next four available below it are subsets of the first – meaning that the Discreet CC contains all of the controls of the Basics, Color Wheel, Curves, and Histogram in one operator. Those listed in Figure 7.6 are all available as

Figure 7.6

individual operators, should you know that you only require one aspect of the Discreet CC. Another reason to break them apart is if you wish to have utmost control of the processing order of the color correction process.

For an explanation of the CC operator, open the Workspace named

ch07_ColorCorrect.cws. This is a colorful sequence that contains primary and secondary colors, as well as a good range of shadows, midtones, and highlights. For the best interaction, go to frame 200 as seen in Figure 7.7.

Master/SMH – These four buttons are visible at all times in the CC operator, as seen in Figure 7.8. These

Figure 7.7

buttons are not just for the Color category seen here; they will be visible for the Color, Basics, and Histogram categories of the CC operator.

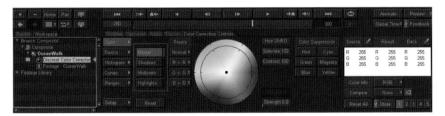

Figure 7.8

When Master is selected, you are dealing with a global color correction process across the entire range of the image. When Shadows is selected, you are isolating the darker colors to work on. When Midtones is selected, this allows you to, for example, 'Gamma up' and affect just the middle range of colors. Selecting the Highlights will isolate just the brighter portions of the image for manipulation.

Color – This category allows you to push color in your image selectively. In Figure 7.9, notice how there are four letters in the color wheel. These represent (M)aster, (s)hadows, (m)idtones, and (h)ighlights, respectively.

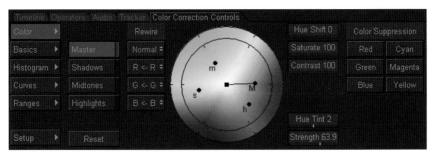

Figure 7.9

For a simple exercise using the color wheel, follow these brief steps:

- 1 Isolate the Shadows by clicking on the Shadows button.
- 2 In the color wheel, click and drag the mouse from the very center to the pure blue. Notice the small 's'. You will see the dark areas of the image become blue.
- 3 Isolate the Highlights by clicking on the Highlights button.
- 4 Drag from the center of the color wheel to the yellows. Only the brightest area in your image will become tinted yellow. Notice the small 'h' in the color wheel.
- 5 Experiment with isolating different values of color and pushing color in various directions. Also try using the color suppression buttons to the right of the color wheel in different combinations. You will see that with very little effort, you can accomplish a great deal just by using the color wheel alone.
- 6 At any time, you can hit the Reset button (Reset) for each category of the CC operator, or the Reset All button (Reset All) for the entire operator and all its categories of controls.

Basics – It sure isn't the most interesting part of the UI, but this is where a lot of the magic happens. Here are all the controls for affecting the Gamma, Gain, and Offset of all the RGB channels individually or all at once. The Basics category also gives you control over image saturation, contrast, temperature, and overall value.

				Gamma		Offset	Color Match
Basics	Þ	Master			. 52	12	Match All
		Shadows	Contrast 100				Match SMH
		Midtones			120		Match Gain
Ranges		Highlights		0.54			Match Offset
			Mag-Grn -80				
			Value 67				

Note: The functions for Temperature, Magenta-Green, and Value are directly tied to the Gain settings, all found within the Basics category.

For a quick challenge, isolate the highlights and then bring the Offset down in just the red channel. Now you are color correcting with finesse. Continue to play with color for a moment by isolating and manipulating SMH, RGB, and Gamma/Gain/Offset.

Tip: Use the input value fields as sliders with the viewport preview enabled. This will allow you to scrub the sliders back and forth while observing the subtle variations and extreme control you have over color aspect.

Histogram – The histogram of an image is like a map showing the amount of any particular color. In the example in Figure 7.10, the image has a nice spread of color with three major peaks in the shadow to midtones, and a falloff to little highlights (read left to right).

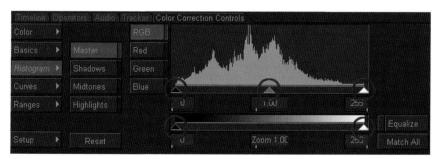

Figure 7.10

The small arrows indicated in Figure 7.10 are input sliders for shifting the bias of an image's color. For example, you can move the middle, gray arrow in the top set to affect the bias of the midtones of your image towards shadow or highlights while you leave the shadows and the highlights alone. The result is an overall darker or lighter image.

The bottom sliders are for output. If your project, for example, calls for no blacks below RGB value 7, then you can remap the darkest color to 7 by dragging the black arrow slightly to the right. This 'clips' color.

Figure 7.11

To the left of the histogram are buttons for working in all RGB channels at the same time, or isolating the histogram for viewing and manipulation in RGB individually.

The Equalize button seen in Figure 7.11 will smooth out the histogram values evenly when enabled.

Curves – The Curves category allows you to remap color values in a visual manner. These curves can be used to replicate the diagram seen in Figure 7.12.

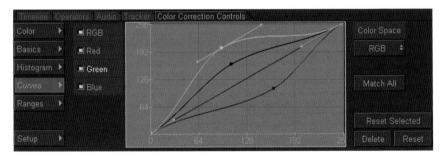

Figure 7.12

The Curves category can also be applied individually as the operator named Discreet CC Curves. It should be mentioned, however, that as an individual operator, it does not have the Ranges category (below) embedded, as do the other three CC operators that are broken out as individual operators.

Ranges – This is where you define what in your image is a Shadow, Midtone, or Highlight area. This can therefore be used in conjunction with the rest of the

CC controls to dramatically change the effects of the other controls. Since midtones fall between shadow and highlights proportionately, only controls for the two extremes are made available. This does not affect the image itself; it only defines the area that will be affected when you use the Shadows, Midtones, and Highlights options.

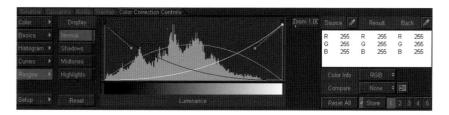

Setup – This last category is not so much for manipulating color as it is for saving your CC settings. Here, you can import and export files to other combustion stations, as well as the systems such as Flint, Smoke, Flame, and Inferno.

Color Matching

Open the project named *ch07_ColorMatch.cws*. This is a simple, two-layer composite of a girl that has been masked to allow the bridge clip to be seen beneath.

Quite often, you have two images that you wish to combine as one. This is frequently the case when you are chroma keying an image and, even though you did an excellent job of eliminating the greenscreen, the subject still does not look like she was shot at the same time as the backplate. Using color matching you can adjust the colors of one image to closely match those of another, target image.

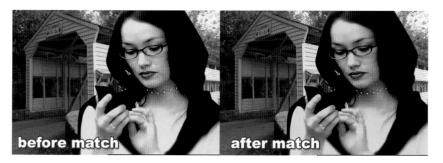

Figure 7.13

Regardless of the category of tools you are currently looking at within the CC operator, to the far right you will always have access to the color matching tools seen in Figure 7.13.

The vernacular of the color match tool is that the Source is the image that the CC operator is applied to and the

Ref(erence) is the image that you are trying to push the color towards, or match. This area provides color pickers (eyedroppers) to use to identify different pixels in your images.

To perform a color match:

- 1 Open the Workspace named *ch07_ColorMatch.cws* and expand the PhoneDial layer to reveal the Discreet CC. Select this operator.
- 2 In the CC controls, select the Shadows by clicking on the Shadows button.
- 3 Select the 'Source' color picker and sample the darkest value in the image that the CC operator is applied to. This might be a pixel from the woman's hair, her phone, or her glasses, which all seem to be near black. To do this you simply highlight the eyedropper icon and then pick a pixel in the image.
- 4 Switch to the 'Back' color picker and sample the darkest area of your target image. This might be the dark area under the bridge canopy, for example. You can temporally turn off the top layer to see the entire shot of the bridge.
- 5 Select Midtones and repeat the previous two steps.
- 6 Select Highlights and repeat.
- Now try any of the Match buttons in the Basics (Figure 7.14). The match options in this example are only available within the Basic CC panel; the Histogram and the Curves sections of the operator only have the Match All button. The result should be the color shifting on the Source image to more closely resemble the colors in the target image.

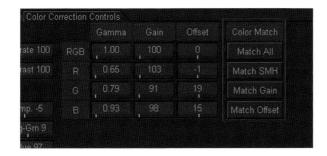

Figure 7.14

A Few Tips for Successful Color Matching

When sampling the shadows and highlights, a single pixel is often the preferred way to go; however, when you sample the midtones, using an area sample will often provide better results. Remember, an area sample can be achieved by dragging a box around the area in question while holding down the Control key.

You do not have to sample all three shad/mid/hi to achieve a successful color match. If it looks right, then it is right.

When sampling shadows and highlights, you do not need to pick the absolute darkest or lightest pixel in an image to achieve good results. You should, however, take a moment to zoom in to the image to pick what closely represents the darkest or lightest pixel in the image. By zooming in and click-dragging your cursor in these areas, numerical values representing colors will be visible and changing in the color swatches of the color Match utility. You do not need to find the darkest pixel, just get as close as possible without spending too much time looking.

When going to sample color from the Back/target image, it is often helpful to quickly turn off the layer that the CC operator is applied to, pick the color, and immediately turn the layer back on. This will allow you to pick from the entire, unobstructed back image. Remember, you can easily turn off elements in the Workspace panel by clicking on the icon left of the item's name.

The Store and Compare Features

As of the subtlety of the effects you can achieve with the Discreet CC, you may often want to get the feel for what a before and after comparison may look like.

Stores – The Stores features highlighted in Figure 7.15 are similar to those found in many other operators such as Paint and the Keyer. These allow you to make both subtle and dramatic changes in the CC while keeping values you may want to return to for comparison.

Figure 7.15

Compare – The Compare tool is a quick way to look at an A/B

comparison of any two nodes in the current Workspace, with the exception of a particle operator. With the release of combustion 4, the compare tool has been moved to the Toolbar and is, therefore, available at all times (not just when color correcting). The compare utility is often utilized when color correcting, and therefore is why it is being discussed here. Keep in mind that it can be used at any time to compare any two nodes in the workspace (using the below technique):

- 1 Open the Workspace named ch07_Compare.cws and advance to frame 200.
- In the Toolbar, bring out the Compare flyout to turn the Compare Tool On.
- 3 Expand the 'Current' field and select Operator . . . from the flyout menu.
- From the Operator Picker pop up, double click on the Footage OceanWalk node. This is the raw footage prior to any color correction.

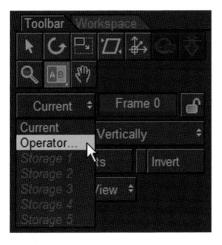

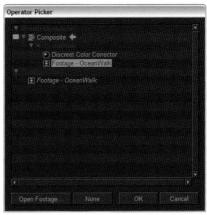

Your viewport should now have a thin vertical line running through the center. This thin line is the Region Limits (Region Limits). On the left is the color corrected version and on the right is the raw footage node.

5 Click directly in the viewport on this line and drag the cursor left and right. You will notice the 'A/B' nature of the compare tool.

There are options for a horizontal and vertical splitting, as well as a rectangular region-of-interest tool that can optionally be inverted to switch the inside and outside A/B comparison.

Notice in Figure 7.16 that an addition parameter of frame offset is being utilized. This allows one to not only compare two nodes in the workspace, but also compare two different times within the workspace as well.

Figure 7.16

6 To stop the A/B comparison, simply re-access the compare flyout from the toolbar and change the setting to 'Compare Tool Off'.

7 As a closing exercise, try storing different CC settings and use the CC's Compare feature to analyze the differences at the same time. This allows for both broad- and fine-tuning of color and easy analysis of different CC settings.

Note: It should be mentioned that a Compare feature can also be accessed at any time by using the Render to RAM utility detailed in Chapter 14.

Closing CC Tip: If you make any adjustment and wish to tone down the effects of the operator without changing the values, you can apply a *Channel > Blend* operator and crossfade to the node just prior to the color correction. This can be done with any operator, for that matter.

For additional information on color correction and color space, I highly recommend Brinkmann's, The Art and Science of Digital Compositing.

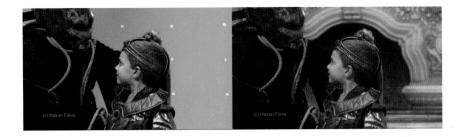

There usually exists a lot of excitement when projects involve keying. The results you can achieve using this process are quite diverse and the benefits of its use are essential when you cannot actually capture a shot in reality. Making the blue or green go away is merely the beginning of creating convincing composites, and understanding a few basics about keying can help you when using combustion. There are, however, other means of keying in addition to using a blue or green screen.

Keying is a generic term that typically means procedurally creating a hole(s) in alpha channel where there typically is not one present. On alpha channels, black is transparent and white is opaque. Therefore, dark areas on the alpha channel allow the images below to come through. Be aware that alpha channels are often not strictly black or white, but have many values of grayscale that represent variable transparency, also called softness.

Note: In the case of most computer graphics applications, the terms 'matte' and 'alpha channel' mean the same thing.

Footage of real-world subjects that is obtained through a camera of some kind cannot contain an alpha channel. 'Life' has no alpha channel; therefore, you must create one if you want to put image A over image B. To create an alpha channel, you can either do it manually using paint or masking operators, you can use another image as the alpha channel source (with the Set Matte operator or Stencil Layer feature) or you can use a keying process to identify areas of the image you want to keep and those you want to eliminate. This last option is often referred to as 'pulling a key'. With careful planning, lighting and shooting of your subject, you can capture footage that is geared towards the process of keying in one form or another.

Under ideal circumstances, you will only ever use a keying process on uncompressed media of live-action subjects. Any form of *lossy* image compression will work against you when pulling a key. That is if your image is not 1:1, then you are not creating an ideal composite. Computer-generated imagery (CGI) can be created that automatically includes a proper alpha channel for compositing. Alpha channels embedded in the frames rendered by animation software such as 3ds max will always result in a better composite than a keyer-generated alpha channel on the same source. Keying of any kind is *not* the preferred way of creating mattes in CGI animations for compositing purposes. The included PNG image series named *Globe###.png* is a good example of CGI footage with an embedded alpha channel.

Keyer Types in combustion

Combustion implements all of its keyers as effect operators. There is an entire category named simply 'Keying' that provides all built-in keyers. Many third-party plugin keyers will be found in other categories according to manufacturer. Regardless of which you use, the operator manipulates the alpha channel (aka 'matte') onto the image to which it is applied.

Difference (Key) – This process, and the operator with the same name, uses two separate pieces of footage to generate a matte. Simply put, you have a clean background plate and another matching image with the subject in frame, the pixels that differ between the two shots are kept and the pixels that are the same are eliminated. For example, if you video an empty wall and then have a separate shot of a person walking by the wall, you could extract a matte around the person because the pixels in the background that do not change from one image to the other are easily identified. To make practical use of a Difference Keyer, however, you must use a good tripod to ensure an extremely stable shot with, quite literally, no pan/tilt/zoom.

Luma Keying – This process forces darker areas of an image to become transparent. For example, if you photograph a person on a black curtain or night sky, you can often eliminate the black while keeping the subject intact. For example, pure (0,0,0) black is the first color to be dropped out and as colors get brighter, they are more visible.

Chroma Keying – The vast majority of chroma keying is performed on a blue or green backdrop, but any color can be used. Yellow, orange, and reds found in human flesh tones have dictated that the cooler colors are easier to remove while leaving skin tone. If you are capturing footage of an inanimate object that is blue or green, you can get great results with a 'red screen' shot. When performing this type of keying, it is known as chroma keying because you are isolating the area to be removed based upon pixel color values. Remember that color = chrominance or chroma. Think of it as 'color keying'. Combustion offers three native chroma keyer operators; Linear Keyer, Diamond Keyer and Discreet Keyer.

More than Just Making the Blue or Green Vanish . . .

Eliminating the blue or green screen from your shot is hardly the entire process of creating a convincing composite. Often your footage will have elements in frame that no keyer could eliminate. Examples include microphone stands, tracking markers, or even the edge of the chroma key screen itself. The workflow seen in Figure 8.1 can be considered one common workflow in the processes of working with chroma key subjects. This is the big picture, if you will; it is more than just making the blue or green disappear:

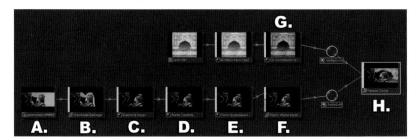

Figure 8.1

- A Raw footage of subjects on green screen
- B Garbage mask out trackers and microphone stand
- C* Pulling a chroma key
- **D** Matte choke to fix edges

- **E** Color spill suppression
- F Paint touch-ups on alpha channel
- **G** Color match one layer/plate to the other
- **H** Layer both plates for further, shared effects operators downstream.
- * Step C is technically the only one that actually involves removing the green screen. The rest of the steps will be detailed first to allow you to understand the aforementioned big picture.

Note: There are two resolution-independent user capsules that replicate steps B through G of this process included with the material for this book. Please refer to the notes within the capsule as to their intended use.

The following details will be clearer when viewing the project named ch08_KeyingSIMPLE-DONE.cws. It will be advantageous to reverse-engineer this finished project while reading the steps below, and then follow later with a step by step of the actual chroma key (step C). All of these actions have been performed on the layer named ActorsLeft that lies in the composite. One way to examine each operator is to double click on it in the Workspace panel. This will send its output to the active viewport. You can also view the composite and turn operators on and off to see what each actually does.

- **A. Raw Footage** This is the source clip of the subject on a chroma key screen. This particular footage is highly compressed to reduce download times for you, the reader. Using compressed footage for chroma key subjects is not recommended and should only be performed when uncompressed footage is not an option.
- **B. Garbage Mask** Often, footage contains extraneous pixels caused by objects such as microphone stands or tracking markers on the key wall. Using a Mask operator prior to keying can quickly eliminate these pixels. This step can typically be done quickly, because you are only eliminating elements that should not be in the shot. If this mask needs to be animated, you should use just a few controls points and keyframe it as quickly as possible. Remember, this is just a garbage mask and should be generated with minimal effort in a few minutes. Garbage masks should not contain any feathering.

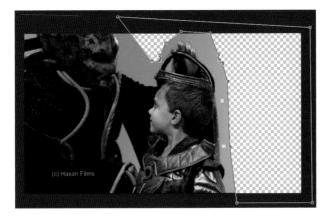

Figure 8.2

Figure 8.2 shows an example of a quick garbage mask. The green screen left over after the garbage mask will be handled by the keyer. The white tracking dots that are still visible are left because they intersect with the moving actor at some point during the clip. These will be eliminated in step F.

C. Pulling the Key – Next is the actual keying process to automatically remove the rest of the chroma key wall. One workflow will be outlined later in this chapter, but it is mentioned here briefly to demonstrate (again) that making the blue or green transparent is often not the entire solution, but just one step in a larger process. Figure 8.3 shows that white tracking dots on the wall near the child are not eliminated by the keyer.

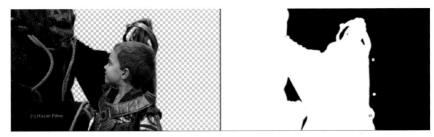

Figure 8.3

D. Matte Choke – After the chroma keyer removes the primary color, you may optionally want to remove additional pixels from the edges of the alpha channel. There are Matte Controls built into the Discreet Keyer operator itself, but if you

want to access these as a unique operator, you can use the Matte Control operator in the keying category of operators.

Tip: Many people do steps D and E in the reverse order than they are listed here. This can often result in a better key, but each circumstance will be different and you should try a quick reorder of the operators in the workspace panel after you have them set up.

- **E. Color Spill Suppression** After the key has been pulled, there may be some color 'bleed' still remaining within the subject. This can often result from reflections of the chroma key wall, poor lighting, blond hair, or any number of other in camera or on set circumstances. The Discreet Keyer has color suppression build into it as a section of the operator. If you are, for example, using the Diamond Keyer instead and need to perform color suppression downstream, you can use the Color Suppression operator found in the Keying category of operators.
- **F. Touch-up Matte** No keying solution in the world is bulletproof. You may work for several minutes or several hours on 'pulling a key' and still have areas of the subject and/or background that are just not cooperating. For example, you might be able to eliminate the chroma key wall, but in doing so, you also eliminate some of your subject by creating unwanted 'holes' in them. Using a Paint operator, you can easily put back or add holes in the alpha channel as a 'post-keying' process. This is the reality of chroma keying and a perfect example of how essential it is to have a non-destructive, vector paint application right in your compositing environment. Figure 8.4 shows three selected objects that were created using the Paint operator and animated to compensate for movement by the actors.

Note: All three of these objects are painting on the alpha channel. Two of these are black 'holes' in the alpha to eliminate the tracker dots and one is pure white to 'put back' the actor's robe. You can toggle these on and off to see which is which.

G. Color Match – After the subject has been chroma keyed and the alpha channel is as clean as possible, the subject may still not look like it is 'in' the composite. For example, if you have an actor lit in a studio but they are supposed to appear as if

Figure 8.4

they are in a dark, night shot. No matter how perfect the key, the two layers do not look like they were shot under the same conditions. Using the Discreet Color Corrector operator to match either the background to the subject or the subject to the background can often be the most important step in creating convincing/ seamless composites. Figure 8.5 shows the original background on the right has been pushed to an orange hue to match the actors on the left.

H. Layer and Effect – Many compositors also want to add effects to both the subject and the backplate to help 'tie' them together visually. By creating a

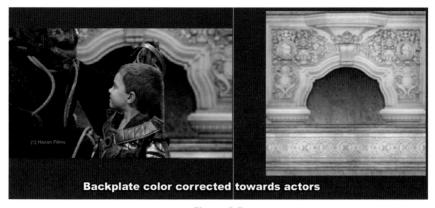

Figure 8.5

composite out of your subject and backplate layers, you can apply operators directly to the composite (downstream) so both layers get affected equally. Film grain, additional color correction and specular blooming are common examples of popular looks in many recent commercials and feature films. Figure 8.6 shows one example.

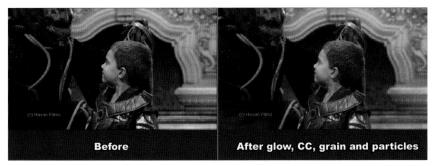

Figure 8.6

Two Keying Operators

The Diamond Keyer and Discreet Keyer found in the keying category of operators will prove themselves to be the most useful for chroma and luma keying. These are two operators are each very powerful in their own way. Neither is better or worse than the other, they simply offer different controls to eliminate the unwanted areas of your source, key-in image. It can be a common workflow to try both on each shot and see which does a better job in each case.

Both of these operators offer common eye-dropper controls () to sample a main/key color to remove within the viewports. They also both have tolerance and softness controls () to add or remove () additional ranges of color to the key. Tolerance and softness can also both be controlled via sliders and numerical data fields.

Note: When sampling the colors during a key, the eye-droppers are picking colors form the key-in source, regardless of what is currently being displayed in the viewports.

The **tolerance** controls found in both operators are one way of increasing or decreasing the range of color to be keyed out. This should only be done after you have chosen an initial color with the Key Color eye-dropper (). To extend the range, select the Add Tolerance picker () and sample the pixel(s) you wish to add. To restrict the tolerance and remove a color from the keying process, use the Remove Tolerance eye-dropper () and the pixels will 'come back'. It is highly recommended to use tolerance sparingly; many new users want to overdo it with tolerance, which will work against you, downstream.

Note: The initial key color you picked and the pixel(s) selected with the Add Tolerance eye-dropper will undoubtedly be different to the ones used for these examples. This shows how every single-keying shot must be treated independently of one another.

The **softness** controls found in both operators are for defining areas in the matte that are transparent. Subjects that are glass, lace, and thin cloth are a few examples of items with partial transparency. You can add or remove softness in the matte as needed.

The Diamond Keyer Operator

This operator can be used as a chroma or luma keyer and has far fewer controls than the Discreet Keyer operator (detailed below). Many users prefer this simplicity, but it should be mentioned that it is often necessary to use additional operators downstream to complete the overall key. These include such as Matte Controls, Color Suppression and Alpha Levels, to name a few. In contrast, many of these features are all found embedded within the Discreet Keyer as categories of that operator.

The Diamond keyer has only two sets of controls: Basics and Output. The Output section simply provides the ability to send the results of the operator out as a key (the default) or as a selection (Chapter 6). It is in the Basics section of the operator where you have access to the controls for the keying process itself. This is where you control the key color, softness and tolerance of the keyer (Figure 8.7).

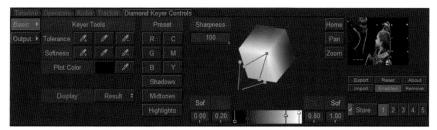

Figure 8.7

The Plot Color swatch and eye-dropper allow you to sample a color in the image. The result will be displayed in the hue cube to the right of the UI.

The Display dropdown found here allows you to change the type of information generated by the keyer:

Front	This is the image that the keyer operator is applied to. Switching to this choice is a way to check back to the incoming pixel information.
Matte	This setting will send the alpha channel as the output of the operator. Temporarily switching to Matte is a way to check the effects of the keyer on the alpha channel.
Result	The default setting that sends out and displays the result of the Diamond key. In a Layer view, the front image will be keyed over black unless you change view modes.

There are several presets for chroma and luma keying that include starting points for (R)ed, (G)reen, (B)lue, (C)yan, (M)agenta, and (Y)ellow chroma keys, as well as Shadows, Midtones and Highlights options for a luma key.

The Sharpness control adds or removes softness of pixels within the current tolerance range.

The hue cube seen in Figure 8.8 offers controls for the tolerance (red) and softness (yellow) as either control-point diamonds within the cube, or sliders and numerical fields below. To the right, basic navigation buttons can be dragged directly upon to fine-tune the Hue cube display.

Figure 8.8

To use the Diamond Keyer, you initially provide a key color either by using the tolerance eye dropper, one of the color presets (R/G/B/C/M/Y), or one of the luma presets (Shad/Mid/High). You can then refine the key as needed by adding or removing tolerance and/or softness. Use the stores to try several passes at the proper settings, and reset the operator as needed to start from scratch.

Remember: The Diamond Keyer operator is often followed downstream by other keying operators to achieve the final overall effect of removing unwanted pixels from your key-in image.

The Discreet Keyer Operator

This robust tool provides many categories of controls for doing chroma, luma, and channel keying. As with the Discreet Color Corrector, the Discreet Keyer provides a myriad of nested controls that should be understood prior to attacking key shots. The five categories of controls within the operator are working in tandem. While the Academy Award Winning Discreet Keyer may not be a one-button solution, it has proven time and time again that it can handle extremely fine keys with just a bit of practice. Each of the following is a brief description of the categories found within the Discreet Keyer operator.

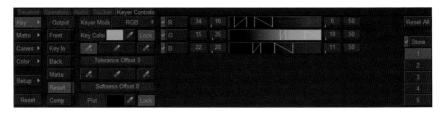

Key – This category is where you isolate a color or a range of colors in a specific color model such as RGB, YUV, and HLS. The Key Color eye-dropper is provided to sample the image and begin the keying process. With it, you isolate a single color and add transparency to the alpha channel where pixels of this color reside in the image. The color fields to the right provide a visual representation of the colors and ranges you set in this category of the operator. In these color fields, the ramp between the *vertical* yellow and cyan bars represents a softness falloff.

If there are two cyan bars in any of these three fields, then the space between represents a range of tolerance. These cyan and yellow bars allow you to adjust softness and tolerance globally or locally to each channel by dragging directly on them in the color fields.

Matte – This section replicates the Alpha Levels and Matte Controls operators (detailed below).

Curves – This is where you can alter how the front matte and the back matte meet. The default is an equal blending of the two, but if you want to bias towards one or the other, you can use the Curves controls to blend the front and background images together. To add a matte curve, simple click on either the Front or Back setting and then click on the highlighted curve. This new point can be edited using standard Bezier editing. The Plot picker here will result in a red line within the Curves editor window. This helps you determine a pixel's matte values. Quite often, you can get by with little or no editing within the Curves section.

Color – This category replicates the Color Suppression operator (detailed below).

Setup – This is an area that controls how the keyer will function. You could almost consider this preference local to each Keyer operator. This is also the area where you can import and export setups for the Keyer operator. These *.KEY files can be loaded by many systems products such as Flint, Flame, Smoke, and Inferno. There is also a useful option here for 'Output Matte As' (the choices are Key or Selection). In many cases, you may find it useful to use the keyer as a Selection operator of sorts. To output the alpha channel as a selection, simply change the setting from Key to Selection. More information about selections is described in Chapter 6.

Note: A few different *.KEY files (that can be loaded into the Setup category of the Discreet Keyer) have been provided with the materials for this book. These allow you to see several keyer solutions for this particular shot.

Output – There is also a vertical column of Output options for Front, Key In, Back, Matte, Result, and Comp. These Output choices dictate what information

is sent out of the operator in the Process Tree. For the most part, you will want the output to end up as 'Result', but often during the process you may want to briefly check another, such as the matte generated by the operator.

I encourage you to try several approaches to the Discreet Keyer. This operator is one of the best places to take advantage of the Stores feature in combustion. If you get to a point that is looking good and you do not want to 'mess things up', simply store those settings and move on. Quite often, I do one complete key, store it, reset the keyer, and do another. Then I can click on the different stored keyer results to see which I like the best.

Additional Keying Operators

Alpha Levels – This is an operator that adds some of the functionality of the Matte section of the Discreet Keyer. With it, you can push the blacks, grays, and whites of the matte. The histogram represents the alpha channel of the matte, not the RGB information. The top row of three slider tabs represent the

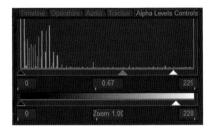

shadows, midtones, and bright (highlights) of the alpha channel. The two black and white sliders below the gradient ramp allow you to remap the overall brightness of the matte:

Zoom Changes the scale of the histogram to the right. This is purely cosmetic and has no effect on the matte.

Lift Offsets all the matte pixels equally. This value can be negative to darken the matte 'down' to pure black, if needed.

Gain This applies a multiplier to the pixel values of the alpha channel. This primarily affects the brighter pixels of the matte.

Note: Lift and Gain are only available within the Discreet Keyer operator and are not found in the Alpha Levels operator.

This process is often called 'choking the matte'. You are essentially limiting the range of gray values available to the alpha channel; therefore, you do not want to pull the black slider too far right or the white slider too far left. This is another feature of keying that has no 'right and wrong' – you just get better at determining what works best with practice. Choking the matte reduces the total amount of gray values made available to the alpha channel resulting from the keying process. If you limit this range too much, you will reduce the ability for objects to have partial transparency and edges will appear like a paper cutout.

Matte Controls – This operator allows you to affect pixels at the edge of the alpha channel. This includes images that never even utilized a keyer upstream. For example, to blur the edge of a 3D rendered CGI alpha channel, you could

use the Matte Controls operator. The three buttons for Shrink, Erode, and Blur allow you to manipulate the edges of the alpha channel by a defined width (measured in pixels).

Shrink	Adds or removes pixels from the edge of the matte.
Erode	Adds transparency to the edge of the matte.
Matte Filter	Applies a blur to the matte. This option has independent settings for width and height of the blur applied. Within the Discreet Keyer Matte area, this is called Blur.

These three can be considered 'last resort' tools and not 'jump right to them' tools. All three of these tools these **remove extra 'these'** tempt many new users because they seem to reduce color spill around the edges. However, if you have loose hair or other extremely thin or transparent elements in your subject, then these three options may actually work against you. In this particular clip, there is actually little stray hair detail. Try repeatedly toggling these on and off while watching both viewports to see if they help or hinder your final result.

Color Suppression – This operator allows you to disguise pixels instead of eliminating them from the image. The seven labels on the left represent seven different color curves available in the color spectrum. To isolate any one of them,

you click on the name to the left and edit the corresponding curve. The two primary options to concern yourself with here are Hue Shift and Supp(ression):

- Hue Shift pushes a color towards the user-defined Hue Shift Target color. This is the color that will be put in the place of color spill and is often set to a color similar to the background of the image and/or the inner edge of the key subject. In the case of our sample image, you may use a yellow-orange as the target color, for example. Hue Shift allows you to change the color of the spill to another color picked from the image.
- 'Supp' is for suppressing color from a specific hue by reducing the saturation of the Color Suppression Target. This target color, in turn, identifies a color to suppress. This can often best be found by using the Plot tool to identify color spill pixels in the image.

The Plot eye-dropper here allows you to click and drag across the image and the pixel color selected will be identified in the Color Histogram by a red vertical line. This can be useful to help select Hue Shift and Color Suppression Target colors. Quite often, the naked eye will see the edge spill as one color when, in fact, it is another color when examined by the eye-dropper.

Figure 8.9 shows the Color Suppression category of a Discreet Keyer operator. Here, you can see two suppression points dragged down to the gray, horizontal bar. This means that color range is suppressed as much as possible without adding in a new color. Dragging suppression points below this 25% height gray bar results in the complementary color being added (instead of just suppressing one color you are adding a second).

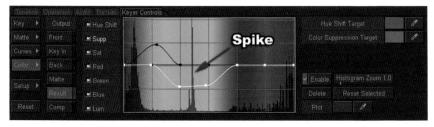

Figure 8.9

This example also shows that the Hue Shift curve has isolated some yellow-green in the spectrum, and it has been pushed (up) towards a tan-brown target. The spike in the color spectrum represents the color that has been keyed out. You typically want to suppress a color to either side of this, because the 'spike colors' have already been removed from the image. This means that your lowest point on the suppression curves would not be in the spike, but instead to the yellow-greens or light blues on either side of this spike (in the case of the example seen here).

Linear Keyer – This down and dirty operator should not be overlooked. This simple chroma keyer uses a color range to determine what will be transparent and what will be left opaque. The linear keyer can often be used with great success on solid subjects that do not contain transparency. Objects such as glass, hair, or lace fabric may not work well with the Linear Keyer, but if you are keying an inanimate object such as a scale model, the Linear Keyer can work great. It is also useful when you want to do a quick, rough key and have another artist refine it later by replacing it with a different keyer.

One Keying Workflow

Outlined here is one method of pulling a key with the Diamond Keyer operator Figure (8.10). You may learn and use a different workflow with great results – this is just one take on the matter. Again, different methods and different keyers may be required from shot to shot. The end result of a convincing blend of foreground and background is what ultimately matters, not how you get there:

Open the file named ch08_KeyingStart.cws.
This project has the garbage masking and touch-up steps outlined above already completed for your examination. There are additional operators for matte choking and color suppression as well. The following lesson is just to isolate the step of keying out the color in the bigger picture.

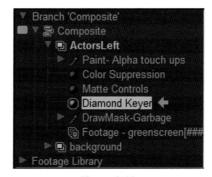

Figure 8.10

Take notice that there are two layers: one of actors shot against a green screen and a still image background. This lesson will walk you through keying the layer named ActorsLeft, which already has several operator applied to it.

- 2 Switch to a two-wide viewport configuration. In the left viewport, put the output of the entire composite by double clicking on the Composite in the Workspace panel.
- 3 In the right viewport, send the output of the Keyer operator by double clicking on the Keyer operator in the Workspace panel. At this point, the viewports should look the same, the right viewport is set to be active, and the Keyer controls are visible at the bottom of the UI.
- 4 Tap the (G)reen preset button. It will remove a significant portion of the green from the image. Notice in the left viewport, however, that the background is showing through the child's garment in the rear and there is still some green color spill down the right side of the subjects. These are good examples of errors you will need to address when chroma keying.

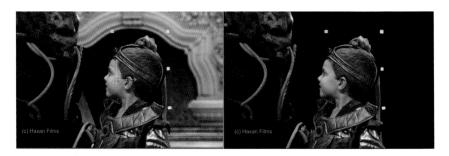

With the Key Color eye-dropper still selected, click a point in the right viewport of the green screen between the two actors' faces. Notice that picking this color results in a completely different 'starting point' for the rest of the keying process. The first major step in keying is finding the most useful key color. In the case of actors with loose hair, this is often the most difficult area to key and, therefore, a good place to start your keying process (near the areas with fine detail to preserve).

The eye-dropper is only picking one single-color value to start keying, but it also adds some softness on each side of this selection.

6 To perform what is known as an 'area sample', hold down the Control key and drag a rectangular region around a larger portion of the green screen. This does not create a range of color; it still only generates one key color – however, this color is the average of all the pixels sampled. Figure 8.11

shows an area sample being performed on the right side of the frame.

For this lesson, you may want to area sample above the actors' heads. Make sure you do not sample pixels of a white tracking marker on the chroma key wall.

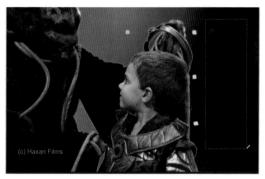

Figure 8.11

Note: In step 4, it may have appeared that the (G)reen preset did a better job initially than the area sample performed here. This often may or may not be the case. You will have to learn how the following steps/operators affect the key color, tolerance, and softness settings here.

7 Switch this right viewport to View Mode > Alpha by tapping (Control + Shift + 8) at the same time. This will result in looking at the alpha channel generated by the operator in the right viewport while still looking at the resulting composite in the left viewport.

This workflow, seen in Figure 8.12, is a fantastic way to chroma key because while the final result is what ultimately matters, the matte being created is what you are actually working on. This side-by-side viewport layout allows you to see both at the same time. This can be useful because sometimes you cannot see if your key has 'holes' in it. This is typically due to the color of your background. Alpha View Mode allows you to see these faults in the matte clearly.

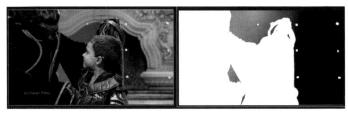

Figure 8.12

8 One by one, turn on the operators for the ActorsLeft layer. Examine the effects of each operator either by turning them on and off, or by double clicking on each operator to send its output to the active viewport.

These are provided for your analysis of the big picture, but this particular lesson is simply the procedure of making the green go away using the Diamond Keyer followed by a few other keyer operators.

At this point, you should experiment with fine-tuning the key using a mixture of refinement steps. Color suppression, hue shift, matte choke, paint touch-ups, and color correction are just a few ways to improve the overall effect. It should be reiterated that these steps are only one brief guide to the workflow in chroma keying within combustion.

Additional Tips for Chroma Keying

If possible, light the chroma key wall and the subject separately. Using soft, warm backlighting (or rim lighting) on your subject often helps separate the very edge from the background color when keying.

Without going into the physics of it all, video equipment responds better to chroma key green and film emulsion responds better to blue. Often you don't have a choice because the studio or location has a specific color already in place. It is fine to use blue for video and green for film, but if you are given a choice, it does not hurt to choose your color according to your acquisition source.

If you are shooting on video of any kind, using a 3CCD or 'three-chip' camera will produce a superior image than if you only use a single-chip camera. This is because there is a separate CCD for RGB color information.

Avoid any compression such as DV or HDV if at all possible. Digital Video in the DV and HDV format is highly compressed to fit on miniDV tapes. While the general use of DV and HDV is great and can look fantastic, these formats are far from ideal for chroma keying due to their compressed nature. If possible, shoot/digitize directly to hard disk in an uncompressed format when acquiring source chroma key footage.

Avoid using auto focus, auto aperture, or auto white balance on a chroma key shoot. These will almost always make keying more difficult because the camera is changing your image dramatically on the fly. Even if you cannot tell so in your viewfinder or preview video monitors, the range of colors is dynamic and presents problems when pulling a key digitally. Manual 'everything' is always the preferred way to go.

If possible, use a shallow depth of field if you can. This will cause the chroma key wall to be slightly out of focus and will aid in eliminating it with a keyer because minute shadow or fabric detail will be reduced.

When shooting your subject, shoot the subject in focus and do not try in-camera tricks like blurring the image for effect. It is much easier and vastly more flexible to add blur as a post-process in combustion. Acquire the source footage of the subject as crisply as possible so that the edges where the subject meets the chroma key wall are clean and in focus.

Make the subject as large in frame as possible. Many people make the mistake of framing their subject as they want it in the final composition. The only thing that actually matters is the lighting and the camera angle, not the placement of the subject in the frame. You can always scale down and move the layer after you have pulled a successful key. This might not be the case with a camera that is moving, but for locked down shots, get the subject as big in frame as possible.

Additional Resources for Chroma Keying

For chroma keying DV, HDV, and other compressed footage, there is an excellent third party plugin available at www.DVgarage.com. DV Matte Pro, by Ben Syverson, is an inexpensive chroma key plugin that you can use in combustion that is very forgiving when generating a matte from a compressed source.

www.Ultimatte.com is a company that is synonymous with chroma keying and has been creating hardware and software for decades. The AdvantEdge plugin is a chroma keyer that has years of development behind it, but at a price. Currently the plugin for Mac and PC is more than the cost of combustion itself. However, if you are heavily involved with chroma keying, this is well worth the investment in the long run. Just like any product, remember that no single-chroma keyer does it all and, in some circumstances, you might use several different keys to get the job done. Ultimatte is a great solution in many cases.

www.StudioDepot.com is an excellent reseller of chroma key supplies of all sizes, including a portable/cloth model that is 5×7 feet and is also collapsible. Studio Depot also carries different assortments of chroma key paint, fabric, tape, etc. Find the Special Effects section in their web site for tons of great goodies.

For a more permanent chroma key wall, check out www.procyc.com. This solution is a bit more costly than fabric or merely painting a wall, but these cyclorama components are beautiful up close.

CHAPTER 9 THE TRACKER

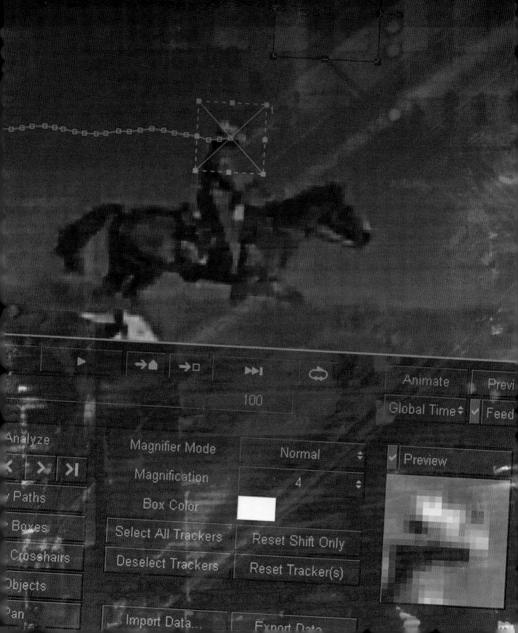

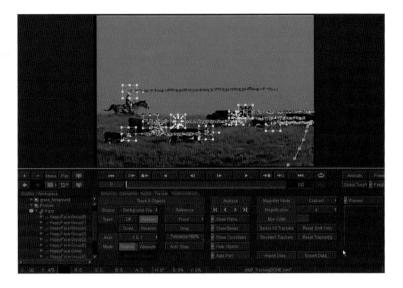

The Enigma Unveiled

While the Tracker is, most definitely, an extremely powerful tool within combustion, it should be said that it really does nothing magical and is not bulletproof (no tracking software is for that matter). The success of the Tracker is largely due to input from you, the user.

Fundamentally speaking, the Tracker is really just a keyframe-generating assistant. That's it. The Tracker does nothing that you could not do by hand; it just aids in creating keyframes, but hopefully speeds up your workflow in the process. It does this by analyzing the image and calculating the pixel shifts based on areas of defined interest.

Note: Combustion uses a 2D tracker that follows changes in pixel data in the images. It does not track 3D camera data.

To immediately reiterate a critical point, the Tracker only generates keyframe data. After it has done this, you move on and the tracking data gets applied to an element in your Workspace as keyframes of position and/or rotation and/or scale information. At that point, the data no longer resides in the Tracker.

Two Questions to Consider

When you are dealing with a tracking solution of any kind, there are two fundamental questions that you should ask yourself to help you with the tracking workflow. You can consider this pair of inquiries the axioms of tracking, if you will. These two questions, or more importantly, the answers to these questions, will help you determine the workflow of the Tracker within combustion at any given time:

- 1 In my image, what is the best reference to provide each tracker?
- 2 What am I going to apply the resulting data to?

The first question is typically the more difficult to answer. Here, you have to look at clips in your viewport(s) to determine what can be isolated and used to extract keyframe information.

The second question is usually a bit easier to answer. The fact that you even thought of using the Tracker probably indicates that you want to use it to apply keyframes to an element within your project.

For example, if you say to yourself 'this clip is shaky and I want to stabilize it', then the Stabilization operator is where you are going to apply the data.

Note: You can track multiple objects in your shot at the same time. Depending on the use for the Tracker, you can have numerous trackers being utilized at any given time.

Applications for the Tracker

You can utilize the Tracker for any number of things within combustion. Its applications are really up to you and your specific project requirements and footage. Below is a brief summary of some common workflow solutions that take advantage of the Tracker.

You can track the motion of part of an image to pin another element to it. For example, if you have a clip of a person walking through frame, you could take an image of a hat and track it on top of their head. This would make the hat move in sync with the layer of the clip with the person walking. Another common use for the Tracker in combustion is to keyframe an emitter within a Particle operator. This would allow you to have a single source of particles follow an element within footage; for example, smoke coming out of a panning chimney.

You can track the control points of a vector object within combustion as seen in

Figure 9.1. Remember that vector objects can occur within a Paint operator as well as in others such as the Draw Selection or Draw Mask operators. For example, using the Paint draw mode of blur or smear, you could paint a small dot on an actor's blemish to remove it

Figure 9.1

For garbage masks commonly used in chroma key shots, you can often track the control points of the mask shape to the object that the mask is meant to obscure. This is often used with great success to track several mask control points at once, so that the mask can distort and drastically changes shape over time, if necessary.

For simple wire-removal shots, you might paint a straight line using a clone source and then track the end points (not the object, but the control points at each end) of the line to an item in the footage containing the rope or wire rig.

You can use the Tracker in combination with the Stabilizing operators to make handheld or vibrating source footage smooth. There is one- and two-point stabilizing within combustion, and both are operators that rely on a symbiotic relationship with the Tracker.

You can track a 'pick point' for an operator tool. Examples include the center of Dolly Blur or Lens Flare operators and the center of the Magic Wand tool within the Paint operator. This would allow the effect of the operator to travel along with an element in your clip.

In a 3D composite, you can use the Tracker to attach the four corners of a layer to elements seen in another layer. This technique is called 'four-corner pinning' and can be accomplished by first making the layer shape a four-corner layer, as seen in Figure 9.2.

Figure 9.2

Then, while holding down the Shift key on the keyboard, each corner can be selected and then tracked to elements in another layer. This is typically used in cases such as replacing a sign on a moving vehicle or putting an image onto a blank television screen.

Let's Make Tracks, Already!

To make some sense out of all of this tracking business, let's first skip the details of the Tracker and go through the motions of performing two simple tracking operations. The first will be tracking a group of vector paint objects onto an element in the footage. The second will be to simply track one layer in a composite to another. We will then look at the details of the tracker in depth:

- 1 Open the Workspace named ch09_Tracking.cws. This is a composite containing two layers; the top layer is temporarily turned off for the moment.
- 2 In the Workspace panel, expand the layer named Pasture and the Paint operator applied to this layer until you see the group of vector paint objects named HappyFace-Group.
- 3 Double click on the name of this group to assign the output of the Paint operator to the viewport. This double click will also select this group at the same time. Your Workspace panel should now resemble Figure 9.3.
- 4 Access the Tracker tab under the Playback Controls or by hitting the F7 key. At the top of the Tracker controls, it should say Track 1

Figure 9.3

Object, as seen in Figure 9.4. This one object is the group making up the happy face.

Click on the Position button

(Position) to turn on the Tracker
and also specify the type of
tracking data you wish to
generate. The happy face will

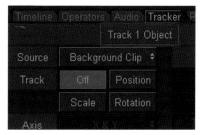

Figure 9.4

disappear. It has been temporarily turned off by the Tracker to allow you to place the tracker object without obstructing your view of the reference image.

- 6 Carefully float your cursor to the center of the Tracker boxes (now visible in the viewport) until your cursor changes to a light-blue crosshair pointing in four directions.
- 7 Click and drag both the Tracker boxes down to the cowboy's head. The Tracker will temporarily switch to a magnified mode to allow

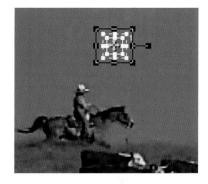

precision placement of the Tracker. When you are finished, the Tracker Preview window should look very similar to Figure 9.5.

Leave all the Tracker settings to the defaults and click the Analyze forward button (). You will notice the Tracker begin working. The Preview window at the bottom right-hand side of the Tracker palette will update, showing the matching reference found by the Tracker as it goes, and there will be a green dotted line representing the keyframe results of the track in progress.

Figure 9.5

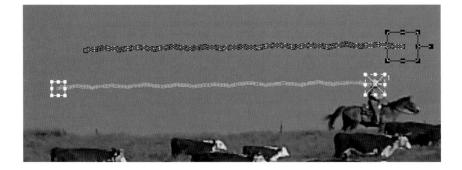

9 When the Tracker is complete, click the off button highlighted in Figure 9.6.
This will turn off the Tracker and apply the data to the happy face.

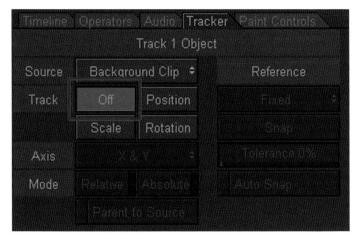

Figure 9.6

- 10 Play back the clip. You will notice that the happy face now travels along and bobs up and down in the exact same manner as the cowboy's head, but with an offset in position.
- 11 While the animate button is off, you can now select the happy face and position it anywhere. Using the arrow keys on the keyboard, position the happy face over the cowboy's head. The animation keyframes that have been applied by the tracker will remain applied to the group of paint objects, but you will offset the location of the entire animation.

Suggestion: Now try turning on the top layer named *grass_foreground* and tracking its position to the cowboy layer. The only real difference in the workflow is that you will have to change the Source to the layer named *Pasture*. At this point, you may want to ensure you are looking at the output of the composite by double clicking on it in the Workspace panel.

Trackers

Before you use the Tracker, the object(s) that you wish to apply the keyframe information must be selected. If you switch to the Tracker Palette (F7) and nothing is selected, the Tracker will not be available for use, as seen in Figure 9.7.

Figure 9.7

The Trackers themselves consist of a few items that all work in tandem with one another. In Figure 9.8, a color-coded version of the Tracker boxes has been recreated for clarity. The Tracker boxes in combustion will all be the same color, typically white.

Reference Box – The solid black inner box represents the image data you are providing the Tracker as a reference to look for from frame to frame. The contents will

Figure 9.8

be visible in the Tracker Controls preview window. You can move the Reference box by clicking and dragging within the shape. Your cursor will change to a four-way arrow indicating you are ready to make the move.

Tracker Box – The dotted, outer box represents the area (from frame to frame in your source image) where the inner Tracker box will look for the reference. If the element being tracked does not have a lot of extreme movement from frame to frame, this box can be small. Conversely, if the item to be tracked jumps around from frame to frame, then this box will need to be expanded to allow the Tracker to look for the item within a larger range of pixels. The larger this box is, the slower the Tracking process. The Tracker box should be made big enough to accommodate the largest movement from between any two frames.

Scaling Handles – The green dots on both boxes represent scaling handles for each box. You can resize the Reference and Tracker boxes by pulling on these handles. Your cursor will change to a two-way arrow indicating a resize.

Number – Individual trackers are often numbered for clarity. This becomes especially helpful when you use two or more trackers at the same time.

Picking an Element to Track

In Figure 9.9, the top row of red boxes indicates elements that the Tracker would follow well and the bottom row of blue boxes displays elements that the Tracker would probably have real problems with. Now why is this?

Figure 9.9

Notice in each of the red examples, there is something distinct within the Tracking box that the Tracker could 'lock onto'.

In all of the blue examples, there is nothing distinguishable in any of the samples. What you need to provide the Tracker with is a unique reference in X and Y.

One might think that the fourth, checkerboard pattern would be OK because of all the distinct edges, but the repetition will cause the Tracker to find the solution in a number of places and not just one. In this case, the Tracker will jump all over, as is potentially the case if you try to track a clean, brick wall. The reference can be found in more than one place in those cases.

The rest of the blue/bad Tracker items will cause the Tracker to slip along the pattern, because elements within these boxes will, undoubtedly, continue outside of the reference box. This will cause the Tracker to slip up and down or diagonally along these items. You may think it is doing a fine job when it is not because, in these cases, the Tracker will actually find what you asked it to look for. Imagine that the second blue pattern was a limb on a tree. This limb undoubtedly extends past this reference point in both directions and therefore will cause problems for the Tracker without greater detail.

When looking for an element in your footage to track, it is a good idea to first cache your footage before tracking. This will allow you to quickly scrub through the frames and concentrate more easily on the procedure of locating a good reference for tracking. Ideally, the reference item will be visible in all frames.

The Tracker Interface in Depth

Source

The Tracker can be accessed at any time by accessing the Tracker tab under the Playback Controls, from the Window > Palettes menu at the top of the combustion UI, or by tapping the F7 key. The interface for the Tracker is seen in Figure 9.10 as it is first encountered.

Figure 9.10

Notice that, in this example, all the controls for the Tracker are disabled with the exception of the Source (none) rollout. This is because the Tracker is turned off when you initially access it.

Composite – When dealing with a composite, the source should be set to the layer that contains the element(s) to which you intend to track your layer or object. This may or may not be the same layer as the one that contains the element onto which you intend to apply the data, as is the case if tracking one layer to another, for example.

Paint Operator – In the case of tracking elements within a paint operator, the options for (Tracker) source will not show layers, but will, instead, allow you to either track the **Background Clip** or the **Clip and Objects** within the Paint operator. Background Clip ignores other paint objects and Clip and Objects will consider them when tracking.

Track (Options)

Position – This option enables a single tracker to follow the position of the reference data.

Rotation – When you enable rotation, two numbered trackers are created, as seen in Figure 9.11. If one tracker's position goes up or down, then this indicates that the source is rotating. Remember, an individual tracker can only track position. Two trackers are needed to calculate rotation and/or scale.

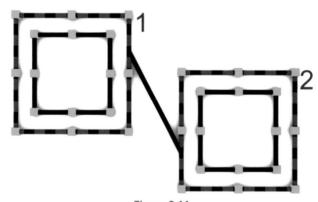

Figure 9.11

Scale – When you enable scale, two numbered trackers will be used as when you track rotation; however, instead of measuring the up or down changes

between the trackers, the distance between the two trackers is used to calculate scale changes. If the pair of trackers grow apart over time, there is a scale increase applied. If the distance decreases over time, there must be a decrease in scale.

Off – As simple as the name suggests, the Tracker's off button is undoubtedly the most often forgotten step in the tracking process. After you have performed a track that you are happy with, the data does not automatically get applied to the elements that you are tracking until you turn the Tracker off. It should also be mentioned that after you turn the Tracker off, the data is then transferred from the Tracker to the object or layer in question. The entire process has been applied and there is no undo. While you can certainly re-track something by repeating the whole process over, you might want to either be completely certain of your work before turning the Tracker off or take advantage of the Export Data feature while the Tracker is still enabled. When you turn the tracker off, all the keyframes generated by the Tracker can then be found on your object(s)'s X and Y channels, and can be modified from that point on using other methods.

Axis

X & Y – This option means that the horizontal and vertical position of the item that you are tracking will be analyzed and that keyframes will be generated for both channels.

X Only – This option means that you will only be tracking the horizontal motion of a tracking target. This is useful if, for example, you had footage of a ball bouncing across frame and only wanted the lateral motion tracked, but not the bounce.

Y Only – This option tracks only the vertical motion of the tracking target. In the case of a bouncing ball, only the bounce would be tracked, but not the lateral movement across the frame.

Mode

Relative – If your reference is in a different location in the image than the object or layer you are tracking, then this is a Relative track. In the example of the

cowboy, you performed a Relative track at first and the result was that the happy face was offset from the element you tracked.

Absolute – If the reference in the source and the item you are applying the tracking data to are in the same location in the image, then you want to perform an Absolute track. For example, if you want to do a four-corner pin for a label replacement, the corners you are tracking are in the same location as the destination layer's four corners.

Parent to Source – This option will be available when you are tracking within composite but not when you are tracking a Paint operator. Enabling this checkbox means that after you finalize your track and turn the Tracker off, the layer that you applied the tracking data to will have the source layer as its parent. This is useful if you think that the parent layer may, for example, go through transformations such as position, rotation, or scale, and you want the object that was tracked to this layer to inherit the same transformations.

Reference

Fixed – Selecting this option tells the Tracker that the reference identified for that particular tracker does not change in appearance over the course of the clip. A common misconception is that Fixed means the items being tracked are locked down and immobile, such as a fire hydrant is to the ground.

Roaming – Any image-based tracking system looks for a reference pattern that is identified by you, the user. Ideally, these items do not change in appearance or shape over time within the clip. If the pixels representing the items that you are tracking change in appearance over the duration of the clip, then this is considered a Roaming reference. This means the reference will be updated based upon the Snap and Tolerance settings.

Snap – If the reference being tracked changes shape drastically at some point in your clip, you can stop the Tracker – click the Snap button to update the contents of the reference. From that point on, the new reference will be what the Tracker will look for in your image.

Tolerance – This feature adjusts the leniency of the Tracker if it cannot find an appropriate match for the tracking reference base on the Tolerance value

(a keyframe will not be created on that frame). The default tolerance of 100% will generate a keyframe on every single frame no matter how poor the match to the reference is. Lowering the tolerance makes the Tracker more rigid in its search for the target. A Tolerance of 0% will only create a keyframe if an exact match is found (which is extremely rare). If a reference is briefly obscured, for example, then you can adjust the Tolerance to accommodate this brief obstruction.

Auto Snap – You can enable Auto Snap to let the Tracker do its best with the Tolerance settings. If it does not like the results it gets on any given frame, it will snap the tracker reference to the last acceptable match found.

Analyze

The four icons in Figure 9.12 are for stepping through the actual process of tracking. The outer buttons are for single frame forward () and backwards analyzing (). The inner are for letting the Tracker analyze forward () or backward () automatically.

Figure 9.12

Note: When using the inner buttons for automatic tracking, you can click the same button again to stop the process part way through. This can be useful if you see a tracker lose its goal and begin to jump about on screen.

For the options in Figure 9.13, the defaults are typically fine and actually helpful, especially when learning combustion.

Show Paths/Boxes/Crosshairs – These options are to toggle the visibility of the keyframe data from frame to frame, the Tracker Boxes, and the crosshairs of the reference to be tracked.

Hide Objects – This option forces the Tracker to temporarily hide (turn off) the elements that you will

Figure 9.13

be applying the data to. In the previous exercise, the happy face was disabled during the track and then turned back on when the Tracker was disabled.

Auto Pan – This feature will pan the viewport automatically if you happen to be zoomed in when performing a track.

Magnifier Mode

When you move a tracker in the viewport, these options change how the tracker reference data is displayed while being dragged.

None - The contents of the reference box will be the same as in the viewport.

Normal – This option uses the magnification setting (below) to determine how the reference box will be displayed.

Contrast – This option changes the contents to a high-contrast, black and white version of the reference box while it is being placed in the viewport.

Edge – This is similar to Contrast in that the contents are displayed in black and white, but the image is an edges-only version of the reference.

The Rest of the Options

Magnification – This is a multiplier of the reference size.

Box Color – This is a color swatch (box 5000) that allows you to change the color of the box of any selected trackers. You can use this if your trackers are difficult to see against the background footage.

Select All Trackers/Deselect Trackers – This is a quick way to select all (Select All Trackers) or none (Deselect Trackers) of the trackers onscreen. While you may sometimes want to analyze trackers one at a time, you can also perform multiple tracks to all trackers by clicking the Select All Trackers button before you do the analysis.

Reset Shift Only (Reset Shift Only) – Only tracking data gets reset, but not the shape and location of the Tracker boxes. Often, if you perform a track and the tracker mistakenly flies all over the place, you may just want to reset the (bad)

data without changing the shape of the Tracker boxes. If you have manipulated the shape of a tracker to accommodate a large or small reference, this will keep these boxes sized per your edits.

Reset Tracker(s) (Reset Tracker(s)) – This will reset the position, shape and any keyframe information for a tracker. When things go really wrong, this is a way to start over for the selected trackers without having to turn off the Tracker itself.

Import/Export Data (Import Data

Preview – This window will show frame by frame the match for the reference by the current tracker. When you have more than one tracker selected, it will show the contents of the last tracker that you select.

Image Stabilizing

There is a category of operators named Stabilize that contains two operators. One is for one-point stabilizing and the other is for two-point stabilizing. These operators are used in conjunction with the Tracker to make footage that has some form of vibration or shake appear as if it was shot mounted on a tripod. The Tracker essentially follows a reference in the frame, the data generated by the Tracker is inverted, and then this negated information is applied to the image so that the new keyframes cancel out the unwanted movement.

To see the workflow of stabilizing a clip with one- and two-point stabilizing operators, we will apply each operator to the same clip to see the differences between the two.

Stabilize 1 Point

This operator is typically used when there is just lateral and vertical motion in a clip, or positional changes in X and Y. This operator uses one pick point and one tracker to invert the motion within a sequence.

Stabilize 2 Points

This operator can also be used to remove positional X/Y data, but it can also optionally eliminate rotation and/or scaling information. Rotation in frame would be caused by an in-camera tilt and scaling is typically caused by either an in-camera zoom or when the camera physically moves closer or further away from the subject. If you want to remove rotation/scale information from a sequence, two pick points and two trackers must be used.

To perform a quick, one-point stabilization:

- 1 Open the Workspace file named ch09_Stabilize.cws.
- Cache the clip with the looping playback option selected. As the clip plays back, notice how there is camera movement and that this movement is in both lateral and vertical directions in the frame. When you have finished, stop playback and return to the first frame.
- 3 Select the layer named Running in the Workspace panel.
- 4 Apply a Stabilize > Stabilize 1 Point operator to the layer and then, with the newly applied operator selected, switch to the Stabilize 1 Point Controls tab seen in Figure 9.14.

Figure 9.14

- 5 Pick the crosshairs icon for the Stabilize Point (). You will notice there is now a crosshair located in the viewport in the center of frame at (360,240).
- 6 In the viewport, click the cursor on the edge of the column indicated in Figure 9.15. To position the crosshair, simply click on the image. There

are, certainly, many good tracking options in this clip, but this is a nice predominant edge and it also stays in frame and unobstructed for the entire duration of the clip. You are looking for a reference that remains fixed throughout the clip.

Figure 9.15

- 7 Click on the Tracker tab to access the Tracker Controls and then click the Position button (Position) to turn on the Tracker.
- 8 Use the default values and click the analyze forward button (>>). This will start the tracking process and the track should complete without difficulty. When satisfied with the tracking results, turn the Tracker off.

Note: The image stabilization does not occur until you turn the Tracker off.

Replay the clip and you will notice that while the layer named Running does not move, the pixel information in the frame is now shifting about to compensate for the motion in the clip. In Figure 9.16, the border has been changed to red for illustrative purposes, but your border is black and changes shape as the piece plays back.

Figure 9.16

10 Exit the Tracker by clicking on the Stabilize 1 Point Controls tab. Then switch the operator controls Mode from Shift to Fit. You will notice that the border goes away and the image is scaled to accommodate the image shift caused by the stabilization.

Tip: For a really strange effect, redo this process but in step 6, pick the woman's face instead. The end result is that the stabilized clip still seemingly has camera motion, but the woman's head is kept perfectly still in frame. This is one way they achieve the effect in those car commercials where the world dramatically changes around a perfectly static (yet rolling) automobile.

Stabilizing Options

Now that you have seen the basics of the stabilization process, the following descriptions of each feature will hopefully be clearer.

Stabilize Points – In one-point stabilizing, this is a reference point to calculate how much movement is in your image. You typically pick a reference that you will later use in conjunction with the Tracker. In two-point stabilizing, point 1 is

the reference for X and Y movement and point 2 is used in determining the rotation or scale changes.

Mode – This option determines how the pixel information will be displayed after the stabilization data has been calculated:

- Shift: Pixels are not interpolated in any way and a border of color is left where stabilization compensation is needed.
- Fit: This option scales the image to fit the size of the layer. Technically speaking, this causes up-scaling and interpolation of pixel data, which means a loss in resolution. In small amounts, the viewer would never know it, but in shots containing gross amounts of movement, this option will introduce the jaggies associated with up-sampling raster images.
- Wrap: This option is only available in one-point image stabilization. This
 ensures that no pixel information is lost. As the image compensates for
 movement in frame, any pixels 'lost' on the left side of the frame are
 wrapped around and now visible on the right side, etc. This is often used in
 conjunction with the invert options, so that you can return pixels to their
 original location, should you so choose.

Resize Image – Enabling this option means that the layer will become larger or smaller according to the results of the stabilization. When disabled, the layer will remain the same size and the pixel information within the image will do all the compensation.

Borders – This controls how the edges of the frame will be treated after the stabilization has been calculated and applied:

- Use Color: This option allows you to change the color of a border that may show up when the Mode is set to Shift. This feature was used to change the border to red in Figure 9.16.
- Transparent: This means that the edges of the clip will become a transparent
 alpha and pixel information below will be allowed to show through in these
 areas.

Invert – This option is only available in one-point stabilizing. This allows you to negate the effects of the stabilization process. An example of when this can be

particularly useful is when you track camera shake not to remove it but to actually introduce it to other elements in your Workspace. You could, for example, go through the process of removing camera shake, then cut the entire stabilize operator off the source of the camera shake and paste it onto one or more other layers. Then, if you invert the data, the elements will all appear to have the camera shake as well.

Position/Rotation/Scale – These will only be available as options in two-point stabilization because they involve the comparison of two references. Scaling and Rotation cannot be calculated with just one reference:

- Position: This option acts just like a one-point stabilizer and only uses the first pick point (point 1) for calculations.
- Rotation: Point 1 is used as the axis of rotation and point 2 is used to
 actually calculate the amount of rotation. Ideally, you will pick points that
 should be immobile in the shot. In addition, the further away from each
 other the points are, the more accurate the results will typically be.
- Scale: The distance between the two pick points is used to determine if
 the image data is scaling up or down. When you attempt to remove the
 effect of an in-camera zoom, you should pick two points that are the
 same distance from the camera so that the changes in distance of the
 two trackers reflects a common, relative change.

Closing Tips

Two things to remember when using the Tracker are: (A) the items that you are going to apply the tracking data to must be selected before going into the Tracker; (B) you have to turn the Tracker off to apply the data to those items. When you do, the tracking process is done and actual tracking data is lost (unless you exported it before turning the Tracker off). The data is then transferred to the items, as can be seen in the Timeline and in the viewports.

Try the default Tracker box sizes first and only resize them if you need to. New users almost always edit the inner and outer Tracker boxes way too big (for reasons I cannot explain). When initially placing and sizing your Tracker boxes, remember that you can zoom in well beyond 100% to get right in on them. Quite often, the default Tracker boxes are very small and when you go to move one, you resize it by accident, or vice versa. Do not worry too much about this, as it is an undoable function.

Take advantage of the ability to change the color of Tracker boxes if your footage makes them difficult to see or if you have several trackers all overlapping and crossing each other.

Lowering the tolerance, using Auto Snap and Roaming track mode are all fine options to use, but they are prone to introducing error. Use these as needed but not as a first-pass solution.

Tracking backwards can sometimes work better than tracking forwards. This can be accomplished by using the backward facing analysis buttons within the Tracker UI. Ask yourself if the item you wish to track is more clearly defined at the beginning or end of the sequence. Quite often, the results from tracking an element backwards can be more successful than the exact same element tracked forwards. This might be especially true when using a roaming reference.

This is just an option, however, and not always the case. Every shot and every track presents its own challenges.

When you are tracking an element with low contrast, you can apply a Brightness/Contrast operator prior to doing the track. By forcing a higher contrast in the clip, the Tracker may provide you with better results. Then, when satisfied with the tracking, you can disable or delete the operator.

You can often do partial tracks and then manually keyframe the rest. Do not be disappointed if you have to do a partial track. Letting the Tracker do some of the tedium and doing the rest by hand is often a reality. For example, if you had a 500-frame sequence and, no matter how careful you were, you could only perform a successful track on the first 400 frames, you could manually keyframe the rest of the animation.

When Stabilization operators have been applied, you can easily see the before and after by letting the cached clip play back and toggling the Stabilize operator on and off in the Workspace panel. Another method is to switch to two viewports and have one show the output of the Stabilize operator and the second showing the output of the node just prior to the Stabilize operator. Both of these options will, however, require both to be cached. You can also use the Render to RAM feature outlined in Chapter 7. This utility can utilize the Compare option that allows you real-time playback of a before and after in the same viewport.

CHAPTER 10 ANIMATION AND THE TIMELINE

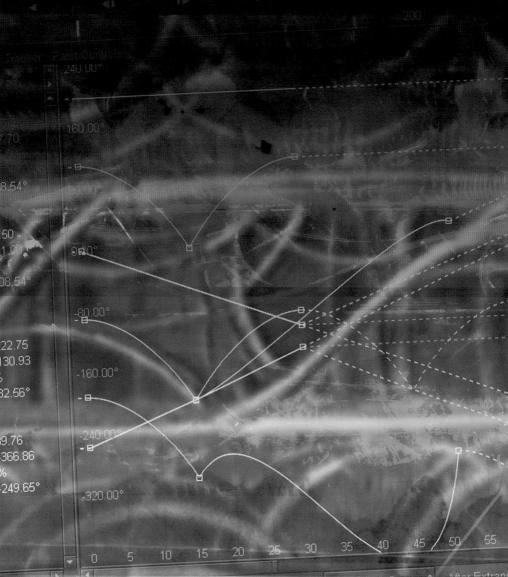

When and How Much?

At its heart, combustion is an application which has the vast majority of its toolset designed for animation. Using several different methods, most parameters allow you to change and keyframe their values over time. One way I like to define computer animation of any kind is by thinking in two terms: when and how much.

The 'when' is typically measured in frames or time code and the 'how much' can be just about any value in the application. Changes in when and how much equate to animation. For example, if something is invisible at the start and over 3 seconds becomes totally visible – the 'when' changes from the first frame to 3 seconds in, and the 'how much' changes from 0% visibility to 100%. Measuring the time (when) is easy, but there are so many potential values for the different 'how much' settings. How much red? How much feather? How much Z rotation? . . . and so on. These values in combustion are all considered 'channels' that can be animated.

While examining previous Workspaces to discuss other features, we have already seen some examples of animation within combustion; however, we have not discussed the different ways of creating these animations in depth. In this chapter, I will continue to use this simple when and how much vernacular to describe certain aspects of creating and editing animations within combustion.

When = frame number or time code

How much = a value of an animation 'channel'

Methods of Animating in combustion

Flipbook – This can be considered the simplest, brute-force form of animation, whereby you manually make changes on every single frame and then play them back in rapid succession. Computer graphics obviously allow for easier ways of animating, but quite often, one still has to resort to frame-by-frame work to accomplish certain tasks. **Onion Skinning** is a utility in combustion that aids in the flipbook/cartoon method of animating. Onion skinning can be used

at any time for any reason, but it is often extremely valuable when doing frame-by-frame animation similar to traditional animators using clear acetate.

You can access the dialog seen in Figure 10.1 by selecting Onion Skin Settings from the Window menu at the top of the combustion UI. What onion skinning does is show you proceeding and successive frames as transparencies over/under the contents of the current frame. These transparencies will not render, but are merely there to help you work without flipping the Playback Controls back and forth. To actually use the onion skin options, you must enable Onion Skinning from the Window menu (or by hitting the ']' hotkey).

Figure 10.1

Keyframing – Keyframing is, perhaps, the easiest way to create and control animation. Keyframes work by setting a start and end value (when) for something (how much) and then letting the computer calculate values in between. This is also known as interpolation, which is the generation of data

based on two different versions of something. You provide a start and end point and the computer interpolates the values in between.

Keyframing in combustion can be done in several ways but the easiest is by using the Animate button (Figure 10.2). When the Animate button is on, it turns red and changes in values (how much) are being recorded and keyframed on

Figure 10.2

the current frame (when). The Animate button will always be visible and can be used at any time. For example, you can simply enable the Animate button, go to a new frame, and move an object or layer across the viewport. You can then play back the animation and see the translation across the frame.

Note: The Timeline, which will be detailed in a moment, does not need to be visible to use the Animate button.

As simple as this method is, it is extremely common for new users to forget to turn this Animate button off when finished with it. I almost wish there was a warning buzzer when the Animate button was enabled, for if this button is red and you are creating and editing anything in combustion, then you are recording these changes (how much) on any given frame (when). This is another point that comes up again and again to most new users. You must always be aware if this Animate button is enabled, and turn it off the second you are done animating values. Another really good work habit is knowing what frame you are working on at all times, especially when this Animate button is enabled. This can easily be accomplished by looking at the number or time code to the left of the Playback Controls.

You can also build keyframe animation by creating keys directly in the Timeline.
Figure 10.3 highlights the Add Key button, which is always available when viewing the Timeline. You can also simply click directly on the Timeline to add a keyframe.

When you are starting out using combustion, I recommend using the first

Figure 10.3

'Animate button' method and only using the Timeline to edit existing animations, not to create new animations from scratch in the Timeline. This will

allow you to become comfortable with the Timeline and not confuse yourself with learning keyframing, animation and the Timeline interface all at once.

Tracker – The Tracker generates keyframe data that can then be manually edited in the Timeline. The Tracker is discussed in greater detail in Chapter 9.

Expressions – Expressions are a means to use the JavaScript programming language to procedurally animate different channels in many, many different ways. Expressions in combustion are discussed in greater detail in Chapter 12.

Creating Simple Keyframe Animations

We will start by creating an extremely simple animation to keep things clear. Keep in mind that all animation is merely changes in 'when' and 'how much' of any parameter in combustion. As simple as this is, this technique can be applied to nearly every value in combustion:

- 1 Create a new, 100-frame paint branch using the DV preset.
- Make a simple shape on the first frame using the Freehand Paint tool ().
- Select this object by using the Arrow tool (). Your viewport should resemble Figure 10.4.

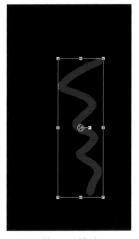

Figure 10.4

You will now animate the object across screen with three keyframes.

- 4 Enable the Animate button to the right of the Playback Controls. It will be red when turned on.
- Go to the last frame and drag the paint object across screen from left to right by clicking on it with the Arrow tool. You will notice a green path in the viewport. This is an indication of the motion of the object.

- **6** Go to frame 50 and pull the object down in the viewport. Notice that you just created keyframes out of order, which can often have its advantages.
- 7 Turn off the Animate button and leave this simple project open.

Tip: This method is a very good way to animate in that you start and end the object when/where you want it, and then let the computer interpolate the in-between values. You, as the animator, decide when/where refinement is needed. This contrasts a method in which you set a key, advance a certain number of frames, set another, and continue doing this to the end. This second method often generates too many keyframes that can result in jerky animation.

With the object still selected, you should be able to see the resulting animation path in the viewport similar to Figure 10.5. This path can be edited directly in the viewport (with the Animate button on or off) or by editing the animation curves in the Timeline. If the Animate button is turned off, editing the keyframes and their tangent handles will change that particular point, but transformations to the selected object will offset the entire animation curve.

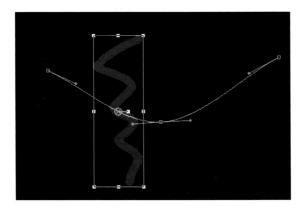

Figure 10.5

Now that you have created some keyframe animation, let's go into the Timeline and explore different ways of editing and manipulating keyframes.

The Timeline

The Timeline can be accessed at any time by hitting the F4 key. This is an interface for viewing, editing, and creating keyframes of animation, and is also where you will create and edit expressions. Down the left side of the Timeline, you view and select different animation channels in a vertical order identical to the Workspace panel. Across the bottom of the Timeline is a measurement of time. This measurement corresponds to the setting in the Playback Controls (frames from 0, from 1, or time code).

Tip: To temporarily expand the Timeline, you can hit Shift + F11 and the entire combustion UI will redraw for a moment. Then, you will have a much larger space to work, should you so desire. You can toggle this back to normal size by hitting Shift + F11 a second time.

The Timeline can be viewed in two distinct ways: Overview and Graph modes. These two modes can be toggled just to the right of the Timeline. They both have their advantages and it is certainly worth understanding the differences.

Overview – This is the big picture of 'when' keyframes. Overview allows you to see when keyframes occur and on what channels, but does not display the 'how much' of a value. For example, in Figure 10.6, there are four keyframes on both the X and Y position channels. You can see that there are keyframes on the first and last frames, and also around frames 30 and 72. As you are in Overview mode, you cannot see what the values are for each of these keys – only that there are keyframes on those channels at those locations in time. The numerical values next to an animation channel only reflect the value of that channel on the current frame. When you move keyframes left or right, you are changing when they occur, but not the value of the keyframe. My recommendation is to always enter the Timeline initially in Overview mode so you can easily find the channels and/or keyframes you wish to edit. Then switch to Graph mode for fine-tuning of the keyframe curves.

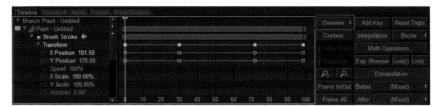

Figure 10.6

Graph – This is the nitty-gritty. Here, you can see function curves that represent the changes in both when and how much. Time (when) is always represented across the bottom and 'how much' values of any kind are viewed on the left, vertical scale. This scale can change depending on the animation value selected. For example, transparency can only range from 0% to 100%; other values can be infinite in positive and negative. Some values in combustion must be whole numbers while other values can be fractional or decimal values. There are even times when the vertical scale will be words, as in the case of Transfer modes (Normal, Multiply, Hard Light, etc.). This scale will change to reflect the measurements of the animation channel(s) selected, but time will always be measured across the bottom.

Note: The Particle operator is the sole exception to this. In a Particle operator, time is still measured across the bottom of the Timeline, but instead of time code or frames, time is represented as a percentage of the particle life.

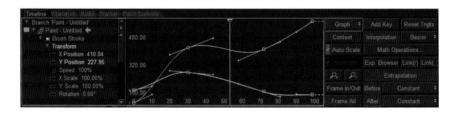

When in Graph mode, the cursor defaults to changing the value of a keyframe as indicated by an up/down cursor. Dragging keyframes up and down in the Graph mode changes the 'how much' of a value. To change the time of a keyframe in Graph mode, hold down the Alt key and the cursor will change to a left/right cursor. This changes the 'when' of a keyframe.

Auto Scale – This option is only available in Graph mode. When enabled, the Timeline scales to fit the selected channel's curves in the window. If you want to manually override this, you must first disable Auto Scale, and then you can use the following shortcuts:

Control + drag up/down	Vertical scale of Timeline
Control + drag left/right	Horizontal scale of Timeline
Alt + drag	Pans Timeline

Animation Channels and Filtering

By default, the Timeline has much more detail listed down the left side than is listed in the Workspace panel. The Workspace panel has a small flyout option tab that can be seen in Figure 10.7. For most purposes, this should be left to the default setting of: *Show Operators . . . and Objects.* This will allow you to select layers, operators, and objects without looking at animation channels for every single object. In the Workspace panel, this is a time saver.

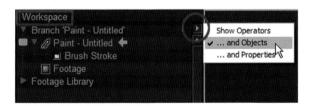

Figure 10.7

In the Timeline, however, you want to have access to all the individual channels of everything in your Workspace. This is because the Timeline is one place where you will potentially keyframe and edit any parameter. Figure 10.8 shows the Timeline options filters. For the Timeline, I highly recommend leaving the default setting of: *Show Operators . . . and Properties* selected.

Note: I would like to reiterate that the defaults described above for the Timeline and Workspace panel are probably the best settings while working in combustion. These controls provide 'what you need, where you need it' for almost all occasions, and changing them from the defaults often leads to confusion for new users. If you make a change to experiment and see the difference, I strongly encourage you to return these settings to the default values.

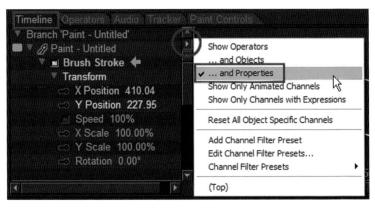

Figure 10.8

Default for Workspace Panel:	Show Operators and Objects
Default for Timeline:	Show Operators and Properties

The **Show Only Animated Channels** is a nice timeline option to turn on and off as needed when working in combustion. This filters out all the channels in the entire Workspace that have not been animated. If you know you are only editing existing animation instead of creating new animation, then this option weeds out the empty channels and presents only those with keyframes.

Show Only Channels with Expressions is a timeline option to filter out all keyframe information and, instead, see only those animation channels that contain JavaScript expressions (detailed in Chapter 12).

These filters are a powerful feature that sometimes confuses new users. If they are enabled and you are not aware of it, then you many end up hunting in the Timeline for something that is not currently available for editing; it is filtered out and hidden.

Object-Specific Channel Filters

When you have one or more objects selected in your workspace, you often want access to common parameters that might be animated. These are known as Object Specific and include position, rotation, scale, shear, and opacity. You can

access these by either right clicking on selected objects or choosing Show Object-Specific Channels from the timeline flyout seen here.

As an alternative, each has an associated hotkey that act as a toggle. That is, when you initially tap the P key, you create a position filer. Tapping the key again turns this filter off. For these hotkeys to work, a layer must first be selected. If a composite is selected, then all the layers within that comp will have the hotkey filter applied. The hotkeys are:

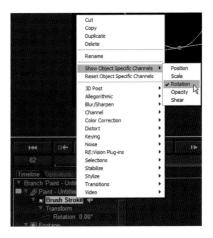

P Position R Rotation S Scale H Shear C Opacity		
S Scale H Shear	P	Position
H Shear		Rotation
	S	Scale
C Opacity	Н	Shear
	С	Opacity

To turn off any Object-Specific Channel Filters, you can also select Reset Object-Specific Channels form the flyout or tap the E hotkey.

Creating Custom Channel Filter Presets

Say you have a complex workspace with dozens or hundreds of different animation channels working at the same time. It can often be beneficial to create custom timeline filters so that you can, for example, see only the position and green channels of an object (whether they are animated or not). These custom filter presets can be named and recalled at any time. To do this:

1 Select one or more channels in the Timeline. These can be any channels you feel might need to be edited and recalled periodically down the road. You select animation channels by clicking on their names in the Timeline (Control + click to select multiples).

Warning: It should be made immediately clear, however, that selecting an animation channel not only isolates and displays this channel in the Timeline, but also selects all the keys in this channel. Keyframes that are not selected are white and keyframes that are selected are yellow. If you select a channel by clicking in its name in the Timeline, you will notice that all the keys on that channel turn yellow. Quite often, users select a channel by clicking on its name and they are unaware that all the keys are selected. Then, when they go to move one keyframe, they offset every single keyframe on this channel, not just the one they intended to move. This can be a powerful feature, but often confuses new users. To rectify/prevent this from occurring, you can select an animation channel and then click in a blank area of the Timeline to deselect the keyframes. Then you can edit them individually by selecting them individually in the Timeline.

- 2 Select Add Channel Filter Preset from the flyout seen in Figure 10.8.
- 3 Name the preset accordingly.
- 4 To recall this preset at any time, expand the flyout seen here for Channel Filter Presets. You can have numerous filter presets to assist you in building a project.

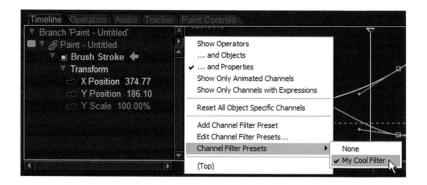

- 5 To edit or delete a custom filter preset, select Edit Channel Filter Presets from the flyout.
- To turn off all custom filters, select 'None' from the Channel Filter Presets flyout.

Context – Figure 10.9 highlights the Context option for the Timeline. When enabled, this option causes the Timeline to automatically show you channels of information pertinent to the current selected item in the Workspace. 'Contextual Timelines' will only show you values for objects you have selected. When Context is disabled, you have to navigate the Timeline manually and this can take some practice. It is a great idea to leave the Context Timeline option on when learning combustion. Once again, this enforces the adage, 'When in doubt, double click its name in the Workspace panel'.

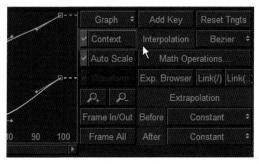

Figure 10.9

Back in Figure 10.6, the object named Brush Stroke is selected and because Context is enabled in the Timeline, only the animation channels pertaining to this object are visible. In addition, you can see that there are only keyframes in the X and Y position channels.

Frame All – This button forces the Timeline to quick-zoom to the width of the range of keyframes for the selected channels. Often when you are zoomed in, clicking on this button is the fastest way to zoom back out to full width.

The key icon next to the left of an animation channel's name indicates that the keyframing functionality is active for that channel. If you toggle this icon off for any channel, the animation for that value is temporarily turned off (and the value is held at the amount of the current frame). The keyframes, however, are still present, but they are inactive, not deleted. If you move the object at that point, the entire channel will be offset. It can often be useful to toggle an animation channel on and off while the clip plays back. This allows you to see the effects of that channel's animation in the overall, larger picture.

Ease Curves

Keyframes are usually defined in detail in animation manuals and tutorials, but there seems to be little emphasis describing ease curves. While keyframes, by definition, are essential 'poses' of animation, it is the ease curves between these keyframes where a lot of the finesse separates good and bad animation technique.

To explain the use of ease curves, I like to use a variant example of the old story of the tortoise and the hare. In my version of the tale, I will ruin the ending and tell you the race ends in a tie. That is, they begin the contest at the exact same time and they tie in the end; however, the race in between is where some interesting things occur:

- 1 Open the Workspace named *ch10_TieRace.cws*. This is a simple Paint branch with several animated groups.
- 2 Cache the clip and let it play back while looping.

To briefly explain what you are looking at, four paint groups have been animated from left to right and they all cover the same distance in the same amount of time. While this might be the case, it is obvious that the rabbit accelerates at the beginning and the turtle gets off to a slow start. The word 'linear' is the only one that remains at a constant velocity, yet all three groups start and end at the same time. What is interesting about these three groups is there are only two keyframes for each: one on the first frame and one on the last. It is the shape of the animation curves in between these keyframes that creates the variation of the three animations. Due to this, the animation for all three groups will look the same in the Timeline Overview mode, as seen here.

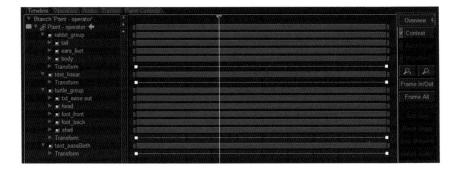

Figure 10.10 represents the Graph curve for the word 'linear' using a linear interpolation type (go figure). This shows that the transition from one value to another is performed at a constant rate.

Figure 10.10

Figure 10.11 represents the Graph curve for the rabbit; it shows a curve that accelerates in the beginning and then slows to a stop at the very end. The tangent handles have been edited to customize the shape of the animation curve for the X position channel.

Figure 10.11

Figure 10.12 represents the Graph curve for the turtle; it shows a curve that has an extremely slow acceleration that increases in speed until the very end.

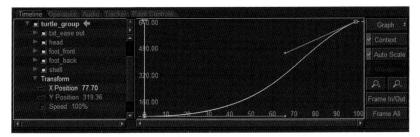

Figure 10.12

Figure 10.13 represents the Graph curve for the 'ease both' text. This curve accelerates slowly to full speed and then slows down to a nice, easy stop.

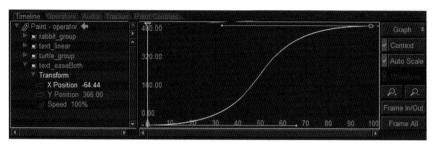

Figure 10.13

As a rule of thumb, when you go into the Timeline, always start in Overview mode to navigate and more easily locate your keyframes. Then, when you have found the specific keyframes you wish to edit, switch to the Graph mode to see the animation curves. Without looking at the Graph mode of the Timeline, you may never know if you have a 'tortoise or a hare' type animation curve and will only be able to see when keyframes are in time – not how they interpolate in between.

Extrapolation

No matter how many keyframes you may have on a given channel, the time between the first and last keyframes can be thought of as one cycle of animation in that channel. Extrapolation is a means to continue this cycle before the first or after the last keyframe you created. Depending on the animation cycle, different extrapolation methods will result in similar or dramatically different animations. What extrapolation does is create 'virtual keyframes' that really do not exist in the Timeline. The resulting animation curves can be seen as dotted lines in the Graph curve editor.

To see the different types of extrapolations, open the Workspace file named ch10_Extrapolation.cws. Cache this clip and loop the playback while you examine the file. Keep the Timeline in Graph mode with Context enabled and

then single click on each layer in the Workspace panel to see its animation curves in the viewport. If you want to see the corresponding animation curves in the Timeline, you have to open the layer, then the transformation and finally click on the X and/or Y position channels.

Constant – A value will remain the same at the beginning or end of the cycle, regardless of the ease curves coming into or out of the cycle.

Linear – This type continues the tangency in a straight line for a constant rate of change.

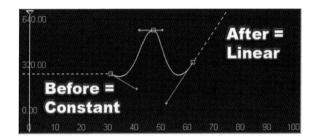

Loop – The animation cycle will play forward and then appear to jump back to the beginning and repeat playing forward indefinitely.

Ping Pong – The cycle will play forward, then backward and continue this repetition indefinitely.

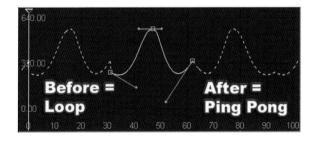

Relative Repeat – This might be thought of best as 'keep on going'. This extrapolation type takes into account the shape of the animation curve, including the ease curves, and continues prior to or after the animation cycle in a manner that continues the curve shape in either direction.

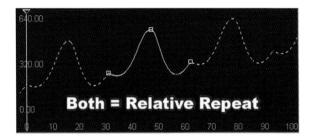

Mixed – This extrapolation definition means more than one type of the choices above is used in the animation channels you have selected.

Note: Virtual keyframes generated by before/after extrapolation cannot be viewed in Overview mode. You must switch the Timeline to Graph mode to see these curves.

Tip: Quite often you may not know which type will best suit your needs. Since the dialogs for before/after extrapolation types are flyouts, you can have an animation playing back while you roll the mouse wheel over these menus to cycle through the different choices.

Math Operations

The Timeline button that says *Math Operations* . . . evokes the menu seen in Figure 10.14. These options can perform transformations either to an entire animation channel or to a selected range of keyframes.

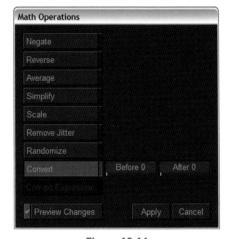

Figure 10.14

Negate	Makes positive values negative and vice versa.
Reverse	Flips the keyframes backwards so the animation is inverted in time.
Average	Averages the 'weight' of keyframes over a user-defined divisor value.
Simplify	Performs a keyframe reduction while trying to preserve the shape of the keyframe animation curve.
Scale	Independently scales the horizontal and vertical axes of the Timeline (or the <i>when and how much</i> values).
Remove Jitter	Smoothes keyframe values.
Randomize	Adds or subtracts a random amount, as specified by the user, to selected keyframe values.
Convert	This makes a user-defined number of cycles of virtual keyframes (created with extrapolation) become real, editable keyframes.
Convert Expression	Turns virtual animation curves resulting from JavaScript expressions into real keyframes that can then be edited normally. The expression is lost after this conversion.

Markers

Markers are available to aid you in many ways while keyframing and editing in the Timeline. You can add markers to operators and layers using the techniques outlined here. In Chapter 11, you will also see that you can apply Edit operator markers as well. Markers are helpful to annotate and point out key locations in time where you might want something to occur in an animation. In the case of the *ch10_Exprapolation.cws* project, there is an operator marker at the composite level on frame 30. This marker identifies the end of the keyframe cycle(s).

Note: You need to first be in the timeline Overview mode to view markers.

To Add an Operator Marker (to the Composite)

- 1 Switch to the Timeline (F4) and enable Context.
- 2 In the Workspace panel, double click the Composite operator onto which you wish to add markers.

markers to the Composite operator.

3 Go to the frame where you want to add a marker and tap the M key. You can alternately go to Edit > Add Operator Marker. This will add

Figure 10.15

To Add a Layer Marker

- 1 In the Timeline, select the layer onto which you wish to add a marker.
- 2 Control + M adds layer markers to selected layers on the current frame. You can alternatively select Edit > Add Layer Marker. You can also add layer markers by holding the Alt key down and clicking in the layer bar in the Timeline.

Tip: When a clip is cached, you can tap Control + M to add layer markers during playback.

Editing Markers

You can move the location of a marker simply by dragging on it.

To edit a marker, right click on it and select Edit from the flyout seen in Figure 10.16. Note the other options presented here.

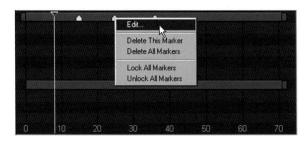

Figure 10.16

You will then be presented with the dialog seen here. This small interface allows you to change the color of markers, annotate markers, lock markers, and step through markers using the previous/next icons.

A marker with annotation in the text field will have a small dot visible in its center when seen in the Timeline.

Remember, the Playback Controls have previous/next marker buttons to help and encourage the use of markers throughout combustion projects. These

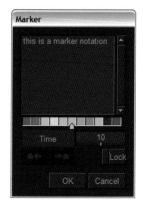

buttons only work if you have a composite, layer or operator selected with markers applied.

Combustion is a tool designed for the creation and manipulation of moving images. Since the possibilities of animation within combustion are literally endless, you are encouraged first to step through the basics of animation, and then begin to combine various methods outlined in this chapter and elsewhere in this book. Remember, creating animated, changing values of nearly anything in combustion is as easy as enabling the Animate button and making the change on the frame you wish the change to happen.

CHAPTER 11 A/V EDITING 2867 Transi Running Schooler Ty Posi 2160 2400 2640 2880 Leng

Combustion has the ability to work with audio and video in a manner much like a non-linear editing application; however, it should be understood that the tools in combustion are designed for different purposes than the likes of long-form editors such as Avid, Premiere, or Pro-Tools. First and foremost, combustion is an effects tool for motion graphics and the like. If you want to cut a feature film or remix the next number one hit album, you should not look to do it in combustion. You could, but you probably don't want to. You can do a lot with a hammer, but you would not use one to drive in a woodscrew. It is really about picking the right tool for the right job.

Audio

Combustion has the ability to load what is often referred to as a 'scratch track' audio clip. If your Workspace has an audio file loaded, you can optionally include the audio in the render as well. To load an audio clip, go to the Audio tab just below the Transport Controls. When you enter the Audio Controls, the only option available is to browse to a directory containing an audio file. In addition to the common WAV, AIFF, and MP3 formats for audio, you can load just the audio portion of an AVI, MOV, or MPEG file.

Note: When you work elsewhere in combustion with MOV or AVI files as footage, any audio contained in those files will not be loaded unless you use the feature outlined here or the 'Set As Audio Source' option in the Thumbnail Browser. Files obtained using the Quick Capture utility can optionally have audio loaded automatically, but they will still be separate files on the hard drive.

1 Click the Browse button and select any audio file you have handy. If you need to, you can use the file named *renderdone.wav* found in the . . . \Combustion4\Data\directory.

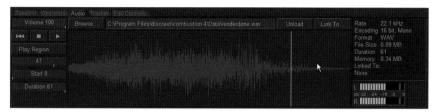

Figure 11.1

You should now see the waveform of the audio clip you selected. In the case of the *renderdone.wav* file seen in Figure 11.1, notice that the amplitude of the sound gradually increases then fades out. To the far right, you can also see basic information about the properties of this file and audio level meters.

Rewind/Stop/Play – These () are for basic playback to test the audio segment. The Rewind button here takes you back to the time set by the Start fields below. If you enable the Play Region option (Play Region), only the range set by Start and Duration will play back.

The **Start** and **Duration** values let you trim the audio in and out points of the audio clip. Use these as sliders to change the range of the audio clip. You should notice the highlighted area change accordingly as seen in Figure 11.2. The highlighted area will be the only portion available to the rest of combustion. Notice how the fade in and out has been trimmed. You can also drag the bars directly in the UI to create a section for the audio section.

Figure 11.2

2 Switch to the Timeline tab and notice that the waveform is visible and that only the trimmed portion of the clip is being used in the Workspace. You can enable and disable the visual representation of the waveform in the timeline by disabling the Waveform checkbox seen in Figure 11.3.

Figure 11.3

3 Return to the Audio tab (tap F6).

The **Link To**... button seen to the right of the file name will bring up the Operator Picker dialog. This allows you to tie the audio clip to an operator or piece of footage in your Workspace. Then, if you make changes in the Timeline to the element picked (such as slipping the in and out points of the footage), the audio file will come along for the ride, as it were, staying in sync.

The Filmstrip

You can certainly use the Filmstrip at any time when working in combustion, but it seems to be particularly useful when doing hand-drawn flipbook animation and especially when using the Edit operator.

To quickly introduce the Filmstrip:

- 1 Open the Workspace named *ch11_Editing.cws*. This is a simple project that contains all the sample MOV files from Digital Juice.
- **2** Go to the Window menu and select Windows > Palettes > Show Filmstrip. The screen will briefly redraw and then you should see a small series of numbered thumbnails appear as in Figure 11.4.

Figure 11.4

- In the very upper corner of the Filmstrip, you can see a small arrow pointing right (Figure 11.5). This opens a menu with several options including thumbnail size, layout of the Filmstrip, and the time scale that the Filmstrip uses.
- 4 From this list, switch from Vertical to Horizontal. The screen will redraw and you will now see the Filmstrip across the bottom of the viewports. The controls for the Filmstrip are now just above the Viewport Controls, as seen in Figure 11.6.

Figure 11.5

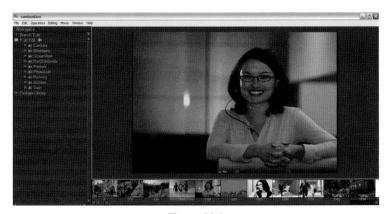

Figure 11.6

Tip: The Filmstrip uses system memory to cache, just like anything else in combustion. Due to this, the smaller thumbnails require less memory. 'Mini' thumbnails, therefore, will use the least memory and cache faster than the rest of the available sizes.

- 5 Re-access the Filmstrip controls and try out the different settings for thumbnail size. They range from 'Mini' to 'huge' (you have to love those naming conventions). Just as using the Filmstrip is, in itself, an option, so too is the size of the thumbnails used within the Filmstrip.
- 6 Try scrolling though the Filmstrip by using the red frame slider just under the thumbnails. You can also drag the entire range of the Filmstrip by dragging the wider, gray bar. Lastly, you can jump to a frame by merely clicking on a thumbnail that represents the location where you want to go in time.

The Filmstrip options seen in Figure 11.5 are briefly outlined below. Remember, you can show and hide the Filmstrip at any time from the windows menu at the top of the combustion UI.

Show Time – This will toggle the visibility of the frame count or time code that is under each thumbnail.

Always Render Current Frame – This option will force the Filmstrip to scroll along in time to continue displaying the current viewport.

Render All – This will force combustion to cache all the thumbnails in the Filmstrip. Then, you can quickly scrub back and forth in the Filmstrip's time slider just like a traditional NLE system.

Zoom In/Out – This changes the time settings in the Filmstrip by setting a number of frames to be skipped. You can also use the small + and - icons that are visible on the Filmstrip itself.

Go to Current Frame – The current frame will be visible in the Filmstrip. This can be used as an alternative to Always Show Current Frame.

Time Settings – This is where you can set the Filmstrip to skip a predetermined number of frames so that more of the entire project will be visible in the

Filmstrip. The first four choices are in frames and the rest are in seconds; the last four use the frame rate of the current project.

Using the Filmstrip for lengthy projects such as those involving editing operations can help you navigate longer sequences. However, technically speaking, the Filmstrip slightly slows combustion down. Use it as needed, but be aware that it is slightly pulling from your total available resources. If you are not actively using it, disable the Filmstrip by accessing the Windows > Palette > Hide Filmstrip option.

The Edit Operator

Before moving on, revert the Workspace from the File menu or (re)open the project named *ch11_Editing.cws*. In the Workspace panel, select the Edit operator and the Edit Controls will appear at the bottom of the UI.

Like the Composite operator, the Edit operator can be thought of as a window of a defined duration, frame rate, and resolution that lets you look at elements within your Workspace. An Edit operator is also similar to a Composite operator in that it brings several clips together as one. The fundamental difference between a Composite and Edit operator is that instead of layering your images on top of each other or using 3D space, you assemble segments head to tail so one plays, then another, then another, and so on. Like composites, the Edit operator has a single, defined resolution regardless of the resolution of the clips being edited. The Edit operator interface is extremely straightforward and only has one primary interface – the Edit Timeline.

Note: Another difference, while purely cosmetic, is that the Schematic node representing a segment of an Edit operator is square, as opposed to layer node entering a composite, which is round.

Output – This second category of the Edit operator is largely the same as a Composite operator, with one exception. Figure 11.7 shows the Auto Adjust Duration option of an Edit operator. When enabled, this will use the duration of the Edit operator's contents to determine the entire duration of the operator.

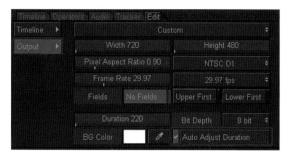

Figure 11.7

Timeline – The Edit operator Timeline is where the majority of all the editing operations occur. Figure 11.8 shows the entire interface. This is not the same Timeline detailed in Chapter 10. The Edit operator Timeline is where you will perform non-linear editing functions, not keyframe animation. If you bring together several segments into an Edit operator as seen here, you can tell where one begins and another ends by the separation of the clips by name and also by the (default) cut edit from one to the next.

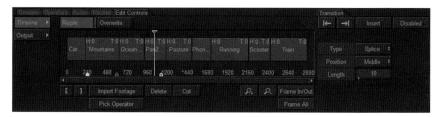

Figure 11.8

The descriptions of the primary buttons found in the Edit operator are found below:

кірріе	shorter (as needed) to accommodate the edits you perform. Start and end times of clips are edited when you change the duration of any other clips.
Overwrite	When enabled, the overall duration of the operator remains the same, regardless of any edits you perform. This option causes frames to be replaced to adhere to this duration.

Mhan analalad tha Tinadina will alaman tha a second de

Dinala

Frame All The Frame All button zooms in or out to accommodate the entire Timeline.

Trimming Heads, Middles, and Tails

The beginning and end of a clip within the Edit operator are called the head and tail, respectively. In the case of merely playing clips end to end, you often do not need to worry about these, but when you want to trim a clip shorter than its potential full duration, you can either shorten the head or tail, or cut out a portion of the clip from the middle.

When viewing segments in the Edit operator timeline, a fair amount of information can be read off the appearance of the clips. Here, the clip named Mountains is selected. In its current state, it has 69 head frames, no tail frames, and has a duration of 337 frames (out of a possible 406).

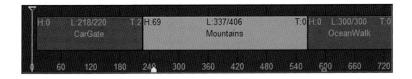

1 To examine how to trim heads and tails, open the Workspace file named ch11_EditingABC.cws. This is a simple, three-segment clip of stills each having a 150-frame duration.

Place the cursor over the edit splice and the cursor will change to indicate which 'side' of the cut you will edit. Figure 11.9 shows both the new cursor editing the tail of clip A and also that 20 frames have been trimmed off the tail of this clip.

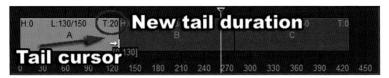

Figure 11.9

Note: If there are head and tail frames available, it is also possible to perform a rolling edit by placing the cursor directly over the point between two segments and dragging the mouse. Your cursor will become a double arrow indicating it is ready to perform a rolling edit.

- 3 This example shows a Ripple trim of clip A. You can tell this is a Ripple edit because as the tail of a clip is adjusted, the following clips move to compensate for the loss of duration in clip A. Undo the previous action and switch to the Overwrite mode of the Edit operator.
- Trim the tail of clip A again and notice that a gap is left this time, as seen here. This is due to the nature of Overwrite mode.

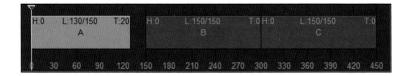

Experiment with Ripple and Overwrite modes while trimming the heads and tails of clips. Notice the effects upon the duration of the clips and the duration of the Timeline as you work.

To take a section out of the middle of a clip, you position the Timeline indicator over a point in a clip and click the Cut button below the

Timeline. This will make two clips out of one. Each of the resulting clips will play back end to end without any indication of the cut, but there are head and tail frames now available on either side of this cut edit you created.

Note: This last step may be more obvious on moving video clips and not the ABC still samples currently loaded.

Simple Editing

- To see how a few more functions of the Edit operator work, let's begin anew by choosing Revert Workspace from the File menu (or reopening the Workspace named ch11_EditingABC.cws). Expose the Edit operator timeline select the middle clip named B. It will become yellow when it is selected.
- 2 Verify you are in Ripple mode.
- 3 Click and drag segment B up and to the left. During this operation, your Timeline window should resemble Figure 11.10. Notice in this example how the head and tail frame numbers are displayed as you drag the segment.

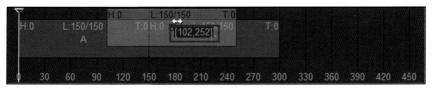

Figure 11.10

4 Release the mouse when the segment is partially over segment A. The resulting Timeline will look like Figure 11.11.

H:0	L:10)2/150 A	T:48	H:0		I50/15 B		T:0	H 102 A(2))	L:150	0/150 C		T-0
	30	60	90	120	150	180	210	240	270	300	330	360	390	420	450

Figure 11.11

Due to the Ripple edit function, segment A was split in two and segment B was inserted in between this split. The overall duration remains the same. You can scrub time or cache the clip to see the cuts-only edits switch ABAC.

- 5 Undo the last operation and switch the Edit operator Timeline from Ripple to Overwrite mode.
- 6 Repeat the segment B movement up and to the left over segment A.

This time, when you release the mouse, you should notice there is a gap left where the end of segment A was and where segment B used to be. Figure 11.12 shows these results of this Overwrite edit.

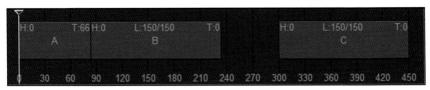

Figure 11.12

7 Switch back to Ripple mode and then, while holding down the Shift key, drag segment B in front of segment A. You should notice that dragging segments with the Shift key held forces them to snap to heads and tails of other segments, even when in Ripple mode.

Duplicating Segments

You can duplicate an edit segment to easily create multiples of a clip within the Edit operator. To duplicate a segment:

- 1 Place the cursor in the Edit Timeline where you wish to insert the duplicate
- **2** Select the segment you want to replicate.
- 3 Choose Edit > Duplicate (or hotkey = Control + Alt + D). The segment is replicated at the current time indicator.
- 4 Alternately, you can right click on a segment in the Workspace panel and chose duplicate. In this case, however, the duplicate is placed at the end of the Edit Timeline.

Note: Like other types of duplicates in combustion, these all stem from the same source footage, which can easily be seen in the Schematic view.

Transitions

The Edit operator has the ability to add simple wipes and dissolve transitions between two segments in the Timeline. By default, cuts-only (aka splice) transitions are enabled. You can add dissolves or wipes manually, but for these types of transitions to work, you need an appropriate amount of head and tail frames on both segments.

← →	Go to previous/next segment. This pair of controls takes you to the first frame of the clip in question.
Insert	Places a transition at the current time using the current transition settings.
Disabled	Leaves a transition in place, but temporarily turns it off.
Туре	Three choices of transition are Dissolve, Splice and Wipe. In the case of the Wipe a choice of Left/Right/Up/Down is available.
Position	This setting determines where the transition will be placed relative to the two clips in question. Choices are start, middle, end and custom.
Length	This determines the duration of a transition.

- 1 To create a simple transition and experiment with editing, begin by reverting back to (or reopening) ch11_EditingABC.cws.
- 2 Make sure you are in Ripple mode.
- 3 Trim segment A's tail 20 frames and segment B's head 20 frames by dragging the head and tail durations of each corresponding segment.
- 4 Go to the first frame and then click the Next Segment button (). This will jump the Timeline indicator to the exact point between segments A and B. Figure 11.13 shows the resulting Timeline.

Figure 11.13

- 5 Change the Transition type to Dissolve, the Position to Middle and the Length to 40.
- 6 Click the Transition Insert button and you will end up with this:

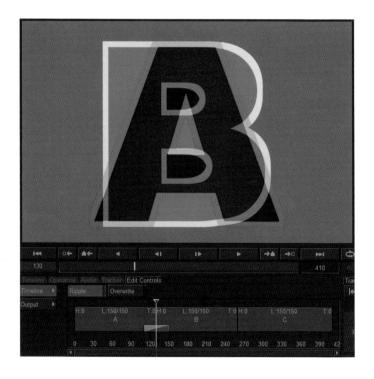

Notice that the current frame is halfway between the two segments and the viewport shows this transition in progress. You can play the series from the beginning and you will see the 40-frame dissolve take place.

- **7** Select this transition in the Timeline by clicking on it. It will become highlighted yellow when selected.
- **8** To the right of the Edit Timeline, change the transition type to Wipe (Right) and play the clip. Notice that the duration is still the same, but the effect and icon for the transition are both changed to a Dissolve.

One- and Two-point Editing

In one-point editing, you set an in point or an out point and add a clip to the Timeline. This point will be used to 'forward fill' or 'back fill' the incoming segment in its entirety.

Note: Ripple and Overwrite perform as usual with one- and two-point editing.

To perform a simple, two-point edit:

- 1 Revert to the project ch11_EditingABC.cws from the File menu.
- **2** Go to frame 50 and set an Edit Timeline IN point by clicking on the in point button () under the Timeline.
- **3** Go to frame 175 and set an Edit Timeline OUT point by clicking on the out point button ().
- 4 Click the Import Footage button below the Edit Timeline.
- 5 Browse to the ... _footage\sequences\digital juice\directory and double click on any of the clips.
- **6** The clip will be inserted and the tail trimmed to accommodate the duration you dictated. Notice that the new segment has a head of zero frames.
- 7 Select this new segment in the Edit Timeline.
- While holding down the Control key, click and drag on this new segment. This will 'slip' the in and out points of the segment at the same time, but will leave the overall duration of the segment the same. While dragging the cursor left and right, you will notice a representation of the entire segment's duration below the Timeline. Figure 11.14 shows this procedure at the midway point.

Figure 11.14

Edit Markers

When you are in either the Timeline or Output Controls of an Edit operator, you can tap the M key on the keyboard to create a marker at the current frame. These markers are identical in function and features to the layer markers detailed in Chapter 10. Like the layer markers, these are provided in the Edit operator's Timeline for your convenience and notation of any point in time. Figure 11.15 shows the Edit operator markers.

Figure 11.15

Remember that you can edit the markers by right clicking on them. Also, the Playback Controls have quick buttons to jump through your markers.

Split Layer

This feature is actually a function in the Composite operator, but it is detailed here because of the editing capabilities of this feature. This performs several tasks at once. It duplicates the layer and all the keyframes, operators, etc. and also takes the out point of one of the created layers to the in point of the other layer.

To split a layer, you do not even need to be in the Timeline. You simply select a layer, go to the frame where you wish to split the layer, right click on the layer

name and select Split Layer. The Timeline does, however, show the effects of the Split Layer function quite well, as can be seen here.

As you can see, the duration bars for the resulting two layers reflect the split layer. All the keyframes and operators of the two layers are still the same, but these in and out points control where the split occurs.

There are many reasons why you might want to split a layer. One example is if you want a new operator to seemingly affect a layer midway through an animation. Instead of animating the operator or setting in and out points for it, you can easily split a layer and add an operator to the second, resulting layer. Playing back this sequence will result in the two layers playing back end to end, but the new operator (a blur, for example) will only affect the second of the split layers.

Additional Notes on Editing within combustion

This chapter primarily explains the tools within the Edit operator, but does not go deeply into the power of having the ability to edit within your compositing application. The edit operator is far from being a stripped down non-linear editor. One real benefit of the Edit operator is that each segment is still an individual element in the workspace. Each can have its own operators applied or even, themselves, be vast composites with many layers intermingling with raw footage on the hard drive.

The Edit operator is often not the last stage in the process of a project. The output of a Edit operator can be fed into a composite as a layer, which can then be treated just like any other layer with transformation, surface qualities, transfer

modes, operators etc. You will undoubtedly come up with new ways to continually incorporate Edit operators in your projects.

The project named *ch11_Editing.cws* is provided as a starting point for experimentation with the Edit operator. You can alternatively start a new Edit project by opening several clips with the Thumbnail Browser directly into an Edit operator. The order that the footage clips are selected in the Thumbnail Browser will be the starting segment order in the resulting Edit operator. Remember, the Edit operator is just another operator that can be applied anywhere within the workspace.

EKPRESSIONS

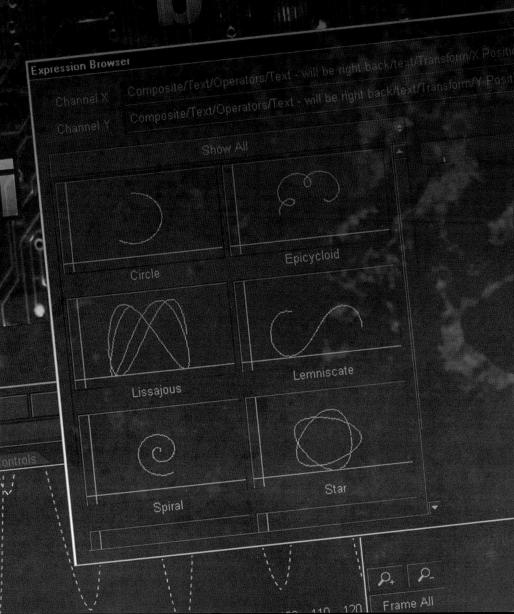

Expressions in combustion are a means of introducing an embedded programming environment into the application. The sound of this (argh, math!) sometimes turns people (artists) off and yet it excites others (coders). Working with expressions can be taken as deep as you want to go, yet they should not intimidate you because of their programming nature. With a few simple tips as background, you can be well on your way to customizing animation controls to your specific needs.

The good news about this whole inclusion of the JavaScript programming language is that there are two means of creating expressions that allow non-programmers access to its power right away. The first is the pair of **Quick Pick** icons and the second is the **Expressions Browser**. Using either of these tools allows anyone to either link parameters together (i.e. this controls that) or see visual representations of the expressions. No programming required!

The programming language that was chosen to incorporate expressions in combustion is JavaScript. This is a programming environment with deep roots in the Internet, but it can also be used for mathematical formulation to drive parameters and variables in software applications like combustion. This chapter will introduce you to the basics of creating expressions, but I encourage you to pick up any JavaScript resources if this incredibly powerful feature interests you further.

'Quick Pick' Link Options

To see how you can create a simple expression, we will look at the two Quick Pick link features. There is an option for linking **absolute** paths () and one for **relative** paths () within the resulting JavaScript code. The easiest way to describe how a link works is to think, 'this controls that'. More formally, what is occurring is that you are creating an animation linkage between two channels where one drives the other in some way. That is a pretty vague way to put it, but you can also see from this description that it is a powerful way to easily create complex animations of nearly any kind.

Note: The single Quick Pick feature found in older versions of combustion is the Absolute link (/..) version of the channel link found within combustion 4.

- Begin by opening the Workspace named ch12_QuickPick.cws. This Workspace contains two layers. The top layer has text with animated tracking values from 199 down to zero. The tracking values can be found in the Paint Controls > Text > Basics section. Cache the clip to see the project and the effect of the animated tracking value.
- 2 Expand the Workspace panel to reveal the contents of the layer named *Paint Text* (see Figure 12.1).

Notice that there is an Unconstrained Box Blur operator applied to the Paint Text layer. Select this operator by clicking on its name in the Workspace panel. This will activate the controls for this operator.

Figure 12.1

- 3 In the Unconstrained Box Blur Controls, scrub the Vertical Radius slider back and forth to see the effects of this operator. When you are finished, return this value to zero.
- 4 With this operator still selected, switch to the Timeline and select the channel named Vertical Radius. The channel name will become white when it is selected.

Note: Make sure you have the 'Show Only Animated Channels' option of the Timeline disabled, or you will not see the two empty channels related to the operator controls.

To the right of the Timeline, enable the Absolute Link(/) button seen in Figure 12.2. It will turn green when it is active.

While a link button is green, combustion is waiting for you to select another animation channel. Upon picking another, you will link the two values together. You can think of this as a slave to the value you are about to pick, in this case the animated text tracking value.

Figure 12.2

Note: This is a one-way connection using this technique. The tracking value is 'unaware' that the Blur operator is tied to it. The first receives the expression and is driven by the second.

- **6** Switch the Timeline to Overview mode if it is in Graph mode.
- 7 Click once on the small up arrow indicated in Figure 12.3. This will take you up a level from just seeing the channels for the blur operator. Then scroll down, expand the text entry and then expand the 'Basics' entry until you see the animated tracking channel and its keyframes indicated in the Timeline.

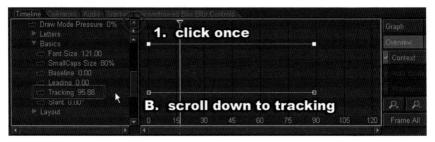

Figure 12.3

- 8 Click once on the name of the channel called *Tracking*. The link is now complete; the button returns to gray and the two channels have been linked. Look at that you just wrote some pretty nifty JavaScript expression code!
- 9 Cache the clip and notice that the vertical blur is now tied to the animated tracking value. At this point, if you edit the tracking keyframes or their Bezier interpolation (Graph mode), you will see the blur respect this change and follow along blindly.
- Scroll the Timeline back up until you see the animation channel named Vertical Radius (for the Unconstrained Box Blur operator). You will notice that there is an expression where keyframes typically reside in the Timeline.

Keep this project open to continue the next lesson.

Editing an Expression

Ok, now that you are a JavaScript expression-programming fiend . . . let's go edit some code!

1 In the Timeline, you can scroll back up to see the Vertical Radius of the Blur operator. Notice the small icon 'E' indicated in Figure 12.4. This means that this channel is being driven by a JavaScript expression.

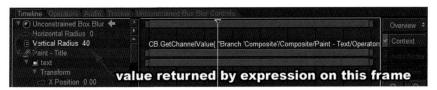

Figure 12.4

2 Right click on this channel to bring up the dialog in Figure 12.5. Here, you are presented several options for editing, copying, deleting, and so forth. Select Edit Expression for now.

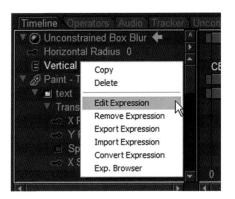

Figure 12.5

Note: This menu allows access to export and import expressions as *.CJS files. These allow you to build libraries and share expressions with other users.

3 The code for the expression will be highlighted and there will be a small button available named 'Multi'. Click this button.

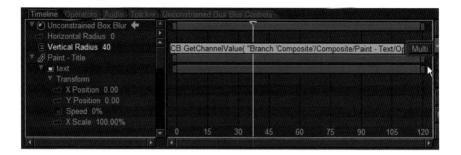

Warning: You will go into a larger editing window but the entire contents of all the characters making up the expression are selected. If you begin typing, you will lose the existing expression. To deselect, click in a blank area of the expression edit window.

This is where a lot of the reverse engineering of the JavaScript language can be done in combustion. Again, the use of expressions is an extremely powerful new feature that can be explored in great depth outside of the scope of this book.

4 For a simple edit, at the very end of the expression is the text:

CB.GetCurrentFrame());

Change this to

CB.GetCurrentFrame())/2;

Note: To accept the change of code, you can click elsewhere in the UI of combustion. The expression edit window has no 'OK' button and you should therefore be careful not to hit the return key on your keyboard (unless you want to add that to the expression).

This simple addition of '/2' at the end of the line will halve the value of the previous expression. This means that the vertical blur amount will be half of the

animated tracking value of the text driving it. Using this simple methodology, you can easily achieve things such as Layer01 controls rotation. Layer02 rotates 9/10ths as much; Layer03 rotates 8/10ths as much, and so on.

Renaming Channels – The JavaScript code created while writing expressions often references the names of objects, channels, operators, etc. Within combustion 4, you can rename anything and the JavaScript expressions that are tied to these renamed values will automatically be updated.

Expression Browser

The second automated means of accessing the expression controls in combustion is by utilizing the Expression Browser. Like absolute and relative links, this feature can be easily used by anyone to generate JavaScript code that can be reverse-engineered, examined, and edited by the user. This workflow is an excellent way to become familiar with the power that lies in the use of expressions.

The Expression Browser is a dialog of presets with adjustable variables that you, the user, input to control the resulting animation keyframes of an element in the Workspace.

The following exercise introduces the Expression Browser for a simple camera shake effect:

- 1 Load the Workspace named $ch12_CameraShakeBEGIN.cws$. This is a simple 3D composite with a resolution of 720 \times 480. It contains a single layer that is 800×600 its edges are currently outside the visible viewport.
- 2 In the Workspace panel, select the camera.
- **3** Bring up the Timeline controls by hitting F4.
- 4 Navigate to and expand the Transformation category for the camera.
- The first transformation is named *X Position*. Click and drag the mouse up and down directly on the name of the channel. You will notice that the layer seems to move in the viewport. What is actually occurring is

that you are slipping the camera laterally back and forth so that the edges of the layer can be seen, as in Figure 12.6.

If you slowly scrub the value back and forth, you will see that at values around -70 to +70, the layer is visible without a transparent edge. Make a mental note of this.

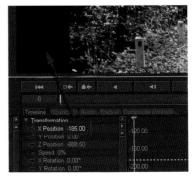

Figure 12.6

Undo any position changes or manually return the camera to the zero X position. Also, verify you have only the X Position channel of the camera

selected in the Timeline before continuing.

- 7 To the right of the animation channels, there is a button (Figure 12.7) for evoking the Expression Browser. Click it.
- 8 You will be presented with the menu seen in Figure 12.8. Click on the Picon named Random. To the right, you will notice there is a Picon Frame Range

indicator slider that can be used to see how the different expressions look over time with the current values.

9 Change the minimum and maximum values to -70and 70, respectively. This represents the range we determined that would keep the layer in frame. Click OK when you have set these values.

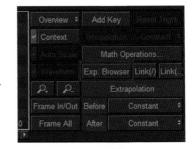

Figure 12.7

Figure 12.8

The Expression Browser is where you can generate many starting point values for your JavaScript controls in combustion, and you can edit them after they are

applied. If you do not like the results of a particular setting, you can also come right back into this dialog and edit the values accordingly. This becomes a lot of trial and error at first, but it is a very fun way to spend your time when on hold with an insurance or credit card company.

Cache the clip and you will notice sporadic horizontal movement of the camera in the viewport. While the camera does, indeed, jump about randomly on its horizontal axis, the image stays in frame because of the range we provided with the expression controls.

Tip: To apply a motion blur to this camera shake effect, select the composite itself and apply a Blur/Sharpen > Motion Blur operator. You will have to double click this applied operator to view it in the active viewport. When you cache the clip, the effects of the motion blur will be visible. At that point, you can experiment with motion blur settings should you so desire.

This is because you are creating an expression for two values in the Timeline. Choose Spiral and, with default values, click OK to accept.

11 Using these same techniques, make a camera shake for Y position information and use a *Random Growing* expression as a starting point. You will have to begin by selecting the camera's Y Position channel in the Timeline and then activate the Expression Browser again. For this example, you can use the default values of the *Random Growing* preset.

Two-Point Expressions

In the previous example, the Expression Browser was used to create animation on one channel and therefore singular expression presets were made available. If you have more than one animation channel selected in the Timeline when you enable the Expression Browser, different options will be made available.

- 1 Open the file named *ch12_Spiral.cws* and select the layer.
- **2** Expand the Timeline (F4) and select both the X and Y Position channels under the Transformation category for the soccer ball layer.

Tip: As in the Workspace panel, you can hold down the Control key to select multiple items in the Timeline.

- **3** Open the Expression Browser. Notice in Figure 12.9 that there are new expression presets available.
- 4 Play the animation. Notice that the expression forces the soccer ball to start nearly off frame and loop back into frame. This starting point was set by the expression offset values.

Figure 12.9

- 5 Instead of redoing the expression over again, try changing these offset values with the editor. Simply select the X Position channel and right click to access the edit expression flyout.
- Notice that the expression is largely in plain English. Even if you do not know a great deal about expressions or JavaScript programming, the resulting expressions created by the Expression Browser are very easy to edit and manipulate because of this. Change both the XOffset and YOffset values to 0.0.
- Repeat this editing for the Y Position channels. Since you created expressions for both X and Y positions of the layer, two expressions must be edited. The resulting clip is a soccer ball starting in the center of frame and spiraling outward as time progresses.
- 8 Leave this project open for the next lesson.

Converting Expressions to Keyframes

To see the animation curves resulting from any expressions, you can temporarily switch to Graph mode of the timeline. As usual, you will need to have the animation channels selected. The curves will be dotted lines, indicating they cannot be edited using standard keyframe editing techniques. At the end of the

previous exercise, you may have noticed that the animation of the soccer ball is centered and moving out of frame in a growing spiral. Let us assume that we want to edit this animation as actual keyframes.

- In the active viewport, select the layer and attempt to move it. You will not be able to move the layer by clicking and dragging on it, as is the norm. This is due to the expression having total control of the position in X and Y. You can still rotate, for example, but the X and Y positions have been tied to your JavaScript code.
- 2 In the Timeline, select just the X position and switch to Graph mode. You will see a dotted line that represents the resulting animation curve; however, notice that there are no actual keyframes. This is a virtual curve like the extrapolation curves seen in Chapter 10.

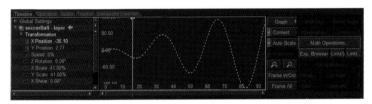

Figure 12.10

3 To convert this curve to actual, editable keyframes, you can right click on the channel name or select Math Operations as indicated in Figure 12.10. This will bring up a dialog with options for the conversion accuracy. Lower values will result in a curve that closely resembles the virtual curves generated by the expression.

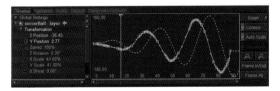

Figure 12.11

4 After you click Apply, the keyframes for the X position will be made actual keyframes that you are free to edit normally.

Note: The Y Position channel is still being driven by an expression at this point. It did not get converted because this is an independent animation channel. In Figure 12.11, both channels have been selected and you can see that one is still being driven by the expression controls. You can also see that there have been manual edits in the keyframed channel.

Ideas for Further Exploration

Writing and editing your own custom expressions can take you places not possible with other means of animation. Below are a few JavaScript functions that you might use within combustion at any time:

CB.GetCurrentFrame();	Returns the current frame number
CB.Random();	Returns a random number between 0 and 1. It should be noted that this value will come back the same time it plays for any given animation channel
CB.GetChannelValue (path, frame);	Returns a channel value at the specified path and optionally at a specified frame
CB.GetLocalTime();	Returns the current local time (in seconds)
CB.GetGlobalTime();	Returns the current global time (in seconds)

Try setting up an empty composite with several null objects. These can be renamed quickly and made into slider controls for things like puppeteering lights. Use the X position of a null to control one value and the Y position to control another. This can be like having a virtual joystick. You can also have these 'sliders' in one viewport and the elements that they control in another viewport.

In a 3D composite, have several layers all with a Blur operator applied to each of them individually. The further they recede in Z space, the more blurred they should become. This is a way to emulate and automate a depth of field effect on 2D elements.

It should now be evident that, with just a few mouse clicks, you can have ties between nearly any parameter using combustion's JavaScript expressions. Don't fear the code!

OpenGL

The Particle operator is different from all the other operators in one unique way – it uses OpenGL to create all the particle effects created within the operator.

OpenGL is a programming language or applicationprogramming interface (API) originally developed back in 1992 for simulations and real-time graphics applications.

At its core, OpenGL allows software programmers to write code that can utilize special graphics hardware (read: graphics cards). This hardware allows images to be very quickly drawn to the computer screen without first being calculated/rendered on the host computer's main processor.

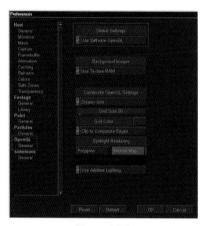

Figure 13.1

In the user preferences of combustion there is a section specifically for OpenGL. The primary concern for these options is the first choice of whether or not to use software OpenGL (see Figure 13.1). Since there are so many different graphics cards on the market, different settings will invariably produce different results. It is well worth the time to test these settings on a saved particle project to see the difference in performance on your particular computer hardware.

To put it simply, you will only want to enable this option for using software OpenGL on computer systems exhibiting problems or poor playback of particles. Enabling this option checkbox for Use Software OpenGL will bypass the hardware on the graphics card and, instead, draw the particles using the computer's CPU. This is often more reliable, but can be much slower. On my beat-up, P3 laptop, particles actually run much faster with this option enabled. On my newer workstations, it would be a mistake to enable this option because of the powerful graphics cards in these systems. I can, however, still achieve real-time playback on a slower system via RAM caching.

Like any other operator, the particle system in combustion can be applied to images off the hard drive, to a solid (usually transparent), to a composite, or added into a series of operators in a long branch. Like a Paint operator, particles only work in 2D space, but they can be applied to a layer that can, in turn, be transformed within a 3D composite.

Another similarity to Paint is the fact that you may have a lot going on within the operator, but the Schematic View only shows the operator itself. The Workspace panel is, therefore, where you will do most of the selections, renaming, and so on when working in a Particle operator.

Components of the Particle Operator

Underlying all the wonderful pixie dust, smoke, water, and fire is a single-particle engine that is easy to understand and control once you break it down into its primary components. Within this operator are three types of elements. At the most basic level, you have emitters, particles, and deflectors.

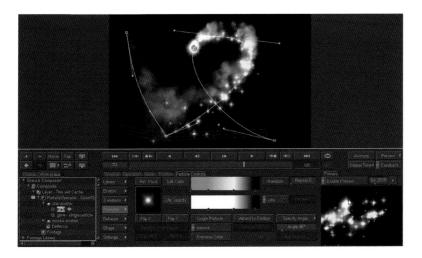

A. Emitters – These are non-rendering elements from which the actual particles spawn. The emitter objects are what you can manually position and keyframe in the viewports with precision. One emitter can have several different types of particle types coming out of it. For example, sparks and smoke can come out of

the same emitter. There are four types of emitters. You can use several different types all within the same Particle operator and Workspace.

Point Fmitter ()

This is a single source of particles. Point emitters have position, direction, and angle of emission but are merely a single point in space (that can be tracked or animated).

Line Emitter ()

The name can be slightly misleading, for these can be irregularly shaped and can have Bezier handles to create any shape of the emission. Only a line emitter allows you to edit control points of the emitter shape; therefore, it can be considered the most versatile choice of the four.

Circle Emitter ()

This creates a hollow ring of particles. This emitter type does not have to be a perfect circle; it can be elliptical as well. Since you cannot add or edit control points to these, you may optionally want to use an irregularly shaped line emitter instead.

Area Emitter ()

This type is useful if you need to create a solid region of particles, such as a wall of smoke or fire. Unlike a circle emitter, which is hollow, this emitter fills a rectangular boundary with particles.

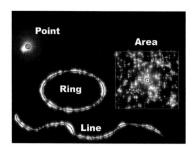

B. Particles – I like to refer to these as 'spriticles', because of their 2D 'sprite' method of simulating complex shapes and patterns. These are typically bitmap images or even other branches in the Workspace. All the particles in combustion are really just different images mapped onto rectangular shapes (similar to many little

layers in a 2D composite). These images, in combination with the characteristics of these rectangles, determine whether the particles look like smoke, disco lights, butterflies, or anything else you dream up.

C. Deflectors (SS) – Deflectors are used when you want to create particles that appear to bounce off of something and are redirected. Like emitters, they are non-rendering entities that you can keyframe to create different effects. Deflectors will only affect the particles within the same operator and the different particle Bounce settings determine how different particles will be deflected.

The Preview Window

The particle Preview window visible to the right of the particle categories is for testing different particle settings. Depending on the circumstances, this can often be used for much faster viewing than playing back particles in the actual viewports. This window uses the preferences setting for OpenGL and reflects how the particles will render. With a particle selected in either a library or within the Workspace panel, you can drag the cursor around within this window to see their behaviors and appearances. Consider this your particle testing ground.

The button above the window labeled 'Enable Preview' turns this area on and off. You can disable this small OpenGL window to give more processing horsepower to your primary viewports at the top of the UI.

Figure 13.2 shows a flyout button for accessing several options to this Preview window, which are outlined below:

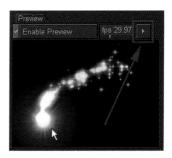

Figure 13.2

Collide with Edges	When enabled, the sides of the preview window act as deflectors for testing purposes.		
Show Motion Blur	When enabled, particles in the Preview window are drawn with the motion blur options in the (last) Settings category of the Particle operator. This option is just for the Preview window and can really slow things down. Use only as needed.		
Zoom	This allows you to see what different particles would look like if they were zoomed up or down. Quite often, you can achieve larger particles with an increase in zoom instead of size, and get the same basic results, but much better performance. It is very useful to check this out, but I highly recommend always putting this value back to 100% before you move on.		
Repeat	This controls a delay (in seconds) between repetitions of a particle that cycle. To see this delay, try selecting the preset named Simple Explosion from the default particle library.		
Color	This allows you to change the Preview window background color. Quite often, particles may look amazing in the Preview window		

	over one color, but when you apply them in the viewport over another color, they appear drastically different (or don't appear at all!). This is to test over black, gray, and white backgrounds.
Show Particle Types	I highly recommend leaving this on at all times. When enabled, it allows you to select a particle <i>emitter</i> and see all the various particles coming out of it. However, if you select just one of the particle types coming out of that emitter, only that particle type will be previewed and the rest ignored (but not turned off in the Workspace). This is extremely useful when you have several different particles coming out of the same emitter and you need to fine-tune them.

Note: If the Preview window ever has a red line around it, this means that changes have been made to a particle type that has not been saved to a library.

Categories of the Particle Operator

Library

These are the presets you can use as starting points for nearly any particle situation you will need. Combustion ships with several *.ELC libraries and each contains dozens of particles presets. There is also a special, empty library simple named 'Blank' for a totally clean slate – should you want to start from scratch

You can load either *.ELC or *.IEL library files. IEL files are Illusion Emitter Libraries from the third-party application named Particle Illusion. Upon loading an IEL, it gets converted internally to combustion's native ELC format. In addition, you can only save *.ELC files out of the Particle operator. You can also download additional emitter library files from www.wondertouch.com. These files must, however, be Illusion v.2.0 or prior to load into combustion:

Add to Current Library	Takes the settings of the selected emitter and adds them as a preset to the current library folder.
Replace from Library	Brings up a dialog for replacing some or all of the characteristics of the selected emitter from a library preset.

Update Emitter	This saves the current emitter settings if they have changed and you wish to save these changes in the library.		
Duplicate Emitter	Creates a copy of the current particle emitter and copies all of its settings, you can then edit this and save the settings.		
Delete	Deletes the selected preset from the library.		
New Folder	Creates a new folder in the current library. This is for organiz your particle presets.		

Emitter

All of these settings can be thought of as global 'multiplier' settings for all particles coming out of the selected emitter. You can have several different particles coming out of the same emitter, yet changes made here will affect them all. The Emitter category is the place where you can make the most dramatic changes to an emitter's global particle settings. To work in the Emitter category, you can have an emitter or a particle type selected in the Workspace panel.

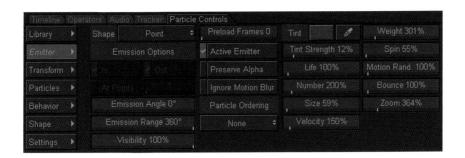

Emission Options:

originate

In/Out

	originate.
At Points	When disabled, the entire emitter shape will spawn particles, when enabled, you can control the spacing of particle emission along any emitter shape. This is disabled for point emitters.
Angle	This controls the angle of emission the particles leave an emitter. 0 degrees

points right, 90 degrees is up, 180 is left and 360 is back to the right. You can go past 360 here to loop.

These options control from which side of a line or circle emitter particles will

Range This is primarily for Point emitters. A values of 360 means particles spawns in

all directions, values less than this will have direction when they leave the

emitter.

Visibility This is detailed in the 'Scaling Factors' section below . . .

Miscellaneous Emitter Values:

Preload Frames	This causes an emitter to begin 'already on' by a certain number of frames when it is first seen.			
Active Emitter	This is an on/off switch for an emitter. You can also turn an emitter on/off in the Workspace panel like anything else in combustion.			
Preserve Alpha	This options forces particles to use the alpha channel of elements behind them.			
Ignore Motion Blur	When enabled, the selected emitter will not calculate particle motion blur set in the Settings category of this Particle operator.			
Particle Ordering	Oldest in Back simulates particles coming at the viewer and Oldest in Front simulates particles going away. If you do not need to use this, leave it to None as this calculation add processing time.			

Tint – The color swatch and picker seen here provide a basic/quick way to color correct all the particles coming out of the selected emitter.

Scaling Factors – There are several parameters in the Emitter category of a Particle operator that are

percentage multipliers that affect ALL the particles coming out of the selected emitter:

Life	This is actually not a frame count, but a generic unit of time. Higher numbers mean longer lives for particles.		
Number	This controls the quantity of the particles.		
Size	This is not a measurement in pixels, but a generic unit of size. Larger values equate to bigger particles.		
Velocity	This controls the speed at which the particles move away from their emitter.		
Weight	These values can be positive or negative. A weight of zero defines a particle with no gravity factor. A positive weight falls and a negative weight rises.		

Spin	This controls the rotation of the particles. These values can be positive or negative. A positive value is a clockwise rotation and negative values result in counter-clockwise rotations.		
Motion Random	Increasing this value causes a natural, organic motion that can slightly override velocity and weight values.		
Bounce	This controls how a particle reacts when it hit a deflector object. If a particle has a bounce value of 0, it may pass through a deflector.		
Visibility	This controls the percentage of opacity. 0 in invisible and 100 is completely opaque.		
Zoom	This last Emitter variable scales both the velocity and size settings for all the particles spawning from the selected particle emitter. Animating this value is the easiest way to make particles appear to have perspective due to simulated 3D space.		

Transform

This is where you can manually transform the invisible emitter object (but not the particles themselves). Depending on the type of emitter selected, different transformations will be available or disabled. When you have more than one emitter within a single Particle operator, it can often be easier to move selected emitters using these controls instead of directly in the viewport.

Note: The next three categories below (Particles/Behavior/Shape) are where you edit and fine-tune the appearance and behavior of the actual particles themselves. To access any of these three categories, you must have a particle type (not the emitter or the operator) selected in the Workspace panel. Remember that there are particles coming out of emitters that are within an operator. Each of these entities can all be accessed, renamed, and selected via the Workspace panel. If you have an emitter or operator selected, these three categories of the operator will be grayed out and unavailable for editing.

Particles

The primary controls here are the Life Color and Life Opacity. These largely set the color and transparency value of each individual particle. Figure 13.3

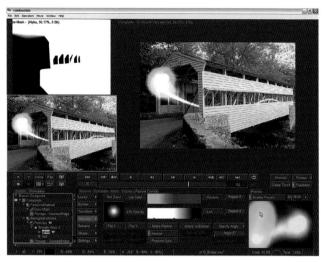

Figure 13.3

shows the Particle settings for the particles named 'glow' in the *file* ch13_Bridge.cws.

Random Start Frame

If a particle sprite image has more than one frame, this will cause it to play back in a random manner instead of sequentially every time. This allows for more natural effects with a sporadic appearance. This will not be available if the particle shape is a single frame.

Life Color

Often, it is actually better to use grayscale particles and let this gradient editor control the color of the particles over their life. This will provide more options for coloration of the different, individual particles coming out of an emitter. On the left is the color of a particle at birth and to the right is the color at the time of their death. The Repeat variable controls how many times a particle will cycle through this gradient over its life. The Random toggle causes the particles to disregard age and, instead pick a color at random from this gradient. This is good for sparkle effects.

Life Opacity

Again, birth of particles is on the left and death on the right. The Link option causes the opacity to be obtained from the luminance (grayscale) version of the Life Color gradient above instead of from this gradient editor.

Lighter Life Opacity values result in more opaque particles. Single Particle This makes the selected particle type one particle that is in the center of the emitter. Instead of many particles coming out of an emitter, only a single particle will be created of this type. This is often used for things like a torch glow that follows the emitter while other particles represent smoke and fire coming out of the same emitter. Intense and Preserve Color Intense will make particle brighter by using an Additive Transfer mode. Preserve color is only available when Intense is enabled and is an option for blending the particles with transparency. When a particle does not appear in the viewport because of the background image 'fighting' the appearance of a particle, these can be used to attempt to make a particle stay visible over different colors. Attach to Emitter When enabled, the particles move with the emitter in a user defined percentage (typically 100%). This option is often used to affect the trails of a moving particle emitter, or on panning footage with a Particle operator applied. This is OFF by default. Particle Angle The specified angle makes all particles have the same starting angle. Random Angle is for organic effects and Align to Motion forces the particles to spawn at an angle

Behavior

You do not have individual controls over every single particle, but here you can control mannerisms of each particle type coming out of an emitter. This simple UI can be broken into three areas, as noted in Figure 13.4.

based on the emitter animation.

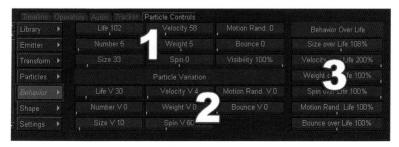

Figure 13.4

- 1 Default Behavior The top nine fields set the default parameters for the selected particle type. These nine settings have the same characteristics as those previously described in the Emitter settings, but here the controls are local to the selected particle type. You may have several particle types coming off one emitter, and this allows you to control them each independently of one another.
- 2 Particle Variation You will notice the bottom nine fields have the same labels as those in Area 1. This is because these represent the variation (+/-) of the values above. For example, if you set the default size in Area 1 to be 10 and the variation for size in Area 2 is set to 5, the resulting particles will range in size from 5 to 15.

Tip: If you want particles to rotate clockwise and counter-clockwise, the Default Spin value should be 0 and the variation for Spin is the value to edit. Again, particle variation is a $\pm 1/2$ amount.

3 Behavior Over Life – These six fields are presented here but are actually best edited in the Timeline (Graph mode). These six values are the only case in combustion where the horizontal scale of the Timeline does not represent frames or timecode. Figure 13.5 shows this special case in combustion.

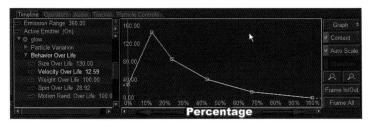

Figure 13.5

In this example, the particle begins its life with a size of approximately 100 and then quickly ramps up in size to 240 after only 10% of its life, then quickly goes down to size 150 at 20% life, and then slowly reduces size to 0 by the time the

particle dies. You can see here why editing the six Over Life values is best done in the Timeline.

Regardless of the life value (resulting from the combination of Emitter/Behavior settings), these percentages still represent the entire life of a particle, whether the life is 13, 194, or 1847 . . . , for example.

Remember, the Emitter category of a Particle operator acts like a global multiplier. If you set particle life to 500 in the Behavior (fifth) category but set Emitter life to 25%, then the resulting lifespan is 125.

Shape

This is where you can set what a particle sprite looks like. There are several different types of presets. You can also assign a particle sprite to be an operator elsewhere in your current Workspace or even an image off the hard drive. Again, it is often advantageous to use grayscale images and let the Particle Life color gradient control the hue of particles.

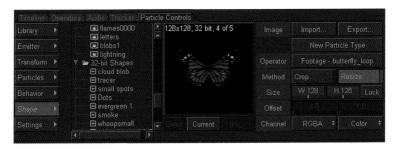

Tip: Due to the nature of the OpenGL programming, it is useful to use particles whose pixel dimensions are 16, 32, 64, 128, 256, or 512 – for example, an image that is 32×32 in size. Remember, this is only the size of a single particle. The smaller the particle, the faster your system will run. You can use other particle sizes, but combustion will have to resize them to the closest value mentioned here to comply with OpenGL.

Swap

To change the appearance of a selected particle, you can simply pick a new preset sprite image from the list and click the Swap button.

Current	Put the sprite image of the current selected particle in the Shape preview window. This allows you to analyze the sprite in detail.			
Info	Provides information as to how and in which emitter a sprite from the shape library is used in the library emitters. It also lists info suc as image size and duration.			
Import/Export	Brings an image into or out of the Particle operator as a sprite image in common formats such as TIF, TGA, and JPG.			
New Particle Type	Duplicates the selected particle in the Workspace. This new particle will be spawning from the same emitter and have the same starting characteristics as the original. These values can then be edited.			
Operator	Allows you to get a sprite from any node in the current Workspace instead of off the hard drive. Useful if you want to create a sprite in a Paint operator, for example.			

Settings

Here, you can control particle motion blur settings local to this operator. You can enable motion blur for each Particle operator if you wish to blur particles without blurring the image that the operator is applied to. You can also optionally load a background image into the operator using controls found here. A background image can be useful, for example, if your Particle operator is applied to a transparent solid but you need to keyframe an emitter over footage in another branch in your workspace. This image will not render out of the operator and is only a reference for editing particles over a background plate.

Note: You will not see the background if the solid onto which the Particle operator is applied is not transparent.

Deflector

This category is only available when a deflector object is selected in the Workspace. To edit or animate a deflector, you can transform it as you would any object in combustion. You can also enable control point editing to edit/add/delete control points as you might a mask or vector paint object.

Library Presets as Starting Points

To demonstrate the ability to create custom particles, you will use a Workspace that contains presets which you can tweak, or change the particle appearance, and fine-tune the actions of these particles.

- Open the file named ch13_ParticleShapeSwap.cws. Play the clip and you will see a simple animation created with a point emitter and a preset named Shoot Smoke. This emitter preset has one particle type spawning from it, named 'plumes'.
 - 2 Expand the Workspace panel and select this 'plumes' particle type.
- 3 Switch the Particle Controls to the Shape category and then tap the Current button. This places the sprite used by the 'plumes' preset in the Shape preview window.
- 4 Click the Image > Import button seen in Figure 13.6.

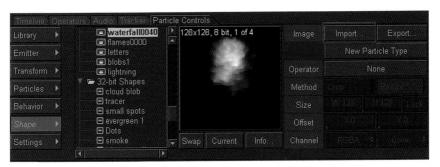

Figure 13.6

Navigate to the . . . _footage\sequences\directory and select the file named butterfly_loop.mov. You will be presented with a dialog that resembles Figure 13.7. This dialog has a few options for how you wish the incoming footage to be treated as a particle.

Tip: In the case of a multi-frame sequence such as this, you can scrub the viewport to see the frames of the incoming sprite.

- 6 Select the Use Alpha option and click OK. The result is the butterfly sequence has been added to the shape library and has been put in the Shape preview window.
- 7 To actually make the switch, simply tap the Swap button under the preview window, and you will have butterflies where you previously had smoke.

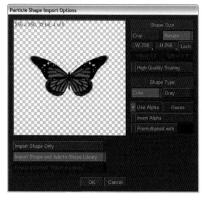

Figure 13.7

8 Experiment with the Emitter,
Particles, and Behavior settings to tweak the appearance of the
butterflies. Also, there are several 'Behavior Over Life' values that can
be manipulated in the Graph mode of the Timeline. These affect the
different particles over the course of their life in ways such as size,
velocity, and so on.

There are a few additional ch13 Workspace files provided for your examination. One recommendation is to expand the Workspace panel of each and go through the settings for the different particle types.

Closing Tips for Particles

If you are not using the preview window, make sure it is disabled. This window uses up a good amount of processing power, whether or not you are using software or hardware OpenGL. If you have lots of particles and emitters in the viewport, this is the place you may end up fine-tuning the particles because you can isolate the different types.

You will often get better response from the OpenGL particles if you use a smaller size particle and zoom the particles up instead. This technically resamples them up, but often this slight loss of resolution is not noticeable and is well worth the trade-off for better performance.

Similarly, you can often have a 'give and take' of size and number of particles to get a very similar appearance, but with much faster playback. For example, size50/number100 might look the same as size100/number50, but the latter will probably play and cache much faster.

If you have several Particle operators, emitters, and/or particle types in a shot, you can temporarily turn them off to concentrate on one at a time for better playback. Likewise, you can turn off particles while keyframing or tracking emitters to speed up the workflow.

If your OpenGL performance is poor, you can always just double click the layer or composite containing the particles and cache this to RAM like anything else. Instead of attempting to continuously redraw the Particle operator in OpenGL, the particles will cache and then have real-time playback on weaker machines without high-quality OpenGL cards.

It is often recommended to use software OpenGL when network-rendering particle Workspaces on machines with different graphics cards. This is to ensure the particles bypass the hardware and draw the particles the same on all machines. Experiment with your network and graphics cards to determine what works best for your pipeline.

CHAPTER 14 RENDERING AND OUTPUT

Elept 8 Bit 4 Confidence CARAMES (allered burder Starting Frame #

Current Frame: 25 (0 of 27)

Total Frames: 0 of 277

ng Up Next...

rendered tga

Using mixed resolutions, nested composites, dozens of layers, and branches . . . AGH! This entire process can get confusing pretty quickly. Organization of projects is, obviously, important throughout the entire process. Even so, for delivery to your target audience, all of these considerations would be for nothing if you didn't output your work in some manner or another.

Output Format Considerations

You should actually have a really good idea of your final delivery format prior to starting a project. For example, it would be terrible to do weeks of work at one resolution and the client then says, 'um . . . this was supposed to be a projected feature film, not a DVD'. Knowing your deliverable medium is critical to beginning a project in combustion. If you always work in DV, for example, then the decision is an easy one (or there is no variable whatsoever), but when you have multiple format considerations, and especially when you mix resolutions and frame rates of source material, you need to use caution and think ahead.

There really is no single answer to output considerations. There are so many delivery mediums available today including the Internet, CDROM, DVD, miniDV, BetacamSP, Digibeta, NTSC, PAL, HD (several flavors), and numerous types of film-resolution outputs. The best, brief advice I can give is to look at samples of projects similar to what your target output is going to be. Quite often, the delivery medium(s) will dictate what they 'want' with little room for interpretation. For example, NTSC DVDs are all 720×480 resolution at 29.97 fps and lower field dominance – period.

Render Dialog Window

When you are ready to finally output your project, you tell combustion to create or render 'flattened' raster files to the hard drive. These are typically the end result of the entire Process Tree for any given branch. You access the primary render dialog from the File menu, which then brings up the interface (Figure 14.1) for setting output options.

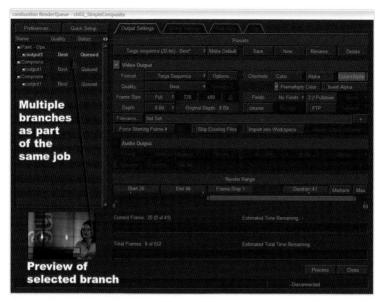

Figure 14.1

Output Settings

When you bring up the render dialog by selecting File > Render, combustion creates what are called **output nodes**. An output node is automatically placed at the very end of the Process Tree of each unique branch. If you only have one branch in your Workspace, then there will only be one output node visible in the schematic, and also only one task will appear in the left area of the Render Dialog window.

As you can see on the left side of this example, there are currently three branches in this Workspace that are ready for rendering. These three branches can each have their own output settings and location on the network to store frames. However, this is all considered one render task to combustion (and to network rendering methods detailed in a moment). You can optionally disable render nodes by either turning them off in Schematic or by clicking on the small icon next to its name in the left portion of the Render dialog seen here. The right side of this dialog shows the settings for whichever output node is selected on the left.

Typically you want to render the end result but you can, however, add an output node at any point along the Process Tree. Say, for example, you wanted to render out just the alpha channel of one branch, setting an output node for that point is a simple undertaking. In the left side of the Render Dialog window, you can simply right click and choose to 'Add Operator' for another output node. As an alternative (and a more visual way of working), you can quickly switch to the Schematic View, right click on a node and select Add Render Output from the flyout menu. In this case, the choices made available in this flyout menu are pulled from the Preset list detailed below.

Tip: You can always assign any preset as an output node in Schematic, and then change all the output settings in the Render Dialog just prior to rendering.

Note: You can optionally have several outputs off the same node in a Workspace. Say you want to render a full DV version of a clip and also a smaller 320×240 version at 12 fps for client review on the Internet.

Presets Area – Along the top of the Output Settings tab is an area labeled 'Presets'. Here, you will find a drop-down list for accessing common output settings such as D1 NTSC, PAL DV, and so on. You can create your own, named custom presets simply by clicking the New . . . button and then providing a name for this preset. For example, 'Web 320 draft rez'. Then you can set up all the parameters, frame rates, file formats, codecs, etc. and ultimately return here and click the Save button. Render presets are written to an ASCII text file named render queue.preset.

Video Output Area – Here, you select the file format and codec, render quality (typically 'Best' for final work), color channels, field settings, and frame size.

Fields – Should you render to fields? Ahh, this question again. Depending on who asked, you will undoubtedly get a different answer every time. For the most part, you should only render to fields if your work is going to be played back on an NTSC or PAL video monitor. Even then, some people prefer to render full frames (no fields) and let their non-linear application such as Avid do the field

separation later. You should consult the manuals to the hardware you utilize for input and output to find what suits you best – and render some quick tests (of boxes quickly jumping around in paint) with different settings and look at the results to see which you like best.

Cleaner – This option allows you to send jobs directly to Autodesk Cleaner for encoding. The proper version of Cleaner needs to be configured on the same computer to use this feature.

Force Start Frame Number – When rendering image sequences, the numbering will be automatic and use the current time settings. For example, frame0001.tga, frame0002.tga, and so on. Setting this to a number will force the numbering of the first frame, for example frame0137.tga, frame0138.tga, etc.

Skip Existing Files – This option can be useful if you have previously rendered part of a segment and do not wish to re-render all the frames. This is also a critical option to check if you plan on using the Watch Folder method of network rendering. This will prevent all rendering computers from processing all frames (each).

Import into Workspace – When enabled, this option will bring the resulting rendered file(s) off the hard drive and into the current Workspace as footage. This footage will then be available both in the Footage Library and in the Schematic View.

Audio Output Area – If your project has an audio scratch track, you can choose to render your project without audio, render the audio to a separate file such as WAV or AIFF, or optionally embed the audio directly into a format such as MOV or AVI.

Render Range Area – This area allows you to specify the duration of a branch to be rendered. You can manually type in a frame range, or you can easily tap the Markers button to snap the render range to the markers set back in the primary UI of combustion.

Process – To begin rendering locally on one computer, you simply click the Process button. An estimated time remaining will be provided for you to see how long until the current job is completed.

Tip: While it is obviously an intensive process, after you start a render you can launch another session of combustion on the same machine. This is only recommended if you plan on working on something that does not require intensive processing or caching (such as creating simple text for titles, etc.).

Global Settings

This is primarily used to set up network rendering options. Input and Output folders allow you to specify locations that rendering machines will look to read (input) and write (output) source footage. These can replace the paths set at the footage level of each source clip in the Workspace.

Tip: If you know you are going to take advantage of network rendering, it is a good idea to get source materials from a shared location while building your projects. This will ensure that all computers see the same source material in the same way.

Statistics

This tab is where you can get information about the current render in progress and also all renders that are queued. When a project is actually rendering, the Statistics tab allows you to see information pertaining to the rendering task. Along the bottom of the combustion render window are an updating thumbnail and information about the progress of the current task. When a render is finished, this area will show information pertaining to the last frame rendered.

Log

The Log tab of the Render Dialog window displays information about the rendered jobs in the queue. These logs are only available for render jobs that have completed rendering. They are a summary of the task in question. These logs are also written to a text file that resides in the 'Renders' directory within the combustion installation folder.

The Render to RAM Feature

In addition to rendering files to the hard drive from File > Render, you also can access the Render to RAM from the File menu. Render to RAM allows you to cache a 'flattened' version of the contents of the active viewport. This can be especially usefully on longer projects or on systems with less memory than others (that is, laptops).

This feature is not actually intended for 'final' renders (but can be used for that purpose as well). It is, in fact, most useful while still in the

Sombustion File Edit Selection Object Effects Movie New... Ctrl+N Ctrl+O Open... Ctrl+Shift+O Open Workspace... Import Workspace... Ctrl+Shift+I Save Workspace Ctrl+S Save Workspace As... Ctrl+Shift+S Ctrl+W Close Workspace Revert Workspace Open Recent Workspace Quick Capture... Save Image... Ctrl+Alt+S Ctrl+R Render... Render to RAM. Ctrl+Shift+R Preferences... Ctrl+: Fvit Ctrl+Q

creation phase of 'heavy' projects that require a lot of memory. Render to RAM allows you to get a feel for certain portions of a project and then, ultimately, render them to disk as actual files using the standard rendering procedure. Render to RAM is something you can do at any time in combustion.

When a Render to RAM process is finished, it should be mentioned that the resulting viewport is a special case. This is a cached viewport of the flattened branch. Notice the name of the viewport in Figure 14.2.

Render to RAM created flattened, cached file in memory only. You can, however, save the contents of a Render to RAM viewport by *right* clicking on it and selecting *Save RAM Player As* . . . You can exit a

Figure 14.2

RAM Player window by closing it or merely sending something else to this viewport (in which case the cached RAM player is lost).

Compare – The Compare within the Render to RAM dialog (Figure 14.3) is useful if you want to render the flattened contents of the current viewport to

RAM, but also judge this against another node in the Workspace. For example, if you wanted to see a before and after of an image stabilization. This feature is identical in function to the Compare feature outlined in Chapter 7. This is just an option and is not required to use Render to RAM.

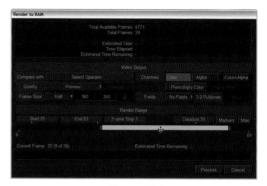

Figure 14.3

Tip: Render Range, Quality, and Frame Size settings in the Render to RAM dialog are excellent ways to further optimize this feature. For example, you can be in the middle of building a huge project and, just before leaving for lunch, you can start a Render to RAM of a half-sized version that is limited to frames 128–387 at medium resolution.

Commit to Disk

The Commit to Disk feature of combustion can be accessed by right clicking on any operator in the Workspace. While this can either be done in a Schematic View or the Workspace panel, it is often easier to understand and visualize the process when viewing a Schematic View.

You now know that a non-destructive workflow means we can go back at any time and make changes. Caching was explained previously and you know that combustion caches all the outputs of a Workspace. But what if you feel that you are pretty happy with one part of the Workspace and wanted to cache only the end result of several nodes and not the entire chain of events?

Commit to Disk is an operation that is basically like Photoshop's 'flatten' feature. Instead of caching a series of operator output nodes, you can pick an output in the Combustion Process Tree and render images to the hard drive that represent the end results of everything downstream from that output. This process works

in conjunction with an operator called **Switcher** (found in the Channel category of operators). The Switcher's role is to flip between the rendered/flattened footage on the hard drive and also keep a wire to the original series of nodes (thus preserving the non-destructive nature of combustion's workflow). At any time, you can switch between the operator's input or the committed footage, if you desire:

- 1 To perform a Commit to Disk, open the file named ch14_ComplexComp.cws.
- 2 Switch to the Schematic View (F12) and fit the contents to the window. You will end up with Figure 14.4.

As you can see, the node indicated here is a composite with several layers. After this point, several operators are used to 'treat' this composite with more effects.

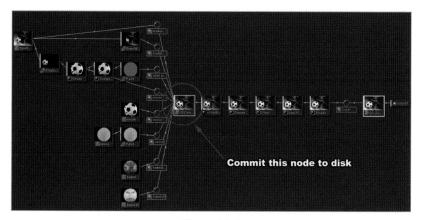

Figure 14.4

Right click on the Composite node indicated here and choose Commit to Disk from the flyout menu that appears. You will be presented with a

rendering window similar to the primary render dialog. Set an output directory and use settings similar to those seen here:

Tip: When you are committing to disk and are in doubt, always render frames as Color + Alpha. This will ensure there is an alpha channel if one is needed. PNG frames are used here because they are a file format that uses lossless compression. If you are planning on using this committed footage within the final rendering of your project, you should use the Best render quality. If you only want to commit to disk to save processing resources, a lesser quality can be used and then switched back to the original prior to starting the final render.

- 4 Click the Process button and combustion will render all the elements up to that node as files to the hard drive location specified in step 3.
- Once finished, notice the changes in the Schematic View. There is a Switcher operator now in the place of the node that you committed to disk. Figure 14.5 shows how the switcher is tied to both the original branch and also to the footage committed to disk.

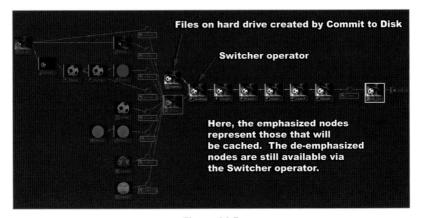

Figure 14.5

- 6 In the Workspace panel, expand the layer and select the operator named Switcher.
- 7 In the Switcher Controls now visible under the Playback Controls, toggle back and forth repeatedly between input 1 and input 2. Notice in the Schematic the primary and secondary input is getting flipped

each time. Only the primary input will be cached, so if you have the new footage as the primary input, then you won't have to cache all the operators and footage still available in the secondary input. In this case, the secondary input does not actually do anything; in effect, it is just 'on standby'. Changes to the long chain of operators can either be recommitted, or you can just switch the longer chain of operators to become the primary input once again. It should be mentioned that switchers can have many secondary inputs on standby in this manner. You can add more by wiring them into the light blue secondary input bar in the Schematic View.

It is often a good idea to render Commit to Disk frames to the same directory for all projects. This is to keep track of the potentially vast number of frames you may generate using this procedure. Also, if you decide to network render, all rendering machines need to be able to access these frames as well. Alternatively just use Commit to Disk as a resource saving tool while building a large project, and then remove any reference to committed footage by deleting it from the Workspace and making the original operators and footage the only input to the Switcher.

Network Rendering with RenderQueue

Network rendering is possible on both Macintosh and Windows platforms through a simple system called the RenderQueue. Essentially, all rendering systems get combustion installed on them and you run an application called **render queue.EXE.** This application looks extremely similar to the render dialog within

combustion, but it is a stand-alone application that looks for jobs in a location known as a Watch Folder. The Watch Folder must be a shared location on the network that all computers can 'see'. For each computer, you specify a folder to watch in the Preferences of the RenderQueue application.

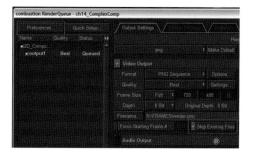

To use the RenderQueue method of network rendering:

Build a project as you normally would (or, for now, open one of the completed projects included with this book). You should, however, keep in mind that if you are going to network render on several machines, all source footage should be obtained from a location that all computers can access. For example:

```
\label{lem:contage} Z:\SourceFootage\ClientABC\RawFootage\. . . . \\ or \Machinename\ShareName\SourceFootage\ClientABC\RawFootage\. . . . . \\
```

2 Set the output settings in combustion Render Dialog. For the RenderQueue method of network rendering to work properly, you must enable the option for Skip Existing Frames. If you forget this step, all machines will render the entire job and you will end up wasting valuable network resources (and lose production time). Also, the output location needs to be a location that is shared and accessible to all computers. For example:

Q:\Output\ClientABC\rough_drafts\ . . .

- **3** Save the finished, unrendered CWS project file somewhere on your computer network.
- When you want this job to begin network rendering, you simply copy this CWS file into the Watch Folder. Any machine on your network that is running RenderQueue and has this location set as their Watch Folder will begin rendering the jobs, including all active render output nodes within that Workspace.

Network Rendering with Backburner

The Windows version of combustion ships with a powerful, client–server network rendering system called Backburner. On a default installation, Backburner can be found in the 'Discreet' folder of installed applications on your computer. They can be accessed via the Start menu of Windows.

Backburner is, in itself, three small applications that can run on one or several networked computers. All three Backburner applications are stand-alone programs that are task management software. **None of them do the actual rendering themselves**. All Backburner does is talk to other software applications and dish out tasks for them to do. Two graphics software applications that Backburner can control are 3ds max and combustion. Backburner can also be used by Burn to process Flame tasks offline on inexpensive Linux computers. You will hear more of Backburner in years to come for sure.

Setting up Backburner is usually a one-time operation and does not require rocket science or any practice of voodoo mumbo jumbo. It's really a snap and the benefits are phenomenal. Do not let the intimidation of dealing with networks stop you from using this incredible tool for productivity. I cannot say enough about Backburner and how it integrates a production pipeline.

Manager.EXE – This is the grand master control of Backburner and the shepherd of the farm. This application only needs to run on a single computer and it controls the entire render farm. This application does not require a lot of memory to run. Remember, Backburner is only task management software. It is combustion that will be doing the actual rendering.

Figure 14.6 shows the Manager application running. Here, you can see that the Manager application is dishing out frames to render. You typically do not need to watch this window, as most of the things you would find of interest

```
₽ Backburner Manager version 3.0beta4
                                                                                        garyd completed 1 task(s)
      Job 'lightmoved - Second Pass' Complete
 INF Sending instructions for job 'teapots02-anim' to garyd
 INF asus completed 1 task(s)
 INF garyd completed 1 task(s)
 INF asus completed 1 task(s)
 INF garyd completed 1 task(s)
     garyd completed 1 task(s)
 INF asus completed 1 task(s)
 INF garyd completed 1 task(s)
INF asus completed 1 task(s)
 INF garyd completed 1 task(s)
 INF asus completed 1 task(s)
 INF garvd completed 1 task(s)
 INF asus completed 1 task(s)
 INF garyd completed 1 task(s)
INF asus completed 1 task(s)
4
```

Figure 14.6

here could best be looked at and edited from the Monitor application (described below).

Server.EXE – This is the application that needs to run *on each machine* in the farm that is going to render. This is the application that talks back to the Manager and says, 'Hello there, Manager, I'm ready to render some frames. You have anything for me to do?'

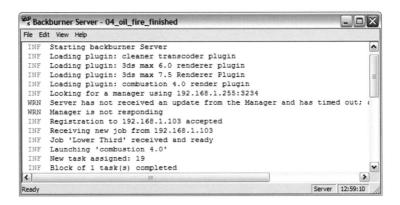

It should be mentioned that combustion will also need to be installed on every computer that is going to be a render server (aka 'render slave'). These installs, however, don't need to be authorized and can be minimal installs.

If you arrive to work, a machine is rendering and someone needs that particular computer to go about his or her regular tasks, just stop Server.EXE from running on that machine. That single computer will stop rendering and you can use it for other things. However, the render queue will still be running and the rest of the rendering computers will pick up the slack. To resume the rendering on that computer, the user merely needs to launch their Server.EXE with a double click, and walk away. The user needs to know nothing about graphics, networks, video, or anything else. If someone can check e-mail, they can handle this small task.

Monitor.EXE – This application has several great features. It is basically a front end or GUI to the Manager. However, this application can be run on any machine on the network to monitor the render queue. You don't necessarily

have to run Monitor on the same machine as Manager. This means from anywhere in the facility, anyone can launch Monitor on their computer to see the progress of the render farm. Once connected to the Manager application, Monitor can get valuable information pertaining to all the jobs in the render queue. Examples include the speed of each machine, which jobs are done, currently rendering and next in line, and which machines rendered which frames.

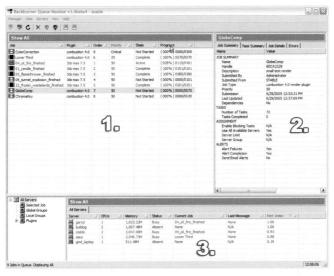

Figure 14.7

Assuming nobody on the network is running Monitor, the first time it is run will create the *controlling* Monitor. From this unique machine, the queue cannot only merely be looked at, but you can also do things like stop and start jobs. After one person has launched Monitor and has 'control' of the queue, anyone else that launches Monitor on their computer will only be able to look at this information, but not make changes to the queue. For this reason, it is often wise to have the lead artist or technician running the controlling monitor. Figure 14.7 is the Monitor application interface. You can see that it is broken up into three main areas:

1 The first is the actual queue in all its glory. Here you can see what jobs are rendering, the order they are going to render, etc. If you are in

control of the queue on your system, you can also do things like reprioritize jobs, turn jobs on and off, and delete jobs from the queue. When you are in control of the queue, most of the commands to do these tasks are in the *right click* menus. One of the right click menus to investigate is called the Column Chooser. Here, you can determine what specific information will be viewed in area 1.

- The second area of the UI is where you can see data about the *individual* task selected in area 1. In the above example, the job currently selected is named GlobeComp. Information about this job is visible in area 2. Examples of information gathered here include which machine is rendering which frames, where the frames are being saved, and how long frames are taking to render. Note that this selected job has not even started rendering. The job actually rendering at the moment is named 04 oil fire finished.
- The third and last main part of the UI is where you can see information about each of the machines on the network that can potentially render. The last column called Performance index was added from the right click menu Column Chooser. The Performance index is where you can gauge the speed of your individual systems on the render farm. A Performance index of 1.0 is the fastest machine overall on your network. The rest will be a decimal value that represents a percentage of speed to the fastest. In the above example, my laptop is 19% as fast as my best two workstations. It can be good to know which machines are doing how much work, and this is the easiest, single way to check. If two identical hardware configured machines are drastically different in speed, then you should investigate why. The right click menus allow you to access the Column Chooser in this area of the UI as well. Here, you can determine what specific information will be viewed in area 3.

Note: Whether you network render with RenderQueue or Backburner, to use multiple computers for rendering one job requires that you render a sequence of frames and not an MOV or AVI file. This is because multiple computers cannot create an MOV or AVI at the same time.

For more information about the numerous advantages to network rendering and Backburner, check out my free whitepaper, 'Down on the Farm'. This document details specifics about setting up your network, how to shop for render machines, advantages of network rendering and even presents hypothetical scenarios outlining a few different studio workflows. There are also details about the pros and cons of various file formats when using network rendering. This 23-page white paper can be found here: http://www.visualZ.com/free/Down_on_the_Farm.pdf.

Outputting your work is an important last step that should not be an afterthought. When building any project, you should be aware of how it will be presented to the viewer and take the necessary steps to ensure that the delivery format accommodates any and all the artwork you create within combustion.

Caching and File Sizes

To calculate the uncompressed file size of an image, you multiply the image height by the width, and then multiply that result by the number of color channels in the image:

Uncompressed size = (image width) \times (image height) \times (number of color channels)

Note: The last variable (number of color channels) is typically three (RGB) or four (RGBA), depending on if you have an embedded alpha channel in the image or not.

Using the equation on a single D1 NTSC frame, you can see the following result:

$$720 \times 486 \times 4 = 1,399,680$$
 bytes.

This equates to roughly 1.4 megabytes per frame when uncompressed. Therefore, 1 second of D1 NTSC video takes up 42 megabytes of hard-drive space and memory used by combustion to cache this image.

To prove this, create a new Paint branch that is 30 frames, D1 (720×486). After tapping the spacebar to begin caching, the cache meter should read 41.1 megabytes after playing through once.

If you use uncompressed files, it is very easy to calculate the hard drive space needed to do renders because every frame of the same resolution will be the same file size.

Format	lmage size	Megabytes/ frame	Frame rate (fps)	Megabytes/ second
NTSC D1	720 × 486	1.40	30	42.0
PAL D1	720×576	1.66	25	41.5
HDTV 720i	1280×720	3.69	30	110.7
HDTV 1080p	1920×1080	8.29	24	198.9
Film, 2K	2048×1556	12.75	24	344.25

Note: Files like OpenEXR and RPF can optionally contain extra channels beyond RGBA. These extra channels can be used for numerous effects that are beyond the scope of this introduction to combustion.

Still Image and Sequential File Formats for Rendering

The file formats below are just a few of the more common image file formats used for network rendering. There are certainly more file formats such as IFF, PICT, TIF, SGI and others, but this list provides some information about the more common formats.

TGA: 'Targa'

Pros – This format can most likely be read by any graphics application you will come across. It is extremely cross platform. Targa files can optionally have embedded alpha channels and/or be compressed.

Cons – I have experienced occasional problems when using compressed TGA files in some applications (I do, however, know others who do this all the time without issues). You will need plenty of hard drive space if you use Targa files, especially if you use the feature known as 'Render Elements' in 3ds max.

JPG (aka JPEG)

This format was made popular by a little thing called the Internet. However, these are widely used in every field of computer graphics. I think far too many people fear JPG compression. JPG at their highest compression look darn good and, to the naked eye (at video resolution), look perfect. I don't care what anybody says about them. Only use these if you don't need an alpha channel. JPG files at maximum quality look great if you are hurting for drive space.

Pros – They can be very small because they can be compressed. The user controls the quality of the compression. Nearly every application can read them and they are widely cross platform.

Cons – The compression algorithms used by JPGs, even at 100% quality, are considered a 'lossy' compression. You are technically losing quality and if you later compile to MOV or AVI, you are going through yet another compression stage. JPG cannot contain alpha channels. If you are going to do any blue- or green-screen chroma keying in your project, avoid JPG files on the chroma key footage. In this case avoid JPG compression.

PNG: Portable Network Graphic (aka 'Ping')

This format was created initially as an alternative format for use on the web, but I have been using it recently for almost all my network rendering.

Pros – These files are compressed in file size, but they use a lossless compression algorithm. Quite often they are much smaller than JPG files yet lose no quality! They can optionally be up to 16 bits of color per pixel (aka 48-bit color space) for when you might be working with very high-resolution output to film scanners. If you are working with video, you only need 8 bits of color per channel. These would be 24-bit color or 32-bit total color if you include an alpha channel. More and more often, higher color space is used, especially in the motion picture industry.

Cons – Not all applications can read and/or write PNG files. It's a good idea to check your editing system and any film recording facility if you plan on using these files. Make sure your favorite applications can read these.

CIN 'Cineon'

Pros – Widely recognized as the format for the motion picture industry. Analog film scanners typically output *.CIN files. This format has 10 bits of color per pixel (30-bit color space).

Cons – These files cannot contain an alpha channel. Cineon files are often difficult to deal with due to a color conversion known as Look Up Tables (or 'LUTs'). Most NTSC displays and VGA monitors can't show this much color without applying some form of LUT. Dealing with logarithmic and linear LUTs can be difficult and shall not be discussed here. If you were planning on doing work for a feature film, it would pay to research this and/or discuss it with someone who has used this format for digital postproduction.

RPF and RLA: Rich Pixel Format

Many 3D applications can now write out RLA files. This is a format invented years ago by Wavefront that has additional information beyond RGBA.

The newer RPF format is a derivative of the RLA and can optionally contain even more great stuff. Please consult your documentation for additional information regarding the integration of these software products.

Pros – In addition to the typical RGBA information contained in an image, these files can contain metadata such as Z-depth, pixel velocity, material, and object effects channels, to name a few. These images can be much higher bit depth than the typical 8 bits of color per channel.

Cons – These individual files are often extremely large. The use of RPF and RLA files often require a deeper understanding of both your 3D software and combustion to fully take advantage of the extra data. A strong coordination between the 3D animator and the compositor is often needed (but when that's the same person, no problem!). RLA files from different 3D applications behave differently.

Single File, Multi-Frame Image Formats

The file types below are just a few file formats that exist today that are a single file on your hard drive, yet they can contain hundreds or even thousands of frames of video or animation. These files are often easier to manage on your system because a single file represents so much information, but quite often they are actually slower than individual, sequential files when used in animation programs such as 3ds max and combustion. This is because, unlike sequential files, these files need to be 'read into' on every frame if you are, for example, using them as a texture map or as a layer in a composite. This is not to say you should never use them as texture maps, etc. – but be aware they are often slowing you down to do so. This is quite often a negligible or even indistinguishable difference, however. Do some tests. Unlike animation software, most non-linear editing systems will, however, work faster with these files if they are in the native codec for that particular editing system.

AVI: Audio Video Interleaf (aka Interleave or 'Video for Windows')

Pros – Many different flavors or 'codecs' for different output applications from CDROM playback, web delivery and broadcast. They can also be uncompressed.

DivX is a new AVI codec that encodes very fast, creates a small file size and looks real nice. DivX is not intended for broadcast but is great for web, emails, and client reviews – www.divx.com

Cons – Can only be created by one machine at a time. Cannot have alpha channels. PC only (however, I've heard some Macintosh applications can now read and even write AVI files). Not ideal for network rendering. Must make sure every machine has the same version of different types of codecs installed to access these files.

MOV: QuickTime

Pros – Widely used in the video production field. Cross platform. Many different codecs for different output applications from CDROM playback, web delivery to broadcast. They can also be uncompressed and optionally contain an alpha channel. This is confusingly named 'Millions of Colors +' (note the + character that indicates alpha channels). Many non-linear editing systems can output a software codec MOV file that can be read by any computer for postproduction and FX work. One example is the Avid Meridian Uncompressed format of MOV.

Cons – Can only be created by one machine at a time. Not ideal for network rendering. Must make sure every machine has the same version of different types of QuickTime installed.

MPG (aka MPEG)

Pros – Highly compressed files that look very good. There are several basic types of MPEG files. 'Type II' MPEG files can be broadcast quality and are 720×480 . This is what you need to burn DVDs. Autodesk Cleaner is great software for creating these files. MPEG type I files are half as small in each pixel dimension (for a quarter total image size smaller) and are good for client review and web purposes. MPEG 4 is gaining popularity fast.

Cons – You typically don't edit MPEG files. They are often highly compressed and should be considered the 'end result' of your projects. You currently can't render MPEG files out of combustion or 3ds max and you should not want to

anyway. Again, they can look good playing back, but are typically very compressed files.

Notes: If you are ever in doubt about what format to use or if another facility can read them into their pipeline, I suggest using uncompressed TGA (Targa) files. They are the 'Fender Stratocaster' of the animation file formats. That is they haven't changed in years and still rock the house no matter what project you are working on. They could be thought of as the Old Faithful of image file formats.

I typically work with PNG files back and forth between 3ds max and combustion, but ultimately output final work as uncompressed Targa. These files can be given to any non-linear editing system made today. Compiling work to uncompressed MOV or AVI is also good for final work. These are just a few ways of working. Remember, your workflow may be totally different and work well for you.

Different hardware editing systems will allow different file types to play in real time, but you should still consider network rendering individual frames and then compiling them to your editing system codec later.

APPENDIX II **GLOSSARY/** INDEX OF COMBUSTION TERMINOLOGY

A STATE OF THE STA

Brunder Library A. Physipper man are 1 at 5 ft.

Marine to Naviga (No.) and

the property of the state of th MANAGER HAS COMMON BUT A TOP YOUR ON THERE! AN problem a security so that the try three is THE STORY STORY OF STREET, ARREST ON PROPERTY AND PROPERTY.

We beneficial of color estimation pomproving expenses. MODE YOU FAN WORK IN B. NO. TO, NO UP PROBE THE SUSPENSION OF WHITE puip time in combinitions targuage, an 2-bit chape has one 18.2

A PROPERTY OF THE PROPERTY OF

no available colors, or (256 ledits x (250)) recovery x (255), and have it graviticase amonge sooth as on alcha chomones con his in up to 25% grade

Brametium ... a Term to all cases food the fiction of conceptable appropriately

of a paragraph is become formula for subsidia.

AND A SECOND PROPERTY OF THE PERSON OF THE P

24p This is the term commonly used to describe a frame rate used in films. This means 24 frames per second in progressive (p) mode.

3:2 Pull Down This is a process that changes frame rates. Typically, one converts the common film rate of 24 frames per second to and from 25 or 30 frames per second of PAL or NTSC video, respectively. This process can also add or remove video fields to images.

Alpha Channel An alpha channel is a grayscale image that represents values of transparency. This information is often embedded in the file along with the red, green and blue color information channels. In combustion, pure black is transparent (0% opacity) and pure white is fully opaque (100% opacity). Any values of gray are somewhere, proportionately, in between. An alpha channel is often called a matte and can easily be created or manipulated using keyers, the Paint operator and/or masking tools.

Anamorphic Has a variety of applications in the film and video world, but in combustion it typically identifies a piece of footage or a composite that is of a wide aspect ratio. This often is accompanied by a non-square pixel aspect ratio. HD is 16×9 , or 1.77 to 1 aspect, and often referred to as anamorphic. Likewise, many feature films are 1.85 to 1 or even 2.35 to 1 anamorphic wide screen images of different resolution.

Aspect Ratio This is the relationship of width to height in an image. An image that is 640×480 is a common 4×3 , 4:3 or 'four by three'. An aspect ratio can be thought of as a fraction, so that four by three is actually 4/3 = image aspect ratio of 1.3333. Also see Pixel Aspect Ratio.

Bit Depth The amount of color information something contains. Within combustion, you can work in 8, 10, 12, 16 or float bit depths at any given time. In combustion's language, an 8-bit image can use 16.7 million available colors, or $(256 \text{ reds}) \times (256 \text{ greens}) \times (256 \text{ blues})$. An 8-bit grayscale image such as an alpha channel can have up to 256 levels of luminance from black to white.

Branch A term that describes the flow of (multiple) operators that are applied to a piece of footage in a certain order of processing. With an empty Workspace, if you select File > New > Paint three different times, you have

three branches in your Workspace. These could be joined into one branch by nesting them all into a single composite as layers.

Composite This is where you create complex combinations of images as layers. 2D composites merely stack layers on top of each other, while 3D composites can transform layers in a space. 3D composites can also include lights and a camera.

Compound . . . Several operators begin with the name 'compound'. Examples include Compound Blur and Compound Channel Selection. Very simply put, what a Compound operator does is take information from one source and apply an effect of some kind to another source elsewhere in the Workspace.

CWS Combustion Workspace (see Workspace).

Duplicates A duplicate of something means that it is repeated and used again elsewhere in your Workspace. These are like copies but they are not separate. That is, changes made to one will also be made to the other(s). They are 'the same', not just copies. Items with names in italics are duplicates.

Fields In the world of PAL and NTSC video hardware, images are often broken down into 'upper' and 'lower' dominant images. Fields are used to help smooth the motion of objects in video and animation intended for playback on video equipment (as opposed to multimedia playback off a computer, for example).

Footage Can either be a solid created within combustion, or images on the hard drive (such as AVI, MOV, TGA, JPG, etc.). Footage can hold a frame rate, duration, pixel size (width \times height) and can have field interpolation for use with video equipment.

Footage Library Contains all the 'raw' elements within the CWS. These are not necessarily visible in the currently viewed branch or composite. This area can almost be considered the entire Workspace's 'bin'.

FPS Frames per second. Something that is '24p' is 24 frames per second. Often in NTSC video, 30 fps is the shorthand for a broadcast standard of 29.97 fps. This fractional difference is to accommodate audio synchronization on video hardware. Interlaced video that is shot at 30 fps actually captured 60 fields per second due to the two fields for every frame.

Groups Groups of vector objects can only be created within *a paint* branch. To 'group' Layers in a Composite, you use Nesting (see below).

HD and HDTV High definition images. There are several different flavors of HD, including 720/30p and 1080/24p. The first number represents the pixel size of an image in height and the second number is the frame rate of the footage. The 'p' indicates progressive, as opposed to interlaced frames. For example, the higher resolution of the two is 1920×1080 at 24 progressive frames per second.

HSL Hue, Saturation, Lightness. This is one of the color spaces that combustion can often work.

Interlace/Interleaf The term(s) that can describe footage that contains field separation. You might hear these interchanged depending on the vendor or person. For television, most studios use field separation/acquisition when shooting or generating their clips for broadcast. Opposite = Progressive.

Keyframe This is not only the 'how much', but is also the 'when' of any value that changes over time. There are several different methods of interpolation between keyframes in combustion. Keyframes can be viewed and edited in the Timeline. The easiest way to create keyframes is to enable the Animate button at any time.

Layer An element within a composite. Layers are usually the end result of branches containing operators applied to one piece of footage. Layers hold transformations (move/rotate/scale/etc.) and can have transfer modes applied. By default, in the Schematic View, a layer is represented by a round circle and should look different to composites, operators, and footage. A layer is always rasterized and never a vector.

Luma Keying A process similar to chroma keying, but instead of creating an alpha channel (matte) based on color values, it eliminates pixels based on how dark they are.

Luminance The brightness level of a pixel. In the HSL color space, the L is for luminance.

LUTs/Look Up Tables Simply put, an LUT is a way of representing one color space in another manner.

Mask Often synonymous with matte. Within combustion, this is a vector object or series of objects that isolate portions and image to show through. They are typically used to generate or edit an alpha channel in some way.

Matte An image that represents the transparency information of another piece of footage. Used loosely, this is often another term for the alpha channel embedded in an image or the result of the keying process.

Nesting Nested composites can have one or multiple layers (at least one of which is a 'group' of independent layers and/or operators to act as one layer). The output of a nested composite can be a single layer within a whole new composite. This is a very important concept for complex work in combustion.

Node/Node-based This is a general term for the iconic method of compositing. The Schematic View is a node-based system of working. Other compositing applications such as Flame and Digital Fusion are also node-based systems. In combustion, items are often called nodes because of the Process Tree.

Non-destructive Any process or step can be edited at any time. You can 'go back' at any time, make changes and the changes will be reflected 'downstream'.

NTSC National Television Standards Committee. This is the video standard used in North America as well as other parts of the world, depending on broadcast standards acceptance. NTSC is a smaller frame than PAL, but has a higher frame rate of 29.97 frames per second.

Operator An effects process of any kind is applied through the use of operators. Examples include such familiar effects as blurring, painting, masking, chroma keying, and color correcting. Third-party plugins to combustion are applied as operators.

Paint Combustion has a very special operator simply called Paint. This is arguably half of the power of the entire application. Objects created in Paint can be animated and are always non-destructive (to use a Photoshop term, they are never 'flattened'). You should get to know the Paint operator no matter what you use combustion for. It can be extremely handy to have a built-in, full blown Paint application within a compositing environment.

PAL Phase Alternate by Line. This is a video standard common throughout Europe and in many parts of Asia. This has a larger image than NTSC, but a slower frame rate of 25 frames per second.

Pixel A single element of color information. In combustion, all spatial measurements are made in pixels, never inches, dots per inch (dpi) or centimeters.

Pixel Aspect This is a number that represents the aspect of width to height of each pixel in an image. In a 'square pixel' image, the pixel aspect is 1.0 or 'one to one'. Two images might contain the same number of pixels, but the pixel aspect ratio can cause them to be viewed differently by different hardware and monitors. For example, an image that is 720×480 with a pixel aspect of 0.9 is a common format for DV. The pixel aspect of 0.9 causes these images to have an aspect ratio of 4×3 ; the same DV image with a 1.2 pixel aspect ratio will be anamorphic and have a 16×9 image aspect ratio.

Plate A term often referring to a background. Plate can also describe raw unedited footage as shot by a real-world camera.

Process Tree All the branches in a current Workspace make up the Process Tree.

Progressive The term often used to describe an image that does not contain field separation for video hardware devices. This is a full frame that, if paused on a broadcast video monitor, would not contain the jitter commonly seen in fast-passed clips shot with field separation. Opposite = Interleaved.

Proxy A lower resolution stand-in for a piece of footage. Using proxies makes combustion cache faster and use less memory. Combustion can render proxies within the application at any time, hardly slowing the work process. When roughing out a composite containing numerous and/or extremely high-resolution images, taking advantage of proxies can be a great time saver.

Resolution In combustion, this only refers to raw pixel dimensions of width and height (typically in that order). Nowhere in combustion will you see the measurement of inches, centimeters, or dots per inch (DPI) representing resolution. Since combustion was primarily designed for film and video, the spatial measurements of this type are irrelevant. Think for a moment if you play

a video on a small TV or a large one – they both have the same number of pixels, but one is spatially bigger. This might be the case, but they are, however, the same resolution in pixel dimensions.

RGB Red, Green, Blue. This is the primary color space that combustion uses. Depending on the bit depth, the range of each value, when mixed with others, represents the complete digital spectrum.

RGBA Red, green, blue and alpha channels.

Roto or Rotoscope In traditional animation, this is often the name of the process of tracing a live-action plate to create realistic motion in animation. In computer graphics, this is often a generalized term for things done manually frame by frame.

Schematic A 'node' or graphical, icon-based viewer of the entire Workspace. This shows the flow of operators made to footage in the Workspace. The schematic viewer does not show hierarchies of layers, vector objects occurring within a Paint operator, or any information about things occurring in 3D space. It tells nothing about animation or keyframes. It only shows the flow of operators applied to footage, and how layers go into composites. You might best think of the Schematic as a river of Effects operations, and the end result is what typically represents that particular branch (layer) of the flow of the project.

Solid A piece of footage that is nothing but a color 'placeholder'. This can hold a few basic statistics for a layer such as duration, frame size/rate and bit depth. A solid is often created (just) to be a source on which operators work their magic.

Sprite A 2D image mapped onto a rectangular shape that, in turn, always 'faces' the viewer. In combustion, the Particle operator uses sprite technology to simulate complex patterns in an extremely efficient manner.

Telecine This is the term often used to describe the process (or the actual machine) that changes film's frame rates to video frame rates. For example, film footage shot at 24 fps might be converted via a telecine to 30 fps so that video equipment can display it at the native frame rate.

Timeline Panel This is where you edit and view keyframes of animation.

Overview Mode: For animation editing, this is 'the big picture'. Here, you typically see and edit *when* (on what frame) something happens, but not how much (value).

Graph Mode: For animation editing, this is the 'nitty-gritty'. Here you typically edit both *when* (on what frame) something happens, and also *how much* (values).

Transfer Modes Different ways of displaying paint objects or layers so that items 'below' show through in different fashions. The default is 'normal' but others exist such as Add, Soft Light, Negative and Screen. A layer's transfer mode cannot be viewed when the viewport is in a Layer view. You must view a composite to see the effects of different layers' transfer modes.

Vector Objects These are mathematically created processes that are resolution independent. Unlike bitmap or raster objects, they will not lose resolution if they are scaled up past 100% size. In combustion, they are typically created within a Paint, Mask, or Selection operator.

Viewport The areas at the top of the UI where you view selections in the Workspace panel. This is also where the Schematic View can be displayed as well as the Footage Library viewer. It is extremely useful to utilize more than one viewport when working in combustion.

Workspace (*.CWS files) Contains all elements in the current session of combustion. Can be considered the current project running in combustion at any time. A combustion Workspace (*.CWS file) contains everything. This can be considered the project at hand. Although you can only have *one* Workspace open at a time, this can include any number of branches, composites and operators.

Workspace Panel The tab bar that is docked next to Toolbar by default. This is often where you can build, rename, reorder and edit the elements in your project. In the Workspace panel, the icon that looks like a TV monitor identifies what is being displayed in the current viewport. The icon of an arrow pointing left identifies what parameters are currently being displayed at the bottom of the UI. You select items in the Workspace panel by clicking on the name of the item, not the icon to the left of its name. Clicking on the icons will turn off those items instead of selecting them.

YUV A color space often used by computer graphics and video applications.

Index

2D composites, 92–3, 94–107 3D composites, 92–3, 105–13 3:2 Pulldown, 35 8-bit color, 156, 157 10-bit color, 159 16-bit color, 159–60 Arrow tool, 66, 98 Audio Toggle, 48 Audio video interleaf (A Audio/video editing: audio, 242–4 edit markers, 256 edit operator, 247–9,	
Absolute option, 208 filmstrip, 244–7	
Active viewports, 13, 14, 111 one-point editing, 25	5
Add operation, 137–8 split layer, 256–7	
Add Tolerance, 182 transitions, 253–4	
Adobe products see After Effects; trimming, 249–51	
Illustrator; Photoshop two-point editing, 25	5
After Effects, 103, 113 Auto Layout, 133	
Alpha channel: Auto Save, 4–5	
see also Keying Auto Scale, 227	
footage controls, 34–8 Auto Snap, 209, 217	
masks, 145–54 A/V see Audio/video	
preserve alpha, 153–4 AVI see Audio video int	erleat
Set Matte operator, 150–1 Axis options, 207	
transfer modes, 100–1	
viewports, 51–3 Backburner, 300–5 Alaba lavala apparatus 187	
Alpha levels operator, 186 Backlighting, 192	
Always render Current Frame, 246 Backup files, 4 Analysis and 200, 10	7 10
Analyze options, 209–10 Backwards tracking, 217	-10
Animate button, 17, 221–2, 223–4 Basics category, 164–5 Behavior category, 281–	2
Animation: Behavior category, 281- channels, 227-8 Behavior over life, 282-	
ease curves, 232–5 Best quality, 27	3
expressions, 228 Bezier tool, 66, 69, 73,	136 147
extrapolation, 234–6 Bit Depth, 36, 158–60	130, 147
filtering, 227–8 Bluescreen, 174, 176–7,	192
flipbook, 220–1 Blur option, 187	172
keyframes, 221–2, 223–4 Boolean operations, 133	7–43
markers, 237–9 Branches, definition, 10-	
math operations, 236–7 Brush category, 77	
onion skinning, 220–1	
Timeline, 222, 225–6 Cache Meter, 15, 25–6	
Tracker, 201–2, 223 Caching:	
Application-programming interfaces display quality, 26–8	
(APIs), 272 file sizes, 308	
Area emitters, 274 filmstrip, 246	
Area samples, 191 flushing the cache, 26	

Caching (Continued)	multiple clips, 93
instancing, 127, 129–30	nested, 96, 113–16
Paint operator, 56–61	null objects, 93, 94, 96, 113
preferences, 6–7	parenting, 93–4
RAM Cache, 24–5	Schematic view, 121–3, 125
Schematic view, 119	split layer, 256–7
Calculator entry, 19	stencil layers, 151–2
Camera category, 109–10, 113	Tracker, 206
Camera shake, 265–7	transfer modes, 94, 96, 100-1
CC see Color Corrector	transformations, 97-100
CGI see Computer generated imagery	Compound channel selection, 144
Channel Selection operator, 143–4	Computer generated imagery (CGI), 175
Channels, 34, 94, 145-6	Constant extrapolation, 235
Characters, 86–90	Context option, 231
see also Text	Contrast, 164
Choking the matte, 187	Control points, 69–73
Chroma keying, 176, 192–4	Conventions, data entry, 18–21
Cineon (CIN) files, 310	Cropping, 36
Circle emitters, 274	Crosshairs, 99
Clean-up procedure, 120, 122	Cursor location, 15
Clipping color, 166	Curves category, 166
Clone tool, 75	Curves controls, 185
CMYK see Cyan/Magenta/Yellow/Black	Custom brush tools, 77
Collapse feature, 31	Cyan/Magenta/Yellow/Black (CMYK)
Color:	color, 157–8
Bit depth, 158–60	
category, 163–4, 187–9	Data entry, 18–21, 99
channels, 34–5, 53, 143–4, 154–6,	Default behavior, 282
158–61	Default settings, 3
correction, 161–2	Deflectors, 274, 284
keying, 178, 179	Deleting, 42
preferences, 7–8	Depth of field, 193
spaces, 156–8	Depth order, 108–6
suppression, 188, 189, 191-2	Difference keyer, 175
Color Corrector (CC), 162–7, 180	Display quality, 18, 26–8
Color Match, 167–9, 179–80	Draft quality, 28
Color Picker, 75–6, 168	Drag and drop, 72
Commit to disk, 296–9	Draw mask operator, 146–9
Compare feature, 170–2	Draw selection, 144
Composites:	Duplicates see Instancing
2D composites, 92–3, 94–107	Duration, 81–3
3D composites, 92–3, 107–13	5
definition, 9, 92	Ease curves, 232–4
effect operators, 103–7	Edge gradients, 79, 137, 139–40
grouped, 96	Edit markers, 256
importing, 96–7	Edit operators, 9, 125, 247–9, 251–4
Layer view, 101–3	Effects operators, 103–7, 123–5, 130
manipulating layers, 97	see also Keying
merged images, 95	Ellipse tool, 66, 67–8, 139, 141

Importing:	linear keyer, 176
composites, 94–6	luma keying, 175
expressions, 263	matte controls operator, 187
Footage, 30	output operator, 185–6, 180–1
Tracker, 211	paint touch-ups, 177, 179
Workspace, 30	pulling a key, 174, 176–7, 178
In points, 82	setup operator, 185
Info Palette, 15–16	third-party plugins, 193–4
Instancing, 41, 127–30	workflow, 189-92
Interface see User interface	
Intersect operation, 137–8	Lasso selection, 67
Invalid branches, 10	Layers:
Invert Alpha, 34, 53	2D composites, 92–3, 94–107
Invert option, 215–16	3D composites, 92–3, 107–13
Invert selection, 144	definition, 8, 9
	effect operators, 103–7
Jaggies, 83–5	grouped, 96
JavaScript, 223, 260–5, 265–8	keying, 177–8, 180–1
JPG files, 309	Layer view, 101–3
	manipulating, 97
Key category, 184–5	markers, 238
Keyboard entry, 19–20	merged images, 95
Keyboard shortcuts see Hotkeys	naming, 123
Keyer operator, 184–6	nested, 96, 113–16
Keyframes:	object duration, 82
see also Tracker	
Animate button, 17	Schematic view, 121–3, 125
animation, 221–2, 223–4	splitting, 256–7
channels, 228–31	stencil layers, 151–2
	transfer modes, 100–1
ease curves, 232–4	transformations, 97–100
expressions, 268–70	Library category, 276–7
extrapolation, 234–6	Light blue inputs, 124–5
filtering, 227–8	Light category, 109, 113
manual, 217	Line emitters, 274
markers, 237–9	Line tool, 66
math operations, 236–7	Linear extrapolation, 235
particle operator, 287	Linear keyer, 176
Keying:	Link To button, 244
additional tips, 192–3	List View, 31
alpha levels operator, 186–7	Local time settings, 17
chroma keying, 176, 190–3, 194	Lock button, 75
color category, 187–8	Log tab, 294
color match, 179–80	Loop extrapolation, 235
color suppression operator, 187–9	Luma keying, 175
curves controls, 185	Luminance, 157
difference keyer, 175	
garbage masks, 176–8	Macromedia Flash, 80–1
key category, 184–5	Magic Wand selection, 67
layers, 177–8	Make Curve, 70

Manager.EXE, 301–2	Network rendering, 285–6, 291–6, 293–4,
Manual keyframing, 217	299–305
Markers, 237–9, 256	Nodes, 118, 120-5, 133-4
Marquee threshold, 154	Non-destructive vectors:
Masks:	Boolean operations, 137–8
alpha channel, 145–51	composites, 114
Boolean operations, 137–43	masks, 147
draw mask operator, 146–9	painting, 61–5, 74–5
edge gradients, 137, 140-3	rendering, 296–7
feathering, 137, 139–43	NTSC frame rates, 48
free hand tools, 66	Null objects, 93, 94, 96, 113, 270
garbage masks, 149, 176–7, 198	Number item, 204
operators, 145–51	
Paint operator, 149–50	Object duration, 81–3
preferences, 154	Object selections, 144
preserve alpha, 153–4	Off option, Tracker, 207, 213
Set Matte operator, 150–1	Offset, 161
stencil layers, 151–2	One-point editing, 255
Master category, 163	One-point stabilization, 211–16
Math operations, 236–7	One-way connections, 262
Matte Controls operator, 187	Onion skinning, 220–1
Mattes see Alpha channel	Opacity see Transparency
Medium quality, 27–8	OpenGL, 266, 272-4, 277, 280, 283, 286-7
Memory see Caching; Random access	Operator Controls, 16
memory	Operator Markers, 237–8
Merged images, 95	Operators, definition, 8–9
Middles, trimming, 249–51	Optimization, 3
Midtones, 161, 163, 168	Out points, 82
Missing footage, 38–9	Output:
Mixed extrapolation, 236	backburner, 300–5
Mode options, 207–8	commit to disk, 296–9
Modes, Paint operator, 74–6	edit operator, 247
Monitor.EXE, 302–5	formats, 290, 309–13
Monitors, preferences, 5–6	network rendering, 293–4, 299–305
Motion blur, 267, 275	nodes, 291–2
MOV files, 304	operator, 185–6
MPG files, 312–13	render dialog window, 290
Multi-frame footage, 83	render to RAM, 295–6
Multiple:	RenderQueue, 299–300
clips, 93	selection, 80
objects, 197, 200–3	settings, 33, 35-6, 291-4
selections, 40–1, 64, 71–2	switcher operator, 296–9
viewports, 42–4, 56, 148	Overlapping paint objects, 63
views, 112	Overview mode, 225, 256, 262
Multiprocessors, 3	5 5/
	Paint*, 56
Naming, 42, 65, 75, 123	Paint operator:
Nested composites, 96, 113–16	application methods, 56-61
Nested groups, 73	brush category, 77–8

Paint operator (Continued)	Path Option type, 89–90
control categories, 74–83	Perspective viewports, 112
control points, 69-70	Photoshop, 94-6, 100
footage, 56–9	Pick button, 21
'from scratch', 85	Pick points, 212
gradient category, 74–5, 78	Pick tool, 87
grouping objects, 70–3	Ping pong extrapolation, 235
Illustrator files, 85–90	Pivot points, 68–9
keying, 177–8	Pixel Aspect Ratio, 35, 46
masks, 149–50	Pixel dimensions, 283
non-destructive vector painting, 61–5	Play mode, 47
objects, 65–8	Playback:
pivot points, 68–9	controls, 17, 26, 47, 64, 110
preferences, 56	multiple viewports, 42–3
Process Tree, 59–61	particle operator, 279–81
raster output, 83–5	viewports, 56
Schematic view, 124–5	Playback Behavior, 36
selections, 67–8, 144–5	Plot eyedropper, 183, 188
settings category, 80–3	Plugins, 8–9, 102–3
text and characters, 86–90	PNG see Portable network graphic
toolbar, 65–8	Point emitters, 274
Tracker, 196, 204	Polygon tool, 68
transfer modes, 74–5	Portable network graphic (PNG) files, 310
transformations, 76	Position option, 206, 216
viewports, 62–5	Preferences:
Paint touch-ups, 177, 192	caching, 6–7
Pan control, 44–5	colors, 7–8
Pan tool, 65	default, 3
Parallax, 110, 113	floating menus, 5–6, 39
Parent to source option, 208	masks, 149–50
Parenting, composites, 93–4	monitors, 5–6
Particle operator:	OpenGL, 272
animation, 224	Paint operator, 56
behavior category, 282–3	particle operator, 272
deflectors, 273–4, 275	reset, 3
emitters, 273–4	Schematic view, 133–4
library category, 276	selections, 154
library presets, 285–6	transparency, 53
particles, 272–3, 298	Preserve Alpha, 153–4
preferences, 272	Pressure input, 70
preview window, 275–6	Preview quality, 27
scaling factors, 278–9	Preview window, 275–6, 285–6
settings category, 275–6	Primary inputs, 125
shape category, 285	Process Tree:
Tracker, 179	composites, 114
transform category, 273	definition, 10–11
zoom category, 275, 279	Paint operator, 59–61
Particle Variation, 282	rendering, 291–4
Particles category, 276–9	Schematic view, 118, 126

Proxies, 37–8	Reveal tool, 75
Pulling a key, 174–6, 178	Rewiring, 126
	RGB see Red/Green/Blue
Quick Capture, 30–1, 242	Rich pixel format (RPF/RLA), 310–11
Quick Pick, 260–5	Rim lighting, 192
QuickTime, 80, 312	RLA see Rich pixel format
	Roaming option, 208
Random access memory (RAM), 6–7,	Rotations:
24–5, 41–2	composites, 98–9
see also Caching	expressions, 258
Random expressions, 266–7	pivot points, 68–9, 72
Ranges category, 166	Schematic view, 120–1
Raster output, 83–5	Tracker, 203
Raytraced shadows, 112	Round nodes, 120–3, 133
Real Time Roto™, 56	RPF see Rich pixel format
Rectangle tool, 66, 69	
Red/Green/Blue (RGB) color, 156–7, 161	Saturation, 157, 164, 188
Reference Box, 203	Saving, Auto Save, 4–5
Reflectivity, 110	Scale:
Relative option, 207–8	composites, 99
Relative repeat extrapolation, 235–6	particle operator, 278
Remove selection, 145	Tracker, 204, 206–7, 216
Renaming, 42, 62	Schematic view:
Rendering:	accessing, 118–23
backburner, 300–5	appearance, 133
commit to disk, 296–9	applying operators, 123–4
composites, 111	composites, 125
dialog window, 290	definition, 10–11, 17
display quality, 26–8	effects operators, 103, 124–5
network rendering, 294, 299–305	hotkeys, 118–19
output formats, 290, 299–303	instancing, 127–30
output settings, 291–3	Paint operator, 56
Render All option, 246	preferences, 133–4
Render Cache Size, 56	Scratch tracks, 242
render to RAM, 172, 295–6	Scrub buttons, 14, 44
RenderQueue, 299–300	Scrubbing icons, 126
switcher operator, 297–9	Secondary inputs, 125
Replace Footage, 38–9	Selections:
Replace operation, 138–9	Boolean operations, 137–43
Reset options, Tracker, 210–11	channel selection, 143–4
Resetting combustion, 3, 20	composites, 98
Resolution:	draw selection, 144
caching, 25	edge gradients, 137, 139–41
composites, 97	elliptical, 144, 146
display quality, 26–8	feathering, 137, 139–41, 144
footage controls, 35–6	GBuffer material, 144
Paint operator, 83–5	invert selection, 144
proxies, 37–8	multiple, 40–1, 64, 71–2 objects, 144
Response curves, 161	Objects, 144

Selections (Continued)	Surface category, 110
operators, 136–43	SWF format files, 80-1
Paint operator, 61–2, 63–5, 9–50	Switcher operator, 297–8
preferences, 154	
rectangular, 77, 144, 146	Tails, trimming, 249-51
remove selection, 145	Targa (TGA) files, 309, 313
Schematic view, 120	Temperature, 164
Workspace panel, 40–2	Text:
Sequence options, 31	category, 87–8
Server.EXE, 302	operator, 86–90
Set Matte operator, 150–1	Paint operator, 70–3
Settings category, 80–3, 284	selection, 67
Setup category, 167	tool, 67
Setup operator, 185	TGA files, 309, 313
Shadows:	Third-party plugins, 8, 103, 193-4
color correction, 161-7	Three chip cameras, 192–3
color matching, 169	Thumbnail Browser, 11-12, 30, 31-2, 38-9
composites, 109, 112	Time codes, 48
effects, 79–80	Time Indicator, 47–8
Paint operator, 79–80	Time Settings option, 246–7
Shadows/Midtones/Highlights (SMH), 161	Time Stretch, 36
Shape category, 108, 283	Timeline:
Shears, composites, 99	animation, 222, 225-7
Shortcuts see Hotkeys	audio/video editing, 244
Show Marquee, 154	channels, 227–31
Show Only Animated Channels, 227–8	ease curves, 232–4
Show Particle Types, 276	edit operator, 248
Show Time option, 246	expanding, 225
Shrink option, 187	extrapolation, 234–5
Side-by-side viewports, 191	filtering, 227–8
Slider entry, 19	instancing, 130
SMH see Shadows/Midtones/Highlights	markers, 237–9
SMPTE time code, 48	math operations, 236–7
Snap option, 208	Tolerance, 181–2, 208–9
Softness controls, 182	Tool tips, 4
Solids, 32, 75	Toolbars, 15, 39-42, 65-8
Source Frames, 36–7	Touch-up mattes, 177, 179
Source rollout, 205	Tracker:
Source settings, 33–6	analyze options, 209–11
Spline curves, 70, 141	animation, 222
Split layer, 256–7	applications, 198–200
Stabilization operator, 197, 199, 211–18	axis options, 207
Statistics, 294	backwards tracking, 217–18
Stencil layers, 151–2	Box, 204
Still images, 32	interface, 205–11
Store bins, 76	mode options, 207–8
Stores feature, 170	Palette, 203–4
Subtract operation, 138	reference element, 204–5
Suppressing color, 188–9	reference options, 208–9

stabilization operator, 197, 199, 211–16,	definition, 13
217–18	keying, 191–2
track options, 206–7	Layer view, 101–3
Tracking channel, 262	masks, 148
Transfer Modes:	multiple, 56
composites, 94-6, 100-1	Paint operator, 62–5, 90
grouped, 96	view modes, 49–53
Paint operator, 74–5	working with, 42–53
Transform category, 76	Watch folder, 299–300
Transformations, 76, 93, 97–100	Waveforms, 243–4
Transitions, 253–5	Wiring, 118, 125, 198
Transparency:	Workflow:
see also Keying	caching, 24–8
Paint operator, 58, 78	display quality, 26–8
preserve alpha, 153–4	effect operators, 103–7
transfer modes, 100	File menu options, 28–30
viewports, 50–1	hotkeys, 47
Transparent View, 102	keying, 189–92
Trimming, 249–51	non-destructive vector painting, 74–5
True color, 159	particle operator, 287
Two-point editing, 255–6	Tracker, 198
Two-point expressions, 267–8	Workspace:
Two-point stabilization, 212–14	definition, 9–10
Two-point stabilization, 212 14	File menu options, 28–30
UI see User interface	importing, 30
Uncompressed files, 308	Workspace panel:
Ungrouping objects, 72–3	animation, 227
User interface (UI):	composites, 103, 113–14
	definition, 14
appearance, 4 data entry conventions, 18–21	effect operators, 103
	footage, 39–42
graphical explanation, 11–19	instancing, 128, 130
major project components, 8–11 preferences, 3–8	Paint operator, 57, 62–5
preferences, 5–6	viewports, 42–53
Value (color) 157 164	Wrap option, 215
Value (color), 157, 164	
Variable zoom, 45	Write On parameter, 88–9
Vector-based objects, 83–6	Zoom:
non-destructive, 61–5, 74–5, 114, 138,	
147, 296	category, 275, 287
text and characters, 86	control, 44–6
View modes, 49–53	options, 246
Viewport controls, 14, 44–6	tool, 65
Viewports:	
see also Schematic view	
composites, 111, 112	

www.focalpress.com

Join Focal Press online

As a member you will enjoy the following benefits:

- browse our full list of books available
- view sample chapters
- order securely online

Focal eNews

Register for eNews, the regular email service from Focal Press, to receive:

- advance news of our latest publications
- exclusive articles written by our authors
- related event information
- free sample chapters
- information about special offers

Go to www.focalpress.com to register and the eNews bulletin will soon be arriving on your desktop!

If you require any further information about the eNews or www.focalpress.com please contact:

USA

Tricia La Fauci

Email: t.lafauci@elsevier.com

Tel: +1 781 313 4739

Europe and rest of world

Lucy Lomas-Walker

Email: l.lomas@elsevier.com Tel: +44 (0) 1865 314438

Catalogue

For information on all Focal Press titles, our full catalogue is available online at www.focalpress.com, alternatively you can contact us for a free printed version:

USA

Email: c.degon@elsevier.com

Tel: +1 781 313 4721

Europe and rest of world

Email: L.Kings@elsevier.com Tel: +44 (0) 1865 314426

Potential authors

If you have an idea for a book, please get in touch:

USA

editors@focalpress.com

Europe and rest of world ge.kennedy@elsevier.com